INTRODUCTION TO FILM

About the Author

Robert Withers received his B.A. degree from Yale University, where he studied art history, film, and music. Since then, he has taught several video and filmmaking workshops, and has worked in the film industry as writer, director, producer, cinematographer, and editor. He has also continued to make films independently. In 1972, he received a grant from the Connecticut Commission on the Arts for work in film, and also created the electronic music sound track for Standish Lawder's prizewinning experimental film *Raindance*. In 1977, he received a grant from the National Endowment for the Arts to direct a film version of *16 Millimeter Earrings,* the dance/theater work by Meredith Monk. That film has been shown in numerous festivals throughout the United States, Europe and Japan, and won a Merit Award at the Dance Film Festival in New York City. From 1974 to 1982, Mr. Withers was Artist-in-Residence at the Leonard Davis Center for the Performing Arts at the City College of New York, where he taught an advanced filmmaking workshop and coordinated activities of the Picker Film Institute.

Introduction to Film

Robert S. Withers

BARNES & NOBLE BOOKS
A DIVISION OF HARPER & ROW, PUBLISHERS
New York, Cambridge, Philadelphia, San Francisco
London, Mexico City, São Paulo, Sydney

For my teachers, Standish Lawder
and D. A. Pennebaker, and for Ann

Picture credits appear on page 264.

INTRODUCTION TO FILM. Copyright © 1983 by Robert Steele Withers. All rights reserved. Printed in the United States of America. No part of this book may be used or reproduced in any manner whatsoever without permission except in the case of brief quotations embodied in critical articles and reviews. For information address Harper & Row, Publishers, Inc., 10 East 53rd Street, New York, N.Y. 10022. Published simultaneously in Canada by Fitzhenry & Whiteside Limited, Toronto.

FIRST EDITION

Designer: C. Linda Dingler

Library of Congress Cataloging in Publication Data

Withers, Robert S. (Robert Steele)
 Introduction to film.

 Bibliography: p.
 Includes index.
 1. Moving-pictures. 2. Cinematography. 3. Moving-pictures—Appreciation.
 I. Title.
PN1994.W57 1983 791.43'01'5 82–48256
ISBN 0–06–460202–8 (pbk.)

83 84 85 86 87 10 9 8 7 6 5 4 3 2 1

Contents

Preface

This book is intended both for students in introductory film courses and for the general reader with an interest in film. It should serve as an introduction, review, and reference for film study and criticism, and as a general orientation for actual filmmaking. The reader will find here a critical context for film viewing and analysis, as well as a convenient overview of the technical aspects of film. Although the more technical details of film production are beyond the scope of this book, the beginning filmmaker will find a useful introduction to basic film technique, presented in terms of its expressive potential (which is, after all, the reason for knowing technique).

Whether we see it as an art, an entertainment, or a means of communication, film has always been intimately linked with human experience. Accordingly, both aesthetic and technical concepts are presented throughout the book within the historical context of filmmaking, and all discussions of film practice are related as much as possible to the economic and social forces that influence and inspire them. Although film history is not treated *per se,* numerous examples are drawn from the body of world cinema to illustrate various technical and critical ideas. These illustrations should help readers apply ideas to the films they watch and enable them to view films with a more perceptive, critical eye.

Throughout the book, concepts and techniques are also defined in relation to all the important modes of filmmaking—from fiction film and the documentary to experimental film and specialized uses, such as anthropological studies. This should provide a more comprehensive understanding of the film medium as a whole, and of the relationships and cross-fertilization between the various modes.

One point should be noted concerning the stills and photographic

images that appear throughout the text. Although in some cases these are actual frame enlargements—blowups from individual frames of an actual filmstrip—as often as not they are production stills shot by a still photographer on the set or location. As such, they may approximate the framing, lighting, and composition of shots within the film, but they may not reproduce the exact camera position, lens focal length, or other elements of the shot. The stills used in this text were drawn from the collections of the Museum of Modern Art/Film Stills Archive (with the help of Mary Corliss), Cinemabilia, Jerry Ohlinger, and Pennebaker Associates.

Throughout the book, the personal pronouns *he* and *she,* where they appear without antecedents, may be taken to refer to either sex and to exclude neither.

1

Introduction

When Louis Lumière's film *Arrival of a Train* was first shown in Paris in 1895, members of the audience screamed, fainted, and some rushed for the exit as the image of a great steam engine seemed to come rolling right off the screen and into the theater. The new invention was a sensation. Within a year or two, people in Europe, America, and many of the world's capitals were flocking to theaters to see such films as *Feeding the Baby* and *The Charge of the Austrian Lancers*. Many of these early films were simply scenes from everyday life, or were short vaudeville tricks and performances lasting no longer than a few minutes. Yet they must have seemed quite magical to audiences of the day. Life-size images of people moving about in real space were quite different from the stiff and formal poses of early still photography.

Soon, however, the novelty began to wear off. Film producers began to experiment with technical innovations, such as making athletes run backward. They began to explore unusual and exotic subject matter, as in *Electrocuting the Elephant,* and to travel the world over in search of new material. Eventually, to lure an increasingly sophisticated audience, they created events and stories for the camera. These might be patterned after real happenings, as in some of the early "documentaries" that showed toy boats reenacting naval battles, or they might spring directly from the imagination, as in the science-fiction and fantasy films of Georges Méliès. People began to respond to the way filmed images were strung together, and to what they might mean. It was really at this point that the art of film was born, as we usually think of it.

VARIETIES OF FILM EXPERIENCE

Movies and television are so familiar a part of our lives that we can enjoy them, respond to them, and make use of them almost without thinking about how they are able to affect us so strongly. However, we are aware of choosing to watch different kinds of films for different reasons, and we expect to feel and think differently about different kinds of films.

Entertainment Films. When we go out to the movies, or watch a film on television, we are usually interested in the story, the actors, and perhaps the photography or special effects. We say that we like or dislike the film because of how it affects us emotionally, whether it be exciting, scary, sentimental, or funny. We want to feel involved in the story and the atmosphere, to enjoy the personalities of the actors, and to feel that the scenes we are watching are really happening. We like a film that fulfills some of our fantasies or daydreams, or confirms some of our feelings and beliefs about the world. We expect the filmmakers to do the work of keeping us interested and involved.

Documentary Films. We approach documentary films and television news specials with quite different expectations. We are impelled by a desire to find something out, to learn something new about the world. We want to see with our own eyes and hear with our own ears people, places, and events that we may have only heard about or read about. We do expect to be emotionally affected, but as much because of our own interest in the subject and story as because of the skill of the filmmakers. If the subject is important to us, we expect the filmmakers to be fair, honest, and complete in the way they present it to us.

Art Films. From a strictly historical viewpoint, the vast majority of films produced during this century would be considered examples of the art of film. Whether good or bad, whether commercial and popular or esoteric, whether simpleminded or intelligent, whether fact or fiction, most films are intended to reach an audience and to create an effect through the visual and musical techniques of the medium. Nevertheless, some filmmakers draw consciously on the traditions and attitudes of the fine arts—literature, painting, music, theater, and dance—in making their films. In Europe, filmmaking has been more often seen in the context of the fine arts, even though

the films themselves may be intended for popular audiences and may even be based on styles and attitudes of Hollywood filmmaking. We no longer refer to almost any foreign film as an "art film," as was common in the 1950s, but reserve the term for those films that are consciously made with reference to the fine-arts traditions. These *art films* may be made by painters or other artists, or by filmmakers who specialize in an exploration of the medium through small, personal films that are consciously aimed at small, specialized audiences. These films are sometimes called *experimental,* because the filmmaker explores techniques and ideas that are of personal interest, without concerning herself with the need for wide distribution and large audiences.

Information Films. People in schools and universities, businesses and government use films and video to teach, to convey information, and to improve communication between groups. When we watch such films, we usually have a specific purpose in mind and expect the film to be of some practical benefit to us. Such films are valuable if they can convey a direct visual experience or feeling for a subject that we couldn't get from books or a lecture, or if the films are so artfully constructed that they make a potentially dull subject more exciting. We expect the filmmakers to do a certain amount of the work in making the film meaningful to us.

There is one kind of information film that is not intended for a very large audience. This is the sort of film that a scientist (like a psychologist) might make in order to have a record of certain experiments, or that an anthropologist might make in order to be able to study a particular ceremony more carefully than he could "in the field." We might call these "research films."

Sponsored Films. Finally, there are certain kinds of films, such as television commercials and fund-raising films in theaters, that we watch not because we have chosen to but because we are waiting to see another film (or for some such reason). Since we have no special interest in seeing these films, the filmmakers try to make them as visually and dramatically exciting as possible, and to make the action move quickly so that we don't lose interest. Often they succeed and we become involved in spite of ourselves. These films often rely on humor, surprise, the visual fascination of movement, and on special cinematic effects.

FILM AND THE OTHER ARTS

In the beginning, films were generally considered a cheap form of entertainment—as vaudeville, as theater, or even, in the case of Mé-liès, as magic show. Film was most often perceived in terms of theater, and the first attempts to give film the status of a serious art were rather stiff and uninteresting versions of classical stage plays—without the dialogue. Gradually, however, filmmakers and critics began to become aware of the special qualities of the film medium—and the ways in which it both differed from and resembled the other arts, including the theater. There were four qualities that seemed to give film a special place among the arts.

Realism. More than even the youthful craft of photography, film seemed to have the ability to present images of a truly wondrous lifelike and realistic quality. Not only did they move and breathe, but they could be projected to life size, or even larger than life. They were not bound to a single location, like a theatrical performance, but could range anywhere in the world that a camera could be taken. For the first time, events could be presented not only in time, as in the other performing arts, but in far-ranging real space as well.

The realism and fidelity to appearance is the recording aspect of the art of film. It is the very light reflected from the scene in front of the camera that actually strikes the film stock and makes an image. In a sense, the film image is a historical artifact—a life mask or direct imprint of its subject.

Synthesis. It was not long after the growth of film as a popular art that certain poets, painters, and composers began to become interested in the new medium for reasons other than its potential for realism. They thought of film as a synthesis of the traditional arts, combining light, movement, color, and sound into a new and exciting art of almost limitless expressive possibilities. And, indeed, it seems that there is not one of the traditional arts that cannot contribute principles and effects to the art of film. Music and dance contribute to the rhythms and effects of film editing; literature and the dramatic arts contribute to the development of themes, dialogue, and dramatic structure in film; and painting contributes to the art of film lighting and photography. Even sculpture and architecture can contribute to the structuring of film space and to the placement of figures in space. This great range of expressive possibilities is sepa-

rate and distinct from the ability of film to record and reproduce other forms of art, which has more to do with film's potential for realistic reproduction.

Visionary Worlds. Although film was initially designed as a medium for reproducing reality, artists such as Méliès quickly realized its vast potential for creating visions of the pure imagination. As a magician, Méliès was concerned with the fantastic, the imaginative, and the impossible, and quickly turned film to his purpose. Although worlds of vision and imagination had long been evoked in literature and painting, from Homer's Cyclops to Bosch's demons, film gave a new vividness and overwhelming presence to the most fantastic flights of the imagination. Fairy tales, worlds of myth and magic, and surreal visions can be created on film with all the immediacy and vividness of a documentary. From Méliès's *Trip to the Moon* to Jean Cocteau's *Beauty and the Beast* to the science-fiction epics of the 1970s and 1980s, visionary worlds have remained a strong presence throughout the course of film history.

Audience. The potential audience of a motion picture is enormous. Whereas the size of a theater audience is limited by sight lines and the strength of the actors' voices, as well as by the location and the cost of performances, this is not so for films. One can make any number of copies of a single film and show them anywhere in the world that the basic projection equipment is available. A film thus has a potentially much larger audience than a work of the plastic or performing arts. Films can easily be translated through the use of subtitles, voice-over, and dubbing in order to make them available to different language groups. Film can also communicate to audiences who cannot read or write, and can convey concrete ideas and information more directly than the more abstract performing arts of music and dance. Even theater is limited to merely talking about certain events; it cannot present a plane crash, or a close-up of a finger pulling a trigger. For these reasons, the art of film has at least the potential for becoming a kind of universal language, with access to a larger audience than perhaps any other medium.

FILM AND THE RELATIONSHIPS OF PRODUCTION

In film as in any art (or indeed any science or industry), there exist a set of relationships between the producers, the distributors, and

the consumers of the art. By examining these relationships, we can learn more about film and its functioning as a part of human culture and experience. Let us look at the four distinct areas in which we can discover these relationships.

Social/Political. The social and political environments have a powerful, if not determining, effect on the production, distribution, and viewing of films. Film has been involved in the political and social currents of modern history (1) as an instrument of pure propaganda, (2) as a means of confirming and establishing social and political values, and (3) as an instrument of social change and political advocacy. Even when a film is not made for a political purpose, it tends to reflect the social and political climate of the country in which it was made. The production of even fantasy and escapist films may have an indirect political effect, and the social and political organizations of a nation may encourage the production and distribution of certain kinds of films, and discourage others.

Film can serve other social functions, such as education and the dissemination of news and information. It can be used as a research tool by science, and by business as an aid to selling products. Popular entertainment is itself a social function, and films have been the source of several of the myths and culture heroes of our time. Chaplin, Bogart, Garbo, and others created mythic figures through their roles. Like drama for the ancient Greeks, going to the movies has become in the twentieth century an accepted social ritual in which our sense of community is both confirmed and expanded.

Psychological. The relationships between producer and consumer of a film may be understood in psychological terms. In the psychological study of film, we focus on the relationship between the individual filmmaker and his work, and on the perceptual and emotional experience of the individual viewer. The viewer may respond directly and almost physically to visual elements such as rapid editing rhythms, or in more subtle ways to such elements as the physical presence of an actor, the psychological associations of images, and the development of dramatic tension through characterization and plot. Psychological film criticism tries to describe and explain these responses. It also concerns itself with the themes and styles of individual filmmakers and of specific historical periods.

Technical. The production and distribution of every art has a technical aspect, which is concerned with the material means of

production (tools, materials) and with the immediate choices of how those means are used—what we might call the "formal" or "stylistic" aspect. A composer has to work not only with the physical means of producing sound—the piano, orchestral instruments—but with musical notation, scales, harmonies, and other means of expressing musical ideas and emotions.

More than many other arts, the art of film is dependent on and intertwined with a sophisticated and changing technology. To know what film writers, actors, and directors do, we must know the possibilities and limitations of the medium they are working in, what tools and techniques are available to them, what limitations they must work within. Anyone who has not witnessed a script conference, observed a scene being shot on a set, sat with the editor as the scene was being pieced together, as sound effects were added, and as

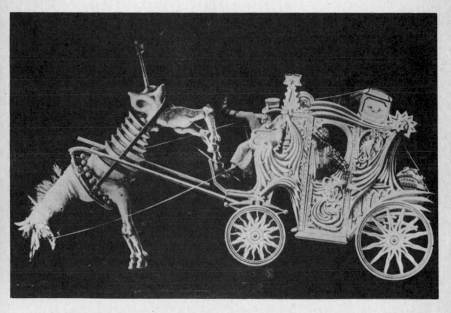

One of the fanciful creations of Georges Méliès, from *The Merry Frolics of Satan* (1906). Attempting to escape from a haunted house, the hero and his servant are accosted by the Devil, who transforms their horse into a runaway demon creature (actually a life-size marionette).

music was composed and mixed to the picture, would be astounded at the number of work hours and the great number of technical procedures that go into making a few minutes of film time on the screen. Yet it is through this long and often laborious technical process that the decisions are made which give shape and meaning to that brief moment on the screen.

The material means of making films have always represented an advanced technology, and the history of film has been strongly influenced by technological innovation. Technological advances have on occasion brought about significant stylistic developments, like the *cinéma vérité* style of documentary film. On other occasions, stylistic and aesthetic demands have led to the development of new technical means.

Economic. Economic factors may be found at the heart of many of the patterns of film production, distribution, and consumption, and these factors have served as the driving or shaping force behind many of the political, psychological, and technical developments of film. An economic analysis reveals much about why films are made, how they are used, and even how they are perceived.

The first great promoters of film, Edison and Lumière, were inventors, manufacturers, and businessmen. They assuredly had a scientific interest in the new film technology, but also a sincere interest in realizing a profit. The economic rewards to be gained from film production had as much to do with the growth of the art as did the demand of audiences for new film experiences.

Film is an expensive art. Perhaps only architecture can begin to rival it in the amount of capital required for production, and in the potential demand for laborers. The high cost of filmmaking has always placed limitations on the kind of work that filmmakers could do, and the financial risk involved has consistently affected the relationship between producers and audiences. (Unlike a building, an unpopular film is of little practical use to its producers.) Economic competition has generated a good deal of the force behind new technological advances, such as the sound film.

Because of its high cost, film production is generally controlled or influenced by those powers in a society that command financial resources and determine how products are distributed. The nature and extent of this influence varies from one political-economic system to another. Even on the psychological level, economic factors

have their effect. The tremendous salaries and expensive life-styles of Hollywood film stars have always been part of their charisma, and part of their fascination as heroes and heroines of our fantasies. The very expense of filmmaking, as it is practiced in the United States, has helped to make it a glamorous, attractive occupation.

VIEWING FILMS

Film appreciation requires a special kind of viewing, in which we are attentive to the techniques employed as well as to the general style of production and the use of film language. At first it may seem that this kind of attention to detail will interfere with our emotional involvement with the film. After some practice, however, attentive viewing can actually deepen our appreciation of films we like, and can open up the possibility of our enjoying many more kinds of films than we are accustomed to.

Wide Viewing. We can increase our appreciation of film by seeing as many different kinds of films as possible, and especially by seeing films that deal with new or unfamiliar subjects, or perhaps deal with familiar subjects in new ways. Documentaries, experimental films, videotapes, scientific or anthropological films—all can increase our appreciation of film's possibilities, even if we are primarily interested in the narrative, acted film. Some contemporary filmmakers have actually attempted to combine these different types of film, and there are elements of film language that seem to operate in many different genres.

Suspension of Judgment. It is often helpful for us to suspend our judgment of whether a film is good or bad, or even whether we like it or dislike it, in order to pay attention more directly to aspects of technique, style, intent, and social or historical context. Even a Grade "B" western can tell us much about the genre, and can provide a basis for comparison when we try to understand exactly why a more inspired work is more effective. A difficult experimental film may be trying to lead us into a new way of seeing—it may require several viewings and an open-minded attitude to begin to appreciate the new visual language. Work done at the borders of film language can reveal much about how that language works.

Selective Viewing. When certain films are mentioned frequently in our study of film history and technique, or for some other reason

arouse our curiosity, we should seek out the opportunity to see them, if at all possible. A few key films are almost essential viewing for the appreciation of film art. Certain groups of films embody similar stylistic and thematic qualities—seeing one of them will give us an understanding of the whole group.

Intensive Viewing. Perhaps the most direct and efficient means of understanding the complex relationships of film expression is the intensive study of a single film or even a single film sequence. Repeated viewing is essential. The best approach is to temporarily acquire a print of the film for repeated viewing on an editing machine. Next best is to attend several screenings of the same film, and to make written notes during or immediately after the screening. You can take note of such elements as composition in the frame, treatment of acting, etc. In a long film, it is often better to concentrate on one scene or sequence, and to compare it to the overall style of the film. You will soon be able to identify specific elements of technique, style, and psychological effect, and understand how they work together to create a unity of effect.

A film is an organic unity of expression. We can analyze the camerawork separately from the plot, the editing separately from the acting, but ultimately these elements have a specific cinematic effect because of the way they have evolved together during the filmmaking process. The separate elements of script, acting, camerawork, directing, and editing influence each other not only during the filmmaking process itself but in their final effect on the audience.

Even in the production process, we can't always separate the basic film technique into specific stages. Ideas about editing may be among the first decisions about a given work; certain aspects of plot or theme may be developed in the final postproduction stages of editing and sound mixing. In the final film, there is no sure way of establishing at exactly what stage in the filmmaking process certain images and effects were introduced if we don't know the history of that particular production—we can only describe their final, coordinated effect. It will help to bear this in mind as you read this book.

2

The Language of Film

Film in some ways is a kind of language. Like a language, film is a medium of communication, a way of expressing meaning, ideas, and emotions, a means of presenting the relationships of people, places, and events. Some theorists understand film as a *system of signs* that convey meaning. This approach is called *semiology,* from the Greek word *sema,* which means "sign." Semiologists regard almost any aspect of a film as a sign, including elements of the editing, the lighting, the script, the casting, and even the costuming (as in the classic case of the good guys with the white hats and the outlaws with the black hats). These signs and elements of a film can be combined with one another in very complex ways to convey complex meanings and associations to the film viewer. Some of these ways of combining signs and elements are predictable and conventional, and both semiologists and others refer to them as the *codes of meaning* by which we understand a film. Again, these *codes of meaning* embrace almost every aspect of film, from script to acting to the sound track. Some are fairly conventional, as in the use of a fade-out to indicate the end of a scene; others are quite original, subtle, and complex, as in the building up of a character through script elements or acting technique.

Film further resembles a language in that its codes of meaning often take the form of elements that combine to form a sequence, much as syllables and words combine to form a sentence, and sentences combine to form a paragraph. Just as we apply the rules of grammar in making sentences out of words, filmmakers often apply conventional patterns and rules of construction when they combine images and sounds to form a scene. By analogy, we can speak of a "grammar" of film. The notion is a useful one, as long as we remem-

11

ber that it is only an analogy, and that film is not a language in the
same way as are English, Swahili, or Fortran.

WHY FILM IS NOT A LANGUAGE

Useful as it is to draw comparisons between language and film,
there are no exact equivalents. The differences are nearly as reveal-
ing as the similarities.

Language is made up of arbitrary sounds and symbols that refer
to things other than themselves. There is no necessary connection
between the word and the thing it represents; it is simply a matter of
tradition and agreement that we use the word "cat" to refer to a
certain small four-legged mammal. The sounds and symbols of lan-
guage are not only arbitrary but abstract. The word "cat" does not
in itself suggest any specific or individual characteristics of this
four-legged mammal, although we may use additional words to do so.

The sounds and images of film, on the other hand, may *suggest*
ideas and things other than themselves, but they are first of all
concrete, specific actualities. The film image of a meowing cat
means something to us because it looks and sounds like a cat, not
because of any arbitrary agreement on what it means. And unlike
the abstract word, the image of a cat presents a specific animal, of a
certain size, color, and shape, resting or in motion.

In the case of *abstract* or *nonrepresentational* films, the distance
from spoken and written language is even greater. Unlike the ab-
stract sounds of language, abstract film images do not convey spe-
cific, concrete meanings.

Film Is a Sensuous Expression. Partly because of the concrete
nature of film images, and partly because the play of film images
and sounds appeals directly to our senses, film expresses emotion,
action, and characterization more readily than it does abstract
ideas. Using language, it is easy to express abstract philosophical
ideas and to communicate such notions as hope, justice, free will,
fate, wickedness, and so on. In a film, such ideas are best expressed
indirectly, through the skillful association of images.

Although film dialogue and narration can present abstract ideas,
the meaning conveyed by the dialogue must be supported by the
dramatic context in order to have impact and clarity. In Marcel
Ophuls's *Memories of Justice,* a documentary film about the Nu-

remberg trials, many of the subjects discuss justice and guilt in the context of the Nazi war crimes. These abstract statements are dramatized, however, by the manner and personal appearance of each speaker, and by our knowledge of their own involvement in the events of World War II, whether as Nazis, as German citizens, as Allied military men, or as victims.

Film Language Has No Fixed Structure. Although the meanings of words and the acceptability or popularity of expressions may change with time, the basic structure of a language is fixed and universally agreed upon by those who use it. By "basic structure," we mean the organization of syllables into words and their modification through prefixes and suffixes, the rules by which words are ordered into sentences, and sentences into paragraphs, and, generally speaking, the whole system of organizing words to create meaning, which we call "grammar." With some local variations, the grammar of a language system is the same everywhere the language is spoken. We do not have to make it up; we have only to learn the basic rules and a working vocabulary in order to communicate verbally. We can analyze any language by studying the discrete, separate bits of meaning that are syllables and words, and by examining the fixed rules by which those separate bits of meaning are arranged.

Film expression, on the other hand, has no such fixed rules of grammar, and does not have even the kind of separate, consistent bits of meaning that could be organized by such rules. The film *frame,* which in physical terms is the smallest discrete unit of the film image, flashes by on the screen too quickly to be perceived as separate from the larger flow of film time and movement.

Although certain film theories propose the *shot* as the basic building block of film editing, this does not mean that the shot has any consistent function like that of a word in a sentence. A shot may be short or long, may contain one strong image or many, may be blurred imperceptibly into another shot, may be part of a sequence of action or contain a whole sequence within itself. It is even possible for an entire film to appear to consist of a single shot.

Film may be said to have a grammar in that there are certain conventions of shooting and editing that are often followed to evoke particular emotional responses or to create an illusion of continuous action in time and space. For example, if we see an image of three

people on the screen, followed by a close-up image of one of the three faces, we assume that this person is in the same space as the previous shot, at the same moment in time. However, while it is a convention that such a shift to a close-up indicates continuity in film space and time, this is not a fixed rule. The camera might even pull back from the close-up to show the same person in a completely different space, alone or with a different group of companions. The filmmaker can use film sequences that employ some conventions and not others without any loss in clarity of expressive content. This would not be possible were film a true language.

Film Is Mediated Expression. Anyone who knows a language can simply and directly say what is on his mind, almost as quickly as the thoughts themselves arise. Such is not the case with film. There are several factors that mediate between the intended expression and its final form, and can even change the final form into something quite different from what the filmmaker intended.

TECHNICAL MEDIATION. One of these factors is simply technical, having to do with the process of exposing film, mixing sound, making prints, and the like, and with the time involved in leading a film through these processes. A documentary-film maker, for example, may decide that he cannot risk disturbing his subjects by setting up and focusing lights. He can then choose not to shoot at all, or he can use an extremely sensitive film stock that will respond to whatever low level of light is available in the location. In this case, his film may have a grainy look that was not part of his original intention but is imposed by the technical limitations of the film process.

ECONOMIC MEDIATION. The amount of money a filmmaker has to spend on a film has a great deal to do with the look and the final shape of the film. Depending on the available budget, filmmakers may or may not be able to use certain equipment, locations, actors, and special effects. They are limited to some degree in the amount of time they have available for shooting, in the amount of experimentation they can do, and in the amount of film stock they are able to use.

SOCIAL AND POLITICAL MEDIATION. Anyone with the necessary vocabulary and facility in a language can simply write or say what she wants to say, unaided. Filmmakers, on the other hand, often require assistance from technicians and craftspeople in order to realize their intended expression on film. In this process of collabora-

tion, which can involve a great many people, the final expression is usually altered. Also, the general social and political climate in which the filmmaker is working may make it easier to find funds and collaborators for some kinds of films than for others.

FILM FORM: THE GRAMMAR OF FILM

We have noted that film, like language, employs certain basic units of expression, which can be combined into larger units or sequences. Some of these basic units define the *form* of a film, as distinct from its *content*.

Units of Expression. Some of the basic units of film form include the frame, the shot, the sound source, and the sound take. There are conventions and *codes of meaning* that apply specifically to these basic forms.

THE FILM FRAME. The frame is the unit of film expression that defines visual space and focuses visual attention. The term is used in three slightly different senses.

1. To a director or a cinematographer, the frame is a rectangular form like a picture frame that marks off the edges of an image. Images and shapes are arranged within the frame and defined by it to create a visual *composition*.
2. In technical terms, the frame is one of a series of small translucent rectangles of film, each containing a single photographic image, that form a long strip of film. A single frame can be directly inspected by eye or held motionless in a viewer or editing machine. When the strip of film is threaded through the viewer or projector and set in motion, the individual frames pass by in rapid succession, giving the impression of motion, or of time passing.
3. The term can also refer to the rectangular area itself, even if no photographic image has been recorded in that area.

THE SHOT. The shot is the unit of film expression that defines a moment of time. Technically, it is the length of film that is exposed to light between the time the camera is turned on and the time it is turned off (*camera take*).

The editor of a film often uses only a portion of the original shot

as it comes out of the camera. If a series of shots are thus trimmed and joined, or *spliced,* together, the length of film between each splice or edit point is considered a separate shot. A shot that appears in an edited film may be of almost any length—from one or two frames to many minutes. The maximum length of a shot is limited only by the length of the roll of film threaded through the camera— usually about ten minutes. In animated films, there are no shots in the technical sense of a continuous camera take of many frames. Still, the length of film between apparent edit points can be thought of as a shot.

THE SOUND SOURCE. There is no exact analogy in the sound track of a film to the compositional frame of the film image. This is because sounds cannot be located in space with the precision of visual images. Also, sounds by their very nature extend in time. If we listened to a single frame of a sound track played through an editing machine, it would sound like a meaningless squawk. We must therefore think of the *sound source* as the basic unit of film sound.

Under normal circumstances, we hear many different sounds at once and select out of this continuum or mix of sound the particular sounds that interest us. At a crowded party, for example, we can follow a single speaker in the midst of the general hubbub, even if his voice is relatively quiet. Almost unconsciously we direct our attention to what we are interested in hearing—that is, to a specific sound source.

Filmmakers can approximate this focusing of aural attention through careful choice and placement of microphones, control over the recording environment, and precise sound editing and mixing. A sound track is built out of many individual sound sources, such as a single speaker, a dripping faucet, or a whole fairground. Sound sources may be recorded separately and mixed together in the editing. If several sounds are recorded together, or mixed to-gether, the louder sounds tend to dominate. Some sounds can thus seem to be in the foreground and others in the background, thus giving a sense of auditory space. This sense of space is secondary, however, to the simple directing of our attention, which the filmmaker controls through the selection of specific sound sources.

THE SOUND TAKE. The sound take is the length of magnetic tape on which sound is recorded between the moment the tape re-

corder is turned on and the moment it is turned off. Like the shot, only a section of the sound take may be selected by the editor for inclusion in the final film. This section may again be as short as one or two frames, or may be many minutes long. Unlike the shot, however, the sound take is not readily recognizable as such in the edited film. Since edit points in the sound track are easily concealed, the different sources and sound takes can be mixed together to produce a seamless continuity of sound. The sound source itself is thus the only *perceptible* building block of the sound track.

Techniques of Combination. These basic units of expression— the frame, the shot, the sound source, and the sound take—can be combined into the larger units of *scenes* and *sequences*. There are several conventional approaches for combining the basic units of images and sounds, some of which have specific meanings or implications.

Combining Images. Filmmakers can combine images simultaneously within a single frame or build a sequence of images in time through addition.

Simultaneous Combination. The simplest way of combining images simultaneously is through the *superimposition* of one shot on another. If done in the camera, this is called a *double exposure.* A superimposition can also be produced in the laboratory by the successive printing of two separate shots onto a single strip of print stock. The special technique of *optical printing* allows the most control over the way images are combined: One part of a shot may be precisely positioned within another shot, so that the overlapping of images is more selective.

The superimposition of titles or credits over a photographed sequence is a common example of combined images. In a narrative context, a superimposition may suggest a dream image or a vision. Superimpositions are also used to suggest a mood or feeling, or just to create an abstract play of forms. In Kenneth Anger's *Inauguration of the Pleasure Dome,* an increasingly rapid flow of superimposed images suggests a hallucinatory altered state of consciousness.

Sequential Addition. Filmmakers can also combine images sequentially in time, either within a single shot or through the addition of separate shots into an edited sequence. There are several ways of doing this.

1. The Moving Camera. Within a single shot, we can change the

image on the screen, and thus the composition, simply by moving the camera, just as we would change our field of vision by walking from one room into another or by turning our head to look behind us. The continuous movement of the camera can give an effect of subtle, gradual change and of a continuous spatial environment.

2. The Moving Subject. The filmmaker can set up a shot in such a way that subjects enter and leave the frame while the camera remains fixed. The images and compositions can thus be changed within a single shot without moving the camera.

3. The Zoom Lens. Again within a single shot, the zoom lens can change the compositional frame by compressing or expanding the camera's field of view. The moving-camera and zoom-lens techniques are often used at the same time to create subtle transitions from one composition to another.

4. The Cut. This is a common transitional device in which two separate shots, or two separate sections of a single camera take, are combined. What appears on the screen is the instantaneous replacement of one image by another, with no time elapsed in between. Cuts may be smooth and go almost unnoticed in the sequence of shots, or they may be abrupt and draw attention to themselves, to relationships between images, or to the structure of the film itself. The cut may represent a simple change in perspective within a scene, or may signal a shift to a completely new scene or location.

5. The Fade-Out and Fade-In. Fades are used as a transition between two shots or two whole sequences of shots; they can also be used to open or close an entire film. Traditionally, the picture fades to black, and fades up from black, but this is not a strict rule. (In *Cries and Whispers,* Ingmar Bergman fades to a brilliant red screen.) Unlike the cut, the fade-out/fade-in combination has a specific implication: It generally signals a transition between sequences of distinctly separate times and locations, or between major dramatic sequences.

6. Black Frames, Colored Frames. In one sense a variant of the fade-out/fade-in, this transition is found frequently in experimental and independent films. It appears as an abrupt cut from picture to black (or to a colored field), followed by another abrupt cut to picture. The duration of the field varies from a few frames to one or two seconds. This device has no specific implications, but is perhaps the most vivid, visually shocking form of transition.

7. The Dissolve. Here, one shot gradually fades from the screen while at the same time another shot fades in to replace it. There is no fade to black—instead, we see a momentary superimposition, or overlapping, of the two images. Like the fade-out/fade-in, this device usually signals a transition between distinctly separate scenes or sequences.

COMBINING SOUNDS. Filmmakers can splice sounds together to form a sequence. They can also *mix* sounds together simultaneously, even more easily than they can simultaneously combine visual images.

Microphone Position. Within a single sound take, it is possible to change the relative loudness of two sound sources and in effect replace one source with another. This can be done either by physically moving the microphone, as we would move the camera, or by using two fixed microphones and adjusting their input levels as they both feed into the same recorder. The effect is one of changing sound perspective: either that we are moving closer to a sound source or that the source is moving toward us. The identical effect can be achieved by mixing together two separate sound takes in the studio.

Moving Sound Source. A fixed microphone can allow for a transition between sound sources if the sources move past the microphone.

The Sound Cut. Like photographic film, the magnetic-film sound track can be cut and spliced. The effect of splicing two portions of a sound take together is an instantaneous transition from one sound to another. Since most sound takes consist of both sounds and silences, a sound cut can be concealed simply by making the cut during a silent part of each track. It is even possible to delete words or syllables from spoken dialogue without the deletion being at all detectable. If desired, however, sound cuts can be emphasized. The editor might make an abrupt cut from a quiet countryside scene to the loud racket of a factory interior.

The Sound Fade. In the mix studio, sounds recorded on one or several tracks can be transferred and rerecorded on another track. During the transfer and recording process, sounds from the original sound takes may be gradually faded down (faded out) to silence or faded up (faded in) from silence. A sound may be faded down to a lower, but still audible, level, or may be faded in to the desired

degree of loudness. Since a sound track may be composed of several separate takes mixed together simultaneously, only one or two of the takes may be faded while the others are maintained at a normal level. For example, the sound of a train might be faded in and out while dialogue is maintained at a constant level.

Cross-Fade. In some ways similar to a dissolve in the picture, a cross-fade is simply the gradual fading down of one sound while another is simultaneously fading up. For a short time we hear both sounds at once. The sound cross-fade may accompany a dissolve of the picture, but may also be used independently of the picture. A cross-fade is also used at the point of a simple cut in the picture to soften the transition from one location to another.

The cross-fade may vary in length, and often indicates a change in sound perspective or a change in subjective mood or feeling. Also, the two elements of a cross-fade need not begin and end in total silence. For example, if a moving camera follows an actor as he gets out of an idling car and walks toward a group of people, a cross-fade might be made from the sound of the car engine to the sound of an animated conversational exchange. The engine sound might not fade down completely, but could linger faintly in the background behind the conversation to create a specific sound perspective.

In a more expressionistic or feeling-oriented scene, we might follow an actor as he walks through a city, and indicate a change in the actor's mood by a slow cross-fade from a piece of music to actual sounds of the city streets.

The Sound Mix. Transitions like the fade and the cross-fade are usually created in the sound mix, during which many sound tracks are played simultaneously and mixed together at different levels into the one mixed track that we hear with the finished film. As few as two separate tracks may be mixed together, or as many as twenty or more.

FILM CONTENT: THE VOCABULARY OF FILM

Film has an immense range of possible content. There are almost no practical limitations to what can be represented or suggested by the film form, whether sounds, images, movement, color, speech, music, time past or present, events real or imaginary, locations familiar or exotic. If we think of film form as the grammar of film language,

Four frames from *T.Z.* (1980), by independent filmmaker and artist Robert Breer. This one-image-per-frame montage creates a high-energy visual impact, which is given shape by its recurring image patterns and rhythms. Breer often works with images drawn or painted on index cards, which can be structured and sequenced in the way a composer might work with notes and chords.

then we might think of film content as something like the vocabulary. In most modern films, the filmmaker's vocabulary has both a visual and an aural range.

The Visual Image. The visual image is *what* is inside the compositional frame, *what* is the content of the shot. The image may be *abstract*, like a painting, a cartoon or a graphic design, or *concrete*, and rich in photographic detail. The image may be *simple*, presenting a single design or image, or *complex*, combining many different design elements and subjects within a single frame. A visual image may simply stand for itself, like the image of a burning building in a television news show, or it may *represent* an idea or part of a fictional story in the way that an actor represents a fictional character.

The film image can move, of course. Movement can be incidental and descriptive, as in a shot of a city street filled with traffic and pedestrians, or it can contribute specific meaning to an image, as in the sprightly or dejected shuffle of Charlie Chaplin's little tramp. A specific movement can become the primary focus of interest of a shot, as in a close-up of a finger pulling the trigger of a gun, or a close shot of the wheels of a train beginning to turn.

The *meaning* of an image derives partly from the way it is presented—that is, from the film form—partly from its own internal characteristics, and partly from external references both to other images in the film and to our knowledge of other films and of the world. In Robert Flaherty's documentary film *Nanook of the North,* we are shown images of Nanook's sled dogs fighting over a piece of seal meat. Much of the meaning and emotional impact of the scene comes from its own internal characteristics—the violence and quickness of the dogs, their curled lips, raised hackles, and bare fangs. These images speak to us directly. The larger meaning of the scene comes from the whole context of the film. The dogfight tells us something about Nanook himself—that he is skillful and resourceful enough to have harnessed these half-wild beasts to draw his sled and thus help his family survive. Further, our awareness of how images are used in films may suggest to us that the ferocity of these dogs in fighting for a small piece of food is perhaps symbolic of the sometimes desperate struggle for survival in this frozen land. Finally, our knowledge of the world and of different human cultures suggests a contrast between the wild, brutal, and impulsive behavior of the dogs on one hand and the thoughtful, nurturing, and generous behavior of Nanook and his family on the other.

The Sound Source. Although the sound source is a unit of film form, it may also be considered as subject matter or content. The sound source may be simple or complex, the voice of a single speaker in a soundproof studio or the location ambience of a busy carnival, made up of voices, shouts, whistles, music, and machinery.

It may be abstract, as a musical score used as background music, or concrete, as in the directly recorded sound of a musical instrument played by a performer within the scene. Sound sources may also be *representational,* standing for a fictional or symbolic presence.

We read meaning into the sound track of a film according to the

same principles by which we understand the meaning of visual images. The manner in which the sounds are given form—that is, the way they were recorded, edited, and mixed—plays a large part. Like images, sounds have their own internal characteristics as well as their references to the context of the film as a whole, to other films, and to the world beyond the film.

An offscreen voice raised in anger has its own implications and emotional effect, to which we can respond directly, even if we do not understand the language. The same voice has an additional meaning if we recognize it as the voice of a certain character who has been presented in the film. Finally, the specific tone or accent of a voice may tell us something about a character that is not otherwise suggested in the film.

FILM CONSTRUCTION: FORM AND CONTENT

Since the first days of the art of film, the ways in which the basic units of form and content could be combined have been limited only by the imagination of filmmakers and by the attention of film audiences. The following categories of combination, therefore, are not fixed and immutable forms, but tendencies and approaches that apply to many of the films with which we are familiar, though not necessarily to all films. Nevertheless, we can still identify specific codes of meaning that apply to the combined elements of form and content.

Formal Construction. The basic terms for describing the formal structure of films come from the French, thanks to that nation's early and continuing interest in developing both the technology and the art of film. They are *mise-en-scène* and *montage*. Although montage and mise-en-scène in their specialized meanings are very different approaches to the construction of a film, they are not mutually exclusive and are often used in combination.

MISE-EN-SCÈNE (pronounced *meez-ahn-sen*). This term, which literally means "putting into the scene," derives originally from the theater, and refers to the arrangement of actors, props, and action on a set. As applied to film, it refers not only to the direction of actors on a set or on location but to the technical design of the scene, including lighting, visual composition, and camera placement. In this sense, it means essentially the same thing as direction.

"Mise-en-scène" has also come to have a secondary, more special-
ized meaning when applied to the formal construction of a film. In
this more specialized sense, mise-en-scène refers to a tendency to
combine elements of a scene in long, continuous shots, often involv-
ing a fluidly moving camera, in which the action develops during the
course of the single shot instead of throughout several separate
shots. Many of the American silent comedies relied heavily on mise-
en-scène—the action takes place inside of a relatively "wide" frame,
and we see the full figures of the actors. The final scene of Michel-
angelo Antonioni's *The Passenger* is a tour de force of the technique
of mise-en-scène. The entire final scene is a single shot, nearly eleven
minutes long, which begins inside a hotel room, continues as the
camera moves out through the window of the room into the street,
and concludes after turning 180 degrees to present the action that is
taking place in front of the hotel.

MONTAGE. *Montage* is actually the French word for editing.
Whereas the English word suggests trimming away or cutting out

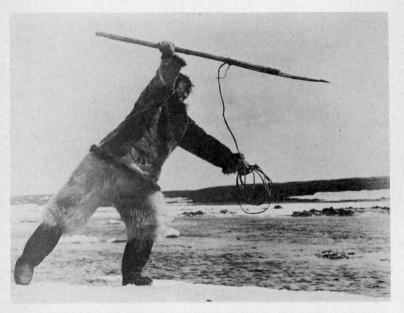

A dramatic image from Robert Flaherty's *Nanook of the North* (1922). The content:
the hunter poised at the moment of concentration and focused strength. The form: a
low camera angle makes him a monumental figure, towering against the sky.

elements, the French suggests a building up or "mounting" of separate elements. "Montage" has come to mean the construction of a scene through the addition of separate shots, each of which contributes to the development of the action. It can also refer to a specific sequence of short shots, often connected not by an action but by content or idea. At the beginning of a television sports special, we sometimes see a montage of many different sports activities.

The classic Hollywood style of filmmaking tended toward an even balance of montage and mise-en-scène. Filmmaker Jean-Luc Godard has written that "montage is above all an integral part of mise-en-scène. Only at peril can one be separated from the other. One might just as well try to separate the rhythm from a melody."*

Combining Forms on the Sound Track. The closest equivalent to mise-en-scène in the sound track is *direct sound*—sound that is recorded as a long continuous sound take, usually with a single microphone and usually on location rather than in the studio. This type of sound is often found in documentary films, especially in the cinéma vérité sytle and in location shooting for television news programs. In the 1950s and 1960s, filmmakers of the French New Wave style often used direct sound for fiction films as well. In direct sound, background and foreground sounds are mixed together by the single microphone, and a background sound may be as loud or even louder than the dialogue. This same approach may be used in the studio, except that here certain sounds and background noises may be eliminated by controlling the environment. Only one portion, say the dialogue, of a more complicated track may be recorded. In this case, the studio recording is not really direct sound even though it is recorded as a long continuous take.

There are two distinct types of *sound montage:* evident montage and concealed montage. (In the visual image, by contrast, montage is always evident.) For *concealed montage,* the sound editor can build up a complex montage of dialogue and sound effects, concealing the edit points and mixing the several tracks so that the sequence is indistinguishable from a single, continuously recorded sound take. With practice, the attentive student of film can usually detect concealed montage by the overall clarity of the sound track, the distinctness of individual sounds, the absence of intrusive background

* Jean Narboni and Tom Milne, eds., *Godard on Godard: Critical Writings by Jean-Luc Godard* (New York: Viking, 1972), p. 39.

noise, and the fact that sound effects and dialogue are carefully spaced so that they will not obscure one another.

The sound track reveals *evident montage* by the presence of several distinct elements, such as music, dialogue, and narration, which are unlikely to have been recorded in the same place at the same time. The visual image can also serve as a clue to evident sound montage. Music that has no apparent source in a scene is a sure sign that the sound track has been constructed from separate elements rather than recorded as a single take.

As with visual montage and mise-en-scène, it is possible to combine several approaches in building a sound track. For example, a music track might be added to a scene that was recorded as direct sound. Or the editor might build a sequence of sound effects and dialogue to create a concealed montage, and then add a narration or music, making the montage evident.

Counterpoint: The Interlocking of Sound and Image. Picture and sound can confirm and reinforce each other, can perform separate but complementary functions, or may comment on or even contradict each other. We are of course familiar with the most common kind of coordination between sound and picture in film, in which the image and the sound source confirm each other, as when we see an actor speaking or a door closing with a slam. There are, however, more complex ways in which sound and image can work together. The sound track can provide information about what is happening offscreen; or, conversely, the image can provide information about the sound track, supporting or commenting on it. Sound, such as music, can also be used to tie together a number of disparate images. Music and other sounds can add an expected or unexpected emotional content to a scene.

Created Worlds: The Building Up of Content in Film. By arranging images and sounds in time, the filmmaker can create a realistic or imaginative world on the screen. Even a documentary-film maker creates a special world for us, by the act of choosing among many possible images and events. The filmmaker can weave together a number of distinct elements to create a world on the screen.

CHARACTER. The impression of a character or personality who exists in time and space, who acts, and who has perceptions and emotions is one of the possible elements of a world created on film.

Lev Kuleshov, in one of the more famous experiments of the early Moscow Film Institute, found that if he built up a montage from first the image of an actor's face bearing a rather blank expression, then the image of a coffin, then the same image of the actor, audiences would find the emotion of sadness in the actor's face. If he replaced the image of the coffin with that of a smiling baby, keeping the same expressionless actor, the audience would discern an emotion of tenderness. Although this example says a great deal about the technique of film acting, it also suggests that our perception of personality or character can be strongly influenced through the addition of essentially unrelated images. Within a single shot, or over the course of a film, an actor's or other subject's consistent and identifiable behavior will contribute to our impression of character and personality.

LOCATION. Another element of the created world is the impression of a location, or a particular place. The filmmaker may move a camera through an actual place in the world (whether that place be a movie set or an unprepared location) or may compose a sequence of many separate shots, each showing a detail of the location that is to be created. These separate shots need not actually have been photographed in the same location. Given a basic logical consistency of content and action, movie viewers will perceive them as connected in space. Conversely, it is possible to film in a real location in such a way that viewers do not know where they are, or do not have the impression of a single location.

TIME PERIOD. A filmmaker can also build up the impression of a particular period of time through the addition of carefully chosen images and sounds. This time period may be simply an immediate, indefinite present, the period of time needed to complete an action, or it may be a larger period of historical time (and place) such as Ancient Rome, or the year 2001. A historical time period can be suggested not only by events and actions that are located in time but by many evocative images and details: costumes, speech patterns, architecture, and customs.

EVENTS AND ACTIONS. Although the camera can of course record many events and actions just as they occur, it is also possible to create the impression of an event through the addition of separate shots. Imagine the following montage:

1. Close shot of the driver of a car. A look of surprise and terror crosses his face.
2. The front tire of a car screeching to a halt.
3. The face of a woman screaming.
4. Feet running toward the stopped car, voices shouting.
5. A body lying facedown in front of the car, limbs jutting at an unusual angle.

The implied action is unmistakable, although it need not have actually occurred. Some kinds of larger events leave the filmmaker no choice—they must be pieced together out of a number of separate shots, each of which presents one part of the principle action.

Other Uses of Created Elements. Through the addition of images and sounds, the filmmaker can evoke specific *emotions,* like suspense, fear, or nostalgia, and *psychological states,* like madness or dreams. *Abstract ideas* can also be suggested by building up of content elements. The opening of Susan Sontag's *Promised Land* suggests the coexistence of the ancient and the modern (and the secular and religious) through a series of shots of television antennas on the rooftops of old Jerusalem, intercut with spires and minarets of churches, temples, and mosques.

Created elements like character, location, and time period are commonly found in both fiction and documentary films, but they are not necessary elements of all films. Many short animated films have characters or actions, but no definable location or historical time period. Bruce Baillie's *Castro Street,* a lyrical study of a train yard, has a location and perhaps a time period, but no significant characters. In several of his abstract "flicker films," Paul Sharits has created a sense of action and a strong physical sensation or emotion without using either characters, location, or an identifiable time period.

The Larger Units: Scene and Sequence. If we look at the ways in which filmmakers apply the structural principles of mise-en-scène, montage, and counterpoint of image and sound, we can identify two larger units of expression: scene and sequence. These units are in fact determined as much by their content as by their formal structure: Locations, time periods, characters, and actions all play an important part.

SCENE. A scene may be a single shot or a series of shots that

takes place in a single location, presents a single main action or activity, and is unified by a minor dramatic complex or expository statement. The unity of a scene may be reinforced by an emotional or psychological feeling as well as by a consistency of film technique. In Fred Zinnemann's *High Noon,* the sheriff enters the town church, interrupts the service, and exhorts the townspeople to join him in arresting some outlaws. A discussion ensues, and the sheriff is eventually forced to leave without having enlisted any deputies. This is clearly enough an individual scene: The single location is the church, and the single activity, although a complex one, can be identified as the sheriff's confrontation with churchgoers. The scene is unified by a gradual building up of psychological tension as the sheriff begins to realize that he'll get no help.

We can easily identify scenes in fictional narrative films and documentary films. For example, we refer to the "igloo-building scene" in Flaherty's *Nanook;* in fact, the film is structured as a series of such scenes. This structure does not apply to all films, however. Andy Warhol's *Blue Movie* is a feature-length film made up of what is essentially one long scene of a couple talking and making love in a single location. Stan Brakhage's *Dog Star Man: Prelude* is basically a long montage of extremely short shots, most only a few frames long, and contains no scenes at all in the usual sense of the word.

SEQUENCE. A sequence is a natural unit of film construction made up of several different scenes, which are all unified by some dramatic, emotional, or intellectual principle, and which represent a major dramatic climax or expository statement. In Akira Kusosawa's *Rashomon,* several witnesses to a crime relate their own versions of what happened. Each version is a separate sequence, beginning with a scene of the witness testifying before the magistrate in the police station, moving on to various scenes in the forest where the crime occurred, and returning to a summation in the police station. Each of these sequences is unified by a buildup of tension and anticipation, and ends with a dramatic climax.

The term "sequence" can also refer to a series of shots (or *shot sequence*) connected by an action or idea, which may or may not comprise a scene. For example, a series of shots of different newspaper headlines might convey information about public reaction to some event. At the end of Woody Allen's *Annie Hall,* a series of shots recapitulates the whole history of the stormy relationship be-

tween the two lovers. This kind of series of shots might also be called a *montage sequence.*

Not every film is organized into sequences. Andy Warhol's *Chelsea Girls* is a two-hour film designed for simultaneous projection on two separate screens. While the film is made up of a number of distinct scenes, there is no narrative development from one to another—in fact, the several reels may be shown in any order, on either of the two projectors! The film's structure is like that of the musical compositions of such contemporary composers as John Cage, whose work contains defined patterns but allows random relationships to take place in the performance.

3

Codes of Meaning in Film

As we have already noted, film can be understood as a system of signs that convey meaning, or as a kind of audiovisual language with its own patterns of grammar and syntax. We have looked at some of the structural elements of film form and film content and at some of the more basic *codes of meaning,* like montage and mise-en-scène, which apply to those elements.

As with any language or system of communication, we must *read* the meaning of a film through an understanding of its codes. The codes of film, like those of the other arts, are made up of sets of rules, conventions, and associations that can communicate ideas and emotions. As a recording art, film can make use of many cultural codes that are simply recorded and recreated on the screen. Cultural codes include patterns of behavior, styles of dress, ways of speaking, and the architecture and design of environments. Other codes are shared by film with the other arts, and include narrative and dramatic structure, rhythm and tempo, movement and composition in space. Finally, there are codes that seem essentially filmic, like montage and mise-en-scène. The codes used in film are not absolute, however. They vary from culture to culture, and even from filmmaker to filmmaker. The ways that filmmakers can present time, space, point of view, and the like are always changing as new ways are developed and old clichés abandoned. The process of change is a slow one, however, and over the course of film history we can identify many recurring patterns and codes.

One difficulty in identifying the codes of a given film sequence is that often a number of codes are operating simultaneously, reinforcing each other and enriching the sequence. The camera placement and mise-en-scène may be telling us something about the relation-

ship between two players, while the lighting suggests a mood and the editing creates a feeling of suspense about the action. However, codes do not always reinforce each other: The dialogue and action in a sequence might suggest one kind of relationship between characters, while close-ups of glances and small gestures might suggest another. The overt action and apparent meaning is sometimes called the *text*, and the implied or suggested meaning the *subtext* of a scene.

The way a filmmaker weaves together these many threads of meaning could be called his "style," and we can observe similarities in the style of certain films because of their codes of meaning. Certain codes are identified with specific historical periods, or with the work of specific filmmakers.

Each technical and creative process of filmmaking has its own codes of meaning and its own possibilities of influence on both text and subtext. In this chapter we will deal with *synthetic* codes, those that are created through a combination of conceptual, technical, and directorial means. In the chapters on film technique and on the creative personnel, we will concentrate on the codes that belong to the specific areas of photography, sound, editing, acting, and the like.

The following are by no means all of the possible synthetic codes of meaning, or necessarily the most important ones for every film. We might well explore the codes of suspense and anticipation, which have been developed to such refinement by Hitchcock and others, or the codes of reality and illusion explored by Buñuel and Cocteau. Nevertheless, the following codes, some of which apply to arts other than film, are used consistently by many filmmakers, and can serve as a springboard for our own analysis and study of other kinds of codes.

POINT OF VIEW

Many different points of view can be presented within the course of a film. In fact, each shot within a scene can present a different point of view, and the sound track can either confirm or contrast with the point of view presented in the picture. The weaving together of these different points of view creates dramatic possibilities that are not possible in the theater. When we watch a performance on the stage,

we are limited to a single point of view—we see the entire stage, from an angle and a distance that does not change. In film, camera placement can suggest many different points of view. We might see first through the eyes of one actor, then through the eyes of another, and then see them both as if we were standing very close to the two of them, or as if we were watching them from a great distance. At the same time, a voice-over on the sound track might present still a different point of view. Film has the potential for great flexibility and vivid contrast between various points of view. The point of view can shift either within a scene or between larger sequences of a film.

Points of View—The Essential Dynamics. Filmmakers work with two basic kinds of relationships when creating different points of view. The first is between the objective, third-person point of view and the subjective, first-person point of view. The second is the relationship between the distant, often intellectual or thoughtful, point of view and the close, often emotional or involving, point of view. Like most codes of meaning in film, these two dynamics usually operate simultaneously.

THE OBJECTIVE/SUBJECTIVE DYNAMIC. The *objective point of view* in film is perhaps closer to the point of view of a theater audience. Implied is the notion of an omniscient third-person narrator or showman, who simply presents events to us as they happen, or reveals and presents locations and objects within a scene. As the audience, we become voyeurs, watching what takes place within the created world of the film as if we were invisible. The filmmaker may present locations and events in a wide angle of view, as we might see them on the stage, or present portions of the scene in closer shots. Both wide shots and close-ups may represent the objective point of view, and an entire film may be composed in the objective mode.

The objective point of view usually employs naturalistic sound— the sounds as we would hear them if we were present as invisible observers within a scene. Sound perspective is also usually naturalistic—we hear sounds become louder as the apparent sound source draws nearer to us in space. We may also hear sound sources that are outside the compositional frame, but still within the neighboring film space. An alternative to naturalistic sound is the third-person narrative voice, which describes events shown on the screen or provides information that is not presented visually or through the use of naturalistic sound. The objective narrator is an unidentified voice,

representing neither the filmmaker as an individual nor any character who appears within the film. In the days of silent films, the function of the objective narrator was sometimes served by title cards, and even now we sometimes see a simple *subtitle* superimposed on the principal image, telling us the date and location of the scene.

The *subjective point of view* is presented visually by a shot that gives us the angle of vision of one of the characters within a scene. For example, consider a shot of silent-comedy star Harold Lloyd clinging to the window ledge of a building, high above the street, turning his head to look over his shoulder at the street below. If the next shot is a view looking straight down at the street from many stories up, it clearly represents Harold's point of view. This kind of shot is called a *point-of-view* shot, often abbreviated to POV. Point-of-view shots are usually used in combination with objective shots, as in the above example, but filmmakers sometimes construct fairly extended sequences based on one or more POV shots. There was even one notorious attempt to construct an entire film in the subjective point of view. The film, called *Lady of the Lake*, contained scenes in which the leading lady apparently attempted to kiss the camera! The leading man was seen only in mirrors, since the film was based on his point of view.

A point-of-view shot can be gradually introduced into a scene, sometimes so subtly that we are not really aware that it has happened. For example, using the technique of montage, we might film a shot from the side of a man and a woman having a conversation; then a closer, three-quarter angle shot of the man alone; then a similar shot of the woman; and then a nearly frontal close-up of the man speaking directly to the camera. The final shot in fact represents the point of view of the woman, and the scene has been gradually led from an objective to a subjective point of view. The next shot might be a similar frontal close-up of the woman, thus shifting from the subjective point of view of one character to that of another. (In actual practice, the actors in a scene like this might be directed not to look directly into the lens of the camera but slightly to one side. This is because an actor who is looking directly into the lens may seem to be speaking directly to the audience.)

The technique of mise-en-scène creates special possibilities for shifting between objective and subjective points of view. For exam-

ple, an extended shot might begin with an objective composition of two people, say, fighting a duel, with two seconds in the background watching the swordplay. As the shot continues, the camera might gradually circle around the two duelists, turning 180 degrees at the same time, until it comes to a halt just behind the seconds, but remaining still focused on the duelists. A closer shot of the duelists would then represent the subjective point of view of the seconds. The effect would be reinforced if one of the duelists turned to look in the direction of the camera in order to address some comment to one of the seconds, or if we heard the offscreen voice of one of the seconds, in close sound perspective. The opposite transition, from subjective to objective point of view, might also be constructed.

The subjective point of view can also suggest the physical or psychological state of a character. We are all familiar with the use of the hand-held camera to evoke the physical sensation of, say, riding a galloping horse, or standing on the deck of a boat in a storm. A blurred-focus, reeling image can suggest the POV of a punch-drunk boxer, and an image that reels and spins up to the sky can suggest that the boxer has collapsed or been knocked to the ground. In *Repulsion,* Roman Polanski uses the subjective point of view to suggest dramatically the deranged mental state of his heroine. Through a distorting lens, she sees the distance across her living room become a vast and fearful abyss; hands reach out of the walls to grasp her, and the walls of her bedroom begin to crack and shift before her eyes. A dream sequence within a film is really an extended subjective point of view, framed by more objective sequences about the character who is dreaming.

In many cases, the sound track for POV shots or POV sequences will not differ significantly from the sound for an objective sequence. In one of the examples just mentioned, the montage sequence of the man and woman in conversation, the sound perspective would not normally change between the side shot of both people, the three-quarter angle close shots of each individual, and the frontal POV shots. Nor would it necessarily change in the example of the duelists. Since in this case the camera remains at the same distance from the duelists throughout the shot, the sound perspective of the clashing swords would also remain the same. There are cases, however, in which the sound track might be used expressively to reinforce the feeling of a subjective shot. In the example of Har-

old Lloyd hanging from the window ledge, the cut to his POV of the street below might be accompanied by a welling up of traffic sounds from the street, by the shouts of a crowd watching below, or by the sound of the siren of a fire company coming to attempt a rescue.

The sound track can also be used expressively to suggest a subjective psychological state, or subjective thoughts and feelings. In Polanski's *Repulsion,* the drip-drip-drip of water from a faucet becomes louder and more insistent as Catherine Deneuve progresses into her condition of schizophrenic terror, becoming obsessed with the small physical details of her environment. In *Blackmail,* Hitchcock's first sound film, a girl who has just stabbed someone to death is sitting at the breakfast table with her family while they discuss the crime, without knowing that she is the murderer. The family talks about the fact that the killing was done with a knife, and gradually we hear their conversation become a vague jumble of voices, with only the word "knife" heard clearly and repeatedly. Suddenly, the girl hears her father's normal, loud voice say, "Alice, please pass me the bread knife." The sound track for this scene clearly represents from a subjective point of view the girl's obsession with her crime in the midst of the ordinary family breakfast. In both examples, the sound perspective has changed from an objective, naturalistic one to a subjective, expressionistic perspective.

There are two elements of the film sound track that can suggest a subjective point of view in what is perhaps a more obvious and direct manner: the first-person narration and the music track. In Bo Widerberg's *Elvira Madigan,* the light and elegant strains of Mozart's violins suggest the romantic and liberated feelings of the two lovers as they romp through the tall grasses and wildflowers of the sunny countryside. In Terrence Malick's *Badlands* and also in his *Days of Heaven,* the first-person narration in the voice of the young heroine simply and directly presents some of her thoughts, feelings, and impressions as the events of the film unfold.

THE DISTANCE/CLOSENESS DYNAMIC. The point of view of the audience may change many times during the course of a film. In fact, the audience's point of view changes every time the compositional frame changes, whether by moving the camera, cutting to a new shot, or zooming the lens. One of the most striking and effective changes in audience point of view is the shift from a distant view of the subject to a close view, or the opposite shift.

The *distant point of view* (the terms are of course relative) may be closer to the viewpoint of a theater audience. If the subject is people, we see full figures within the compositional frame, and the principal action takes place within the frame. The early films of Lumière and Méliès were all shot in this relatively distant, theatrical perspective. Entire sequences, and even entire films, can be shot from this perspective, provided that we are close enough to follow the principal action. The *panoramic,* or extremely distant shot, is a special case of the distant point of view, in which the action shifts to an even larger field. In the panoramic battle scenes of D. W. Griffith's *Birth of a Nation,* we see entire armies opposing each other in a single shot. In John Ford's *Stagecoach,* a panoramic shot shows the stagecoach as a tiny, bustling vehicle in the vast open spaces of Monument Valley, dwarfed by the brooding towers of rock formation. The shot suggests the toylike fragility of the stagecoach as well as the great distances it must travel and the inhospitable emptiness of the territory.

As the *close point of view* became an accepted technique, filmmakers discovered its special expressive potential for visual storytelling and for emotional involvement. Significant visual details could be picked out of a scene in order to tell a story through purely visual means. In extreme close-up, an actress could express deep emotion through the most subtle of facial expressions. In a scene between lovers, the audience could be brought visually as close to the actors as they were physically close to each other.

It is difficult to generalize about the effect of close and distant views, but we find that many filmmakers use the more distant views to present information or an intellectual understanding, and the closer views to create a deeper emotional involvement with characters on the screen. In the classic Hollywood style, a scene begins with more distant views, which present the basic location and show us in full figure how characters are dressed, what they are doing, and how they relate to each other in the larger space. As the scene progresses dramatically, we see closer shots showing individuals rather than groups or pairs, partial figures rather than full figures, and eventually close-ups of faces. Once the basic information is presented, the filmmakers move toward the emotionally involving close-up. In close-up, we are more attracted to a sympathetic character, more repelled by an unsympathetic one. Our emotional involvement

with the dramatic action of the scene is thus heightened by this gradual shift to the closer perspective.

Perhaps the most involving close-up is the one in which we intercept the gaze of a person on the screen. In *The Four Hundred Blows,* François Truffaut occasionally has the young Jean-Pierre Leaud gaze directly into the lens of the camera. We seem to be looking right into his eyes, and feel an intensified emotional connection with the young schoolboy who is oppressed by his teachers and unwanted by his parents.

Close-ups of inanimate objects have their own special fascination, and can also be used to build emotional tension. In *High Noon,* close shots of the hands of a clock, and of the turning wheels of a train, remind us that time is running out for the marshal who is trying to organize a posse before the outlaws arrive in town. In Alfred Hitchcock's *Sabotage,* close shots of the time bomb that the unsuspecting young boy carries on the jostling bus create an almost unbearable tension. The explosion of the bomb is itself portrayed in a series of close-ups of flying debris and stricken passengers, and followed by a long shot of the smoking bus, which reestablishes a mood of relative calm.

The dynamic between long views and close views can have other implications than the tension between information and involvement. In the American silent comedies, much of the action was presented in distant shots, making the pratfalls and even the terrible accidents of the comedians seem hilarious rather than pathetic. Charlie Chaplin was a master at contrasting these disasters, hilarious in distant view, with the pathos and tender sadness evoked by the close shots of the little tramp. There are even cases when a distant shot can create more emotional tension than a close-up. In Francis Flaherty's *Louisiana Story,* the struggle between the young boy and the alligator is made more real and more disturbing by the fact that we see both of them within the same frame, rather than in separate, closer shots, which could have been shot separately and artificially joined together on the editing machine. In this scene, the long shot creates a strong sense of reality, and the close shots simply confirm an emotional involvement that has already been established.

In the *sound track,* too, filmmakers can exploit the dynamic relationships between a distant and a close *sound perspective.* By isolating certain sounds from an environment and making them louder

(and therefore closer), a filmmaker can contribute to the mood of a scene or build up emotional tension. The ticking of a clock or the dripping of a water faucet in a room, heard in close sound perspective, can convey a feeling of emptiness or stillness about the scene. The creaking of stairs and doors, the whistling of the wind, and the loud bang of a window or a door slamming shut can increase our apprehension in a scene within a haunted house or castle. These sounds may be mixed louder than we would normally hear them, in order to increase their emotional effect.

A music track may dominate or subtly support a scene, depending on whether it is in close or distant perspective. In a tender love scene, a quiet and delicate music track may affect the mood in a subtle, almost subliminal, way. In a scene of passionate reconciliation, a louder track might dominate. In an action scene, whether a storm at sea, a chariot race, or a pitched battle, the music track may take over in the foreground of the sound track and provide much of the total emotional impact of the scene. By gradually shifting from a distant sound perspective to a close one, the music track can help build the emotional climax of a scene. In countless Hollywood productions, the music track is played very quietly in the background at the beginning or middle of a scene, is gradually increased in loudness and intensity as the scene builds to a climax of emotional tension, and finally takes over completely as the emotional climax is reached. The approach is obvious, but effective.

The use of narration or voice-over offers examples of another kind of dynamic between close and distant sound perspective. We are all familiar with the kind of documentary or educational film in which the narrator speaks in a deep, unnaturally resonant, and precisely intoned voice as if addressing a crowd through a public-address system. At a closer distance, we have the simple, direct, and naturally accented conversational tone of the young heroines of Terrence Malick's films, or of the filmmaker himself in Michael Rubbo's documentaries. At the near distance, there is the intimate, quiet "stream of consciousness" voice-over of the heroine of Godard's *A Married Woman,* or the whispered, quiet voice in his *Two or Three Things I Know About Her*. In these cases, the sense of closeness or distance is conveyed by the tone and quality of the voice, rather than simply by relative loudness.

In many cases, sound track and picture simply reinforce each

other in presenting a close or distant point of view. In distant shots of the fairground scene in Hitchcock's *Strangers on a Train,* we hear on the sound track a general mix of location sounds: shouts of the barkers, music from the various rides, hubbub of the crowd. As the camera moves in to closer shots, we hear bits of actual conversation between Guy's wife and her friends. Sometimes, however, for expressive purposes, the picture and sound track begin to work at different distances. For example, the voice of an actor on the sound track does not usually become louder simply because we cut to a close-up in the middle of a scene. It seems more natural, and less obtrusive, to keep the sound-track loudness at a constant level throughout an exchange between actors if the space between them does not change drastically. We are also familiar with the kind of scene in which we see a relatively distant shot of two actors walking together, and hear their conversation as if we were much closer. Here the unnatural effect is used deliberately, in order to present an image of the actors in a wide space without sacrificing the content of their dialogue.

Sometimes sound and picture work in counterpoint in order to contrast the close and distant points of view. In Godard's *Two or Three Things I Know About Her,* the intimate, whispering voice of the narrator is contrasted with the distant, documentarylike view of the city and of construction sites. A tension is created between the interior, philosophic, and emotional life of the spirit and the external, economically determined geography of the cityscape. In Jean-Marie Straub's *Othon,* which is based on a play by Corneille, the filmmaker uses many close-ups of the young actors, which involves us emotionally in their conflicts at the same time as their intentionally rapid, singsong reading of Corneille's verse distances us from the dramatic action. Straub creates a tension between the objective, intellectual way in which we use and understand language and the direct and emotional impact of the human physical presence.

Points of View—The Larger Perspective. In literature, we are familiar with the difference between the first-person subjective narrative voice and the third-person "omniscient" and objective narrative voice. These voices can sometimes be combined in a single work. For example, we might find an extended first-person narrative presented as a quotation within a larger, third-person narrative. Or a

novel might present a sequence of events as experienced by several different characters, through a sequence of different first-person narrations. In considering the overall point of view, or "voice," of a narrative, we generally overlook small-scale variations of point of view within the narrative. For example, a first-person narrative does not begin every description with an "I saw" or "I heard," but contains many objective statements and descriptions that we understand to be the subjective observations and impressions of the narrator.

These different voices and points of view apply to film as well as to literature. Both the first-person narrative form and the objective form can be used in structuring a film. The same possibilities also exist for minor variations within the overall structure.

THE OBJECTIVE FILM. Most films are presented in the objective form, as if there were an omniscient narrator/showman guiding us through a series of locations and events, without calling attention to himself but simply pointing out the sights and sounds. Whether in a documentary or a fiction film, people and events are presented as part of some kind of meaningful whole that the filmmaker/showman finds in the world, but which is not dependent on any one character's point of view for its meaning. Within this overall objective structure, the filmmaker may introduce moments, or even extended sequences, that present one or another character's point of view, but the overall objective point of view is not altered. The use of occasional POV shots does not change the basic objective structure of a film. In Ingmar Bergman's *Passion of Anna,* the use of several subjective dream sequences does not negate what is basically an objective portrait of a woman suffering a nervous breakdown.

THE SUBJECTIVE FILM. The first-person narrative is less frequently found in film, perhaps because the camera itself seems somehow to present things in an objective manner. Nevertheless, some of the most interesting films ever made have used the first-person subjective style.

The first-person narrative in film is usually created through a combination of means, including such techniques as POV shots and voice-over. It is not necessary that an entire film be shot in POV shots to create the first-person narrative, although one such film was actually made. Entitled *Lady of the Lake,* it presented a narrative

entirely through POV shots—the audience could see the narrator only in mirrors and reflections. The film is more interesting in the attempt than in the execution.

A narrator's voice on the sound track is perhaps the strongest means of creating the first-person narrative in film. Although films such as Terrence Malick's *Badlands* and Francis Ford Coppola's *Apocalypse Now* use voice-over to communicate the thoughts and feelings of a central character, the films themselves are basically presented in an objective style. Sometimes, however, a voice-over becomes the dominant force in determining a film's overall point of view. Werner Herzog's *La Soufrière* is a documentary film about the threatened eruption of a volcano in the Caribbean, on an island from which all the inhabitants but two have been evacuated. It is also about the filmmakers' journey to this island, their confrontation with the danger, and their fascination with the motives of the two who refused to leave. Herzog himself narrates the film as a kind of diary, describing his motivations for the journey, his impressions and feelings about what he shows us on the screen. Although we do not interpret every shot specifically as Herzog's POV, we do accept the shots as representing what Herzog as an individual found personally meaningful on this journey, as distinct from what an impersonal, objective narrator might have shown us. Herzog even appears within the film, carrying a tripod up the slopes of the volcano, thus presenting us with his own image of himself on this journey. (As it turned out, the volcano never did erupt.)

In Bergman's *Wild Strawberries,* the central figure of the film, Isak Borg, narrates his own story. The many subjective sequences, including Borg's dreams, daydreams, fantasies, and memories, are woven so deeply into the fabric of the film that we perceive the film as a whole as a first-person narrative even though there are many objective shots of Borg, both in the dreams and flashbacks and in the present tense. In this case, the dreams and the other subjective sequences are identified as first-person by their context in the narrative rather than by POV shots. We know from the context (including the narration) that they represent Borg's private dream images and memories, and not objective or historical images from the past.

MULTIPLE POINTS OF VIEW. Perhaps more than novelists, filmmakers have exploited their medium's potential for contrasting several vivid subjective points of view within a single work. One of the

more interesting uses of multiple points of view in film has been to present a portrait of a single person or a single event through the eyes of several different characters. In Akira Kurosawa's *Rashomon,* the story of the murder of a nobleman and the rape of his lady is narrated by several different witnesses. Each subnarrative begins with the image of the witness telling his version of the story, either to a traveler or to a magistrate, and shifts to a portrayal of the rape and murder itself, as that particular witness presents it. The central crime is portrayed differently each time, and we realize that not all of the witnesses can be telling the truth. The difference in their versions emphasizes the subjective nature of each one, at the same time suggesting larger questions regarding the nature of truth itself. In the end, we are never told by any omniscient narrator what really happened. Instead, we are forced to draw our own conclusions, based on our impressions of the witnesses and of human nature, much as we do in real life.

Orson Welles employs a similar technique in *Citizen Kane* to create a portrait of a rich and powerful newspaper baron. Kane is seen through the eyes of several different characters, each of whom describes the Kane that they knew to a newspaper reporter. Again the descriptions begin with an actual dialogue between the reporter and one of Kane's associates, and shifts to actual scenes from Kane's life, as described by his former friend, his wife, his butler, etc. In each sequence, we are presented with scenes in which one individual is subjectively and personally involved with Kane, and which tend to reinforce his or her judgments about Kane's personality. Each person attempts to explain the mystery of Kane's overwhelming ambition, but in the end no one story is sufficient in itself. As in *Rashomon,* some of the mystery still remains, and the revealed meaning of Kane's last words does not completely solve the puzzle. Finally, we must draw our own conclusions, unaided by any omniscient narrator.

FILM SPACE AND TIME: REPRESENTING OUR EXPERIENCE

It is by manipulating filmic time and space that filmmakers can represent events and locations as they might appear in reality. Only rarely do we find "real" space and time in film, presented simply as

they were perceived by the camera and tape recorder. Filmmakers generally create an illusion of space and time that is logical and expressive enough to be accepted without questioning.

Several kinds of time and space illusions are used. One is the *flashback,* in which a sequence from an earlier time (and sometimes a different place) interrupts the normal flow of events. Another is *parallel cutting,* in which the editor alternates between shots from two different locations and two different events that are happening at the same time. Perhaps the most common illusion is that of *continuity of space and time*—in which a scene is made up of many separate shots, each presenting a different image or action, so that the scene appears to unfold in a smooth continuous flow of time and in a continuous, unbroken film space. An action such as that of a woman entering a house may be made up of many separate shots— feet walking, a shot of the door, a close-up of a key turning in the lock, a shot from inside of the door opening, feet crossing the vestibule, a close-up of the woman's face—yet it appears to us as a continuous, unbroken, uninterrupted action. Although the feet on the walk, the exterior of the house, and the interior shot of the door opening may all have been shot at different times and on three separate locations, we have the impression of a continuous, unbroken space, one in which we could walk around and explore as the woman on the screen appears to do. Let us see how these illusions are created, and why they are believable.

Film Space. The illusion of film space is created through the combined effect of the camerawork, the editing, and the sound track.

FILM SPACE AND THE CAMERA. Film space as presented by the camera is defined in two ways: by the edges of the frame and by the direction in which the camera is pointing, which is called the *camera angle.* (The use of lenses of different *focal lengths* also affects the quality of film space, but we will deal with these effects in chapter 4.) We see only what is in front of the camera, and within a specific and limited field of vision.

There are several ways in which filmmakers can explore and present a space, given the basic limitations of direction and framing. Perhaps the simplest is to use a relatively *wide-angle lens,* and to frame shots in such a way that all of the important action, and the important elements of the environment, can be seen within the shot

and from that particular camera angle. This technique is closest to the technique of the theater, and many early films, such as the science-fiction and fantasy films of Georges Méliès, presented space and action in this way. In fact, Méliès actually framed his images within an arch like the proscenium arch of a theater.

Another way of exploring space in film is to move the camera—to *pan*, to *tilt*, and even to move the camera through the space, so that the camera angle changes and new aspects of the space are revealed within the frame. One of the earliest films to exploit the moving camera was F. W. Murnau's *Last Laugh*, made in 1924. In this tragic story of the humiliation and demise of the doorman of a first-class hotel, the floating, moving camera evokes the central character's own sense of personal disequilibrium and disorientation.

Perhaps the most frequently used method of exploring and revealing a space is to present an environment in a series of separate, successive shots, each of which reveals new details and new perspectives. Frequently a filmmaker will present an event or a character in a series of shots from different angles, so that as the event develops, or the character moves, the space is also gradually revealed.

EDITING FOR FILM SPACE. Filmmakers soon realized a curious fact about the presentation of space through a series of shots: It was not at all necessary that the shots actually be taken in one location! In 1920 the Russian filmmaker and teacher Lev Kuleshov assembled the following shots as an experiment:

1. A young man walks from left to right.
2. A woman walks from right to left.
3. They meet and shake hands. The young man points.
4. A large white building is shown, with a broad flight of steps.
5. The two ascend the steps.

The sequence of shots appeared as a simple, uninterrupted action in a single location. The significance of the experiment, however, is that every single shot came from a completely different location. In fact, the white building in the scene was a shot of the White House, taken from an American film! The other shots were filmed at various locations around Moscow. Kuleshov called this illusion of continuous space "creative geography." This technique for creating the illusion of continuous space has since become a normal part of much filmmaking—exteriors are shot in one place, interiors in another

location, and certain close-ups and insert shots may be shot in still a third location.

Perhaps the most extreme form of creative geography is the use of special effects and optical printing to combine different locations in a single shot, or to create new locations out of separate elements. A painted background combined with a set of a ruined temple can make part of a Hollywood back lot appear to be in the midst of a mountainous jungle. A *rear-projection* process can make two actors appear to be traveling in a moving train, while they are actually seated in a set inside a studio. The complicated animation and optical printing of *Star Wars* placed the actors on location in outer space. Some of the earliest examples of "creative geography" through special effects are to be found in the early documentary films. The American Vitagraph Company presented in 1898 a documentary about Theodore Roosevelt's invasion of Cuba that featured a "Battle of Santiago Bay" fought on a tabletop with cardboard ships and with the smoke of battle provided by cigars and cigarettes.

FILM SPACE AND THE SOUND TRACK. Unlike our visual perception, our sense of auditory space is continuous and "all-around," or *omnidirectional*. Film sound as recorded on tape and mixed in a studio can suggest this same kind of continuous, unbounded auditory space. Although the camera can show us only one aspect of a scene at a time, the tape recorder can present the complete sound record of everything that is happening in the scene at a given moment. The only limitation is that the sounds be loud enough to be picked up by the microphone.

Although it is actually possible to hear sounds coming from all directions at once, we generally focus our attention on sounds that are more interesting to us. As noted earlier, we do not find it difficult to follow one conversation at a time in the midst of a crowded party where the air is actually filled with many voices and words mixed together. We also hear sounds differently depending on which direction they are coming from, on how close or distant we are from the sound source, and on the general acoustics of the space. Filmmakers are able to create these same spatial effects through the techniques of sound recording, editing, and mixing.

Sound Selection. A filmmaker can begin to define a film space simply by deciding which sounds we will hear clearly and which ones we will hear only faintly, or perhaps not at all. A scene of two

people talking in a park might in real life be punctuated by sound of passing traffic from outside the park, or by the shouts of children in a playground. A director shooting this scene might ask for a special microphone placement so that these background sounds are subdued. The park environment will thus seem quieter, less busy, and we will hear the conversation more easily. If the two people are having an argument, the filmmaker might record additional traffic and playground sounds, and mix them quite loudly into the sound track, so as to add to a feeling of tension and anxiety between the actors. Such normal city background sounds might also be suppressed entirely and the shots framed in such a way that the actors appear to be located in the open country. Sounds of birds or wind in trees recorded at another location might also be mixed in to reinforce the open-country effect. This is the kind of "creative geography" that is quite often built up in the sound editing of a film.

Sound Perspective. Our sense of space in film can also be affected by special microphone placement or mixing techniques that create a special *sound perspective.* Proper microphone placement can give an intimate, close feeling to a space, even though a scene is being filmed in the middle of the huge empty interior space of a sound stage. Lowering the loudness of a voice in the mix can make it seem farther away, even though it was recorded at a close distance. Adding echo or reverberation to a sound track can suggest that a scene is taking place in a large hall or cavern, even though we do not actually see the whole of a large interior space on the screen.

Offscreen Sounds. In some ways, the sound track has a much greater potential for creative manipulation in the editing than does the picture, since we do not have to see the source of every sound within the frame. The sound editor can pick and choose from many separately recorded effects in order to build up the atmosphere and mood of a particular location. Our park scene, which becomes open countryside through the addition of birdsongs and wind in leaves, is one example of the use of offscreen sounds. Offscreen sounds can either reinforce the mood of a particular location or create the effect of a location that was not actually filmed.

THE ARTICULATION OF FILM SPACE. Except perhaps for architecture, there is no other art that offers such rich potential for the creative manipulation of space as film. A film can take us to any place in the world, and even to places out of this world and places

that exist only in the imagination. The exploration of a space or location can be fascinating enough to carry our interest throughout an entire scene in which no other action takes place. Many short films have been made whose subject is basically the mood and atmosphere of a certain location.

The creative use of sound and camera can also evoke different moods and psychological feelings within a given location, and can tell us things about people within a space, and about their relationships. Within a given scene, each shot can present a slightly different feeling about the space and about the relationships between actors. For example, the dominant character in a scene might be consistently framed to appear as the largest image within a space, and might be filmed from below to give the impression of towering over the space. A submissive character might be framed so as to appear as a smaller image within the frame, and might be filmed from above so that we are literally looking down on him.

During the course of a scene, the sense of space can develop in such a way as to reinforce or comment on our feelings about the action. To suggest just one example, in François Truffaut's *Four Hundred Blows,* the boy Antoine lives with his parents in a close, cramped apartment. The apartment is filmed in such a way as to suggest the trapped, claustrophobic feelings Antoine has about his family. In the last scene of the film, when Antoine has run away from a home for wayward boys, he takes a walk along the beach, and the vast expanse of sea and sky reinforces the mood of freedom and exultation.

Film Time. The illusion of film time, like that of film space, is created through the combined effect of the camerawork, the editing, and the sound track.

REAL TIME AND APPARENT TIME. In a certain sense, the motion-picture camera is a timepiece. It can count off twenty-four frames per second as regularly as a watch counts off sixty seconds in a minute. The film projector, too, counts off frames, usually at the same rate at which they were shot. If we shoot a long camera take of a scene without turning off the camera and then project the same long shot without cutting out or adding anything, it takes the same amount of time to look at the film as it did to shoot it, and events happen at the same rate of speed. This is called a *real time* sequence.

In actual filmmaking practice, real-time sequences are rather rare. They are most often found in scientific research photography, in anthropological films, and in documentary films of live performances. Usually something is cut out or added to events before they are presented on the screen, so that the time is either *compressed* or *expanded*. In fact, a series of shots can create the illusion that events are taking place in normal, continuous time, even though the separate shots were actually taken at many different times.

The projector itself helps to create the illusion of continuous, uninterrupted time. Because it counts off frames in such a regular, consistent fashion, we trust that events on the screen, if seen within a single shot, are taking place at their normal rate of speed and that time is unfolding in a natural way. When a cut takes place, the projector continues to count off frames without interruption, and events on the screen seem to be taking place at the same normal rate of speed. Without any further clues or signals, we assume that there has been no interruption in the normal unfolding of time, even though we are seeing a different image on the screen.

Sometimes, however, we are given a signal that we have jumped forward (or backward) in time, suggesting that some time has elapsed between two shots. There may be a sudden change from day to night, or an event that was foreshadowed in the script may suddenly be taking place, or the actors may appear in a new location, to which they must have traveled with some elapsed time.

Thus, there are several ways of perceiving time in film. One is *apparent time,* in which events seem to be unfolding in a natural, uninterrupted manner. Apparent time can be real time if events are presented as the camera (or cameras) recorded them, with no additions or subtractions. Apparent time can also be either compressed or expanded time if it takes less or more time to present the events on the screen that it would take for them to unfold in reality.

Another way of perceiving film time is as *screen time,* in which case images and sounds are presented to us with no attempt to create the illusion of continuous, normal time. We become aware of screen time whenever there is an obvious flashback or flashforward in events, or when a montage of shots suggests an emotion quite independent of the unfolding of events. For example, the terrifically energetic montage of Stan Brakhage's *Dog Star Man: Prelude* conforms to no normal perception of apparent time. The indi-

vidual shots are for the most part only a few frames long and vary wildly in subject matter, from abstract imagery to microorganisms to images of the sun's corona. The film unfolds in its own screen time and works emotionally and aesthetically in a place that lies somewhere between painting and music, without any reference to the unfolding of events in apparent time.

Filmmakers sometimes create a deliberate confusion or ambiguity between apparent time and screen time. In Alain Resnais's *Last Year at Marienbad,* there is a deliberately created confusion between past, present, and future. We are never quite sure whether a scene is unfolding in the present, the past, or the future. Another mystery of the film is whether the scenes represent actual events or the imaginings of the central characters, whether memories or fantasies. This kind of structuring of images might be called *psychological time* or *expressive time.*

FILM TIME AND THE SOUND TRACK. Sound can be essential to the creation of apparent time, screen time, and psychological or expressive time. Like the camera, the tape recorder used by filmmakers is designed to run at a constant speed, counting off so many inches per second. When the recorded sound is transferred to a film sound track and mounted on an editing machine or projector, it plays back in exactly the same amount of time that it took to record. When sound is reproduced like this with no cuts or additions to its length, we can call it a *real time* sequence.

Since cuts are easily concealed in the sound editing, it is possible to combine many separate elements to create an effect of continuous, uninterrupted *apparent time.* The apparently unbroken flow of sounds on the sound track can reinforce the effect of continuous time and space as seen on the screen. A series of shots can be held together by the unbroken flow of sound across the picture cuts. For example, a scene in a busy marketplace might open with a series of shots of different characters and stalls, all tied together by the continuous flow of the shouts of vendors and other background sounds across the cuts. Instead of viewing the series of shots simply as different images related by a single theme and location, we have the experience that normal time is elapsing. The sound track has in fact actualized the potential for our experience of time in these shots.

Conversation or dialogue can be used to connect two different scenes and to establish that they are happening without any inter-

ruption in time. In Walter Hill's *Warriors,* we see a shot of a radio announcer in the broadcast station. Her voice is carried across a cut to a shot of teen-agers in another location listening to the radio broadcast. Since the voice is continuous, the time seems continuous between the two different scenes. Dialogue is also frequently used to tie together shots within a single scene. A good example is a cut from a shot of a person speaking to a shot of a person listening, or even to a shot of the speaker from behind. These two kinds of shots are frequently used in documentary editing to tie together sections of an interview that did not follow each other continuously during the shooting. Interviews shot on completely different days can be connected in this way to appear as one continuous scene.

The sound track can also signal that we are watching *screen time* rather than apparent time. A voice-over narration in a travel film makes it clear that we are watching screen time, in which a series of shots is being presented by the filmmaker to illustrate the content of the narration. A flash-forward or flashback in time can also be signaled by the sound track. For example, we might see on the screen two persons discussing a musical concert that is to take place in the future, and then a cut to a close-up shot of them in the audience of a concert hall, with music playing on the sound track. If the conversation had been about a concert that had taken place in the past, the same cut would signal a flashback. The music cut might occur before the picture cut, thus signaling that the flash-forward was about to occur.

The sound track can also help to create *psychological time* or *expressive time*. For instance, a dramatic film may combine both dialogue and narration in a single scene, as when one of the characters describes his memory of an event that happened in the past. In this case, the dialogue and action take place in apparent time, while the narration represents a separate screen time, which comments on the apparent time. If the voice-over commentary is a monologue that has begun in present time, while screen images and other sounds represent the past, the two different sound-track elements are in fact presenting two different time periods simultaneously! In Bergman's *Wild Strawberries,* the voice-over presents past memories not simply as events happening in an earlier time but as subjective fantasies, as a psychological experience of time. In many suspense films, a ticking clock or similar sound is played loudly on the

sound track to suggest a psychological hyperawareness of the pass-
ing of time and the anticipation of some potential disaster.

THE ARTICULATION OF FILM TIME. All of the various illusions
and perceptions of time in film are based on two kinds of dynamic
relationship between shots and sequences: *continuity,* whether real
or apparent, and *discontinuity,* whether definable or indefinite. We
may not always be aware of these dynamics while viewing a film,
but filmmakers apply them at all times, in every stage of production,
from scripting to editing.

Continuity. We are perhaps most familiar with the dynamic of
continuity: the continuous unfolding of time throughout different
shots and even different scenes. Continuity is most commonly found
within a given scene, but can also structure an entire film. *High
Noon* is an example of a film that maintains apparent time continu-
ity throughout its entire length: The events of the film are supposed
to take place continuously during the two hours before noon in a
small town in the American West; and the film itself lasts just two
hours. As we have seen, time continuity can be represented either by
real time or apparent time. In the case of real time, there is a one-to-
one relationship between the elapsed time of events filmed by the
camera and events presented on the screen. We can also present real
time through several different shots, by filming an action or a per-
formance with more than one camera and by cutting from one cam-
era take to another at exactly the same point in elapsed time. Or we
can present a facsimile of real time by combining several different
shots, each of which presents part of an action, in such a way that
the entire action appears to take place in the same amount of
elapsed time as if it had been recorded in one long continuous take.

To create the illusion of continuous time, however, it is not neces-
sary that actions take place in exactly the amount of time that it
would take for them to be actually presented in one long continuous
shot. Filmmakers can present two other kinds of apparently continu-
ous time—one in which an action is compressed between shots to
take place in a shorter than normal time length, and one in which an
action is expanded to take place over a longer than normal time.
These two kinds of apparent time are employed almost nonstop dur-
ing the course of an ordinary narrative film. For example, although
the whole series of actions of *High Noon* takes place on the screen in
the two-hour time span supposedly covered by the script, from min-

ute to minute in the course of the film, time is being expanded or contracted to present the action dramatically. As an example of *compressed time,* we might consider the following series of shots:

1. A man walks toward a house.
2. Close shot of the door. A hand enters the frame and turns the doorknob. As it pushes open the door, we hear music faintly from within the house.
3. From inside the house, we see the door opening, and the man enters, filling the frame.
4. Close shot of his feet on the hall carpet.
5. Shot of his face.
6. Close shot of feet running up the stairs. The sound of piano music is growing louder.
7. Another shot of his feet on the stairs, from a different angle.
8. His hand turning another doorknob and pushing the door open. The music is much louder.
9. From inside a room, the door opening. The music stops.

Although in real time this entire sequence might take several minutes to occur, on the screen the series of shots, linked together by the piano music, might last no longer than twenty or thirty seconds. Alfred Hitchcock has suggested that compressed time is the normal structure of most films—that to truly translate a novel into cinematic terms would require six or eight hours of film time.

Expanded time can be used to build suspense. In the case of a showdown between two gunslingers, the filmmakers might expand the time by cutting from a long shot of one cowboy advancing slowly down the street to a similar shot of his opponent, to several faces of townspeople watching, to individual close-ups of the two gunslingers, to a shot of an accomplice sighting a gun from a neighboring rooftop, back to the two cowboys, etc., until the normal time it would take for each of them to walk twenty feet has been considerably extended. Expanded time is sometimes essential for the sake of simple clarity of action. A very fast action is often stretched out and slowed down so that it will not be missed by the audience.

Discontinuity. This type of film time is simply the interruption of what we perceive as normal time flow. As we have seen, discontinuity is not always perceptible, as in the case of expanded and com-

pressed film time, both of which create an impression of apparently continuous time flow. At other times, however, we are aware of an interruption in normal time flow, or even of the absence of normal time flow. Temporal discontinuity is a particularly powerful expressive device in film. It can be used on a small scale, in the editing of images from second to second; or on a larger scale, in the overall structuring of a script. It can give the impression of interruptions in a normal time flow, or it can replace the representation of normal time flow with a special screen time, in which we are aware of the filmmaker presenting images and sounds to us for purely expressive purposes. The interruptions of what appears to be normal time flow can be either of definable, measurable duration or of more or less indefinite duration, so that we do not know how much time has elapsed between two shots or scenes, or even whether we have jumped to the relative past, present, or future. Let us briefly touch on some of these possibilities.

On the small scale, temporal discontinuity can appear as a sudden jump between shots, or as the connection of shots that do not seem to represent any normal time flow. (Speeded-up motion is a form of temporal discontinuity that involves no cutting at all, and which can be done in the camera.) One kind of discontinuity is called a *jump cut*. In this case, we might see a person start to cross a room and suddenly, at the cut point, "jump" to the other side. It is as if we simply removed the middle of a shot, so that we see the beginning and end interrupted by the jump cut. Or we might see in one shot someone reaching for a gun in his pocket, and cut to a shot of the same person holding the gun in hand. Although jump cuts have been avoided like the plague in the classical Hollywood style, we sometimes see them in experimental films, or in European or Asian films.

On the small scale, a temporal discontinuity can be a jump backward in time as well as a jump forward. The filmmaker can extend an action so that we are aware that it is taking longer than usual to be completed. (When done in the camera, the process is called *slow motion*.) This is accomplished by a jump back in time to show a repetition of a part of an action that has already been completed. In *October,* Sergei Eisenstein shows us a drawbridge being raised to cut off the workers' districts from the central city of St. Petersburg. A carriage attached to a dead horse lies across the gap of the bridge, which is raised in a sequence of slow, inexorable movements until

the harness snaps and the horse and carriage fall on separate sides of the bridge. The suspense of waiting for the fall is reinforced by the slow, abstract movement of the bridge girders diagonally through the frame. Movements are picked up from different angles by jumping back in time to an earlier stage of the movement, thus extending the normal time length of the action through the use of temporal discontinuities. The technique is not concealed in the editing, but is actually emphasized, so that we are made more conscious of the implications of the event and of its visual structure.

Also on the small scale, temporal discontinuity can create the special experience of screen time, of the rhythmic or poetic presentation of images without reference to any normal sense of elapsed time. Many montage sequences are cut according to screen time, without a clue as to the length of time that might have elapsed between one shot and the next. This is often the case when actions in a montage are related by theme or subject or mood, but not by an overall time progression. Melvin Van Peebles's *Sweet Sweetback's Badass Song* contains an extended montage sequence of Sweetback running from the law—a series of shots of Sweetback running in different locations, against different backgrounds. There is no way of even guessing the amount of time that might have elapsed between each of the shots, which are tied together and given momentum by the musical score. The sequence plays in screen time, and the elapsed time between shots is indefinite.

On the larger scale of scripting and story construction, temporal discontinuity can become a part of the basic structure and organization of a film. The transition between any two scenes in a narrative film has a temporal implication—it may represent a jump forward or backward in time, or a continuation of the present in another location or in a player's dream or fantasy. A jump in time between scenes may also be either definite or indefinite—that is, we may know exactly how much time has elapsed between scenes, or merely that some unspecified amount of time has elapsed. It is also possible that the transition between scenes can be temporally ambiguous— the filmmaker can make it deliberately mysterious whether we are seeing the past or the future, a memory or a reality, or a fantasy of what might happen or might have happened. Scenes can also be connected by screen time rather than apparent time. In a documentary film, for example, scenes may be connected according to a logic

of subject development rather than time flow, and the transition between scenes may have no temporal implication beyond the fact that the filmmaker wants us to see one particular scene first, and another second.

REALISM AND EXPRESSIONISM

Realism and expressionism are two stylistic tendencies that arise through the combination of many different filmic elements, including choice of subject, script design, camera and sound work, acting and editing. The two styles date back to the very origin of the art of film, to Georges Méliès and Louis Lumière. Méliès, who had been a stage magician before becoming a filmmaker, created a number of films based on dreams and fantasies, such as *A Trip to the Moon,* and used many special effects and elaborate set designs. His films were *expressionist* in style, combining subjects, scripts, and film techniques to create fantastic and dreamlike worlds that bore little resemblance to reality. Louis Lumière, a scientist and businessman, created films that showed simple everyday events, such as *The Arrival of a Train,* or *Workers Leaving a Factory,* with no technical embellishments. He worked in *realist* style, and his films were a mirror of actual places and events. Filmmakers of today make use of both these styles. We can point to such expressionist films as Steven Spielberg's *Star Wars* and Federico Fellini's *Casanova,* and such realist films as Barbara Kopple's documentary feature *Harlan County, U.S.A.* and Francis Ford Coppola's *Godfather.*

In general, we might say that the realist style tends to evoke thoughts and feelings indirectly, by presenting an illusion of reality with characters and events we can identify with. The expressionist style attempts to evoke thoughts and feelings more directly, by presenting evocative images as in a dream. We might say that realism attempts to present the reality of events as they happen in the world, whereas expressionism attempts to present more directly the reality of our thoughts, feelings, and physical perceptions. Most filmmakers are interested in both.

The Realist Style. Filmmakers working in the realist style try to present an illusion of reality which is so convincing that we will accept the film as an image of the world we live in. The filmmaker uses his technique as a mirror of reality, and attempts to present the

Realism: Dockworkers congregate in Elia Kazan's *On the Waterfront* (1954). The subtext: the other workers form a closed circle—Marlon Brando doesn't belong.

surfaces of the world with as little apparent distortion and alteration as possible.

The realist filmmaker chooses compositions and images that exhibit what seems to be a normal or appropriate richness of detail, neither excessive and baroque nor stripped down and abstract. Costumes are neither flamboyant (unless called for by the reality of the scene) nor overtly symbolic. Sets, when used, are designed to resemble real locations as much as possible. Like his expressionist counterpart, the realist filmmaker must select and emphasize certain details in creating a scene, and suppress others, but he makes this kind of subtle selection as unobtrusively as possible. Details are selected to reinforce our impression of ordinary reality, or to be suggestive without seeming out of place or contrived.

Photography and editing in the realist style tend to be conservative and straightforward, presenting images and events in what

seems to be a simple, unadorned manner so that the events appear to be happening spontaneously on the screen. Lighting and sound imitate natural lighting and our normal perception of sounds. We might say that the technical style of a realist film is as unobtrusive as possible, so that our attention is drawn to the subject and not to the way in which it is presented. This is not to suggest, however, that the unobtrusive style of photography, sound, and editing is technically simple. In fact, it requires great skill and artifice to present a subject in this unobtrusive manner, and the filmmaker's technique can actually contribute important subtleties to an apparently straightforward and spontaneous scene. In the realist film *The Bicycle Thief* by Vittorio De Sica and Cesare Zavattini, Ricco, accompanied by his small son, Bruno, follows the bicycle thief into the thief's own neighborhood. As Ricco accuses the thief, an angry crowd gathers in support of their neighbor, calling at Ricco to get out of the neighborhood and to leave "the innocent man" in peace. The thief has an epileptic fit, and a policeman is called. Throughout this emotionally charged, complicated scene, in which exchanges are taking place between Ricco, Bruno, the thief, the policeman, and various members of the crowd, the action is presented through a series of carefully chosen shots that clearly present each exchange, thus heightening our emotional involvement in the conflict. Camera angles and edit points are determined with great precision, with the result that we are not significantly aware of the camerawork and editing but are totally engrossed in the apparently spontaneous action on the screen. What we *are* aware of are the subtleties of Ricco's emotional responses and Bruno's care and concern for his father, and we wait in suspense for the resolution of the scene.

The Expressionist Style. Expressionist filmmakers work not to reproduce or mirror reality but to transform it, to present a special and altered vision of the world, or even to create a new dreamlike or fantastic world of the imagination. The expressionist filmmaker may create scenes of the imagination through set design and special effects, or may use other technical means to distort and change actual scenes and locations, to make them into something other than they would seem in reality, and to suggest special and extraordinary kinds of feeling, perception, and thought.

The expressionist filmmaker tends to choose compositions and images for their suggestive qualities, and for the sake of the emo-

tions or thoughts that they might evoke in the viewer, rather than for their actual resemblance to the images and compositions of daily life. Compositions may be stripped of detail and made more abstract and symbolic, costumes may be simplified, architecture may be suggested by a few design elements. Carl Dreyer's *Jeanne D'Arc* is an example of this approach. On the other hand, a composition may be enriched by an excess of details; costumes and makeup can be flamboyant and unusual; and architecture can become fantastically complicated and baroque. Federico Fellini's *Casanova* is this kind of film. These two tendencies, toward abstraction and toward excess, can even be combined in a single film. In Kenneth Anger's *Inauguration of a Pleasure Dome,* we see figures dressed in rich and colorful costumes, wearing strange and nightmarish masks and makeup, appearing and disappearing in front of abstract and simplified backgrounds and floating in a space that we can only perceive as complete and undifferentiated darkness.

A classic of German expressionism: Robert Wiene's *The Cabinet of Dr. Caligari* (1919). Note the swirling, looming forms of the set and the diagonal lines of the composition, suggesting danger and unrest.

Expressionist filmmakers may suppress certain details in a scene that would add realism but have no significant suggestive or symbolic implications. They may also emphasize details that *do* have these implications, or distort and transform certain details in order to draw attention to them. For example, in vampire movies our attention is drawn to bats, howling wolves, bare necks, and bared teeth.

Photography and editing in the expressionist style are likely to call attention to themselves, and may tend either toward an extreme and unusual simplicity or toward complication of camera movement, mise-en-scène, and montage. The long takes, frontal compositions, and fixed camera angles of a film such as Jean-Luc Godard's *La Chinoise* are expressionistic because of their very simplicity, whereas the unusual camera angles and edited transitions in a film like Orson Welles's *Citizen Kane* are expressionistic because of their rich variety. Nonrealistic lighting can be used to create a special mood or atmosphere, or to suggest a specific feeling or idea. A face may be thrown into deep shadow to add mystery to a certain character, or a glamorous and brilliant lighting may reinforce a sense of energy and euphoria, as in the large dance scenes of a musical comedy. Sound and music may be combined in a nonrealistic and expressive manner, to carry the mood or feeling of a scene. Nicholas Roeg's *Man Who Fell to Earth* creates a strange and anxious mood through David Bowie's eerie and electronic-sounding music, as well as through the almost musical orchestration of amplified sounds such as the gasping of lovers or the combined sound tracks of many television programs playing at once. The technical side of an expressionist film is not always obtrusive, but it does often serve to give a special emphasis to certain aspects of the subject, or to evoke a particular intensity of mood or feeling.

Combining the Styles. Realism and expressionism are not absolutes but stylistic *tendencies*. Although we can identify some films as distinct examples of either style, the terms are not definitive, and many films exhibit some characteristics of both styles. It may help to remember that the realist style does not present reality itself but an *illusion* of reality, just as the expressionist style presents other kinds of illusions. Not all documentary films are realistic in style, and not all fiction films are expressionistic. Such classics of the documentary film as Vertov's *Man with a Movie Camera* and Robert Flaherty's *Man of Aran* are rather expressionistic, the former

because of its highly imaginative and complicated technical feats; the latter because, using nonactors and real locations in a small fishing village, it presents a picture of a way of life that had actually died out by the time Flaherty made the film. In such half-improvised films as *Shadows, Husbands,* and *Woman Under the Influence,* the American filmmaker John Cassavetes stages fictional dramas with a look of gritty, ordinary reality. Since realism and expressionism are synthetic codes of meaning—that is, derived from the combination of many different filmic elements—it is perhaps more interesting to look at how these elements can be combined in a single film than simply to identify various films as belonging to one camp or the other.

We may find, for example, that certain elements of a film, such as photography and lighting, are realistic, while others, such as script and set design, are more obviously expressionistic. Science-fiction films, from Fritz Lang's *Metropolis* of 1926 to Steven Spielberg's *Star Wars* of 1978, frequently employ conservative and realistic photography and editing (except for certain special effects) and basic psychological realism, in combination with expressionistic set design and conception. In another kind of combination, we may find expressionistic sequences, such as dream sequences, inserted within what is basically a realistic film. We may also find it necessary to identify a particular technique as expressionistic or realistic in terms of the context of accepted film technique. For example, from years of viewing Hollywood productions, Americans have become so accustomed to a certain kind of balanced, consistent lighting that the occasional dark and murky scenes of some European films seem artful and expressionistic even though they are in one sense more realistic—the world as we experience it is not always well lit!

THEME AND MOTIF: THE RHETORIC OF FILM

Meaning is conveyed from moment to moment throughout a film, and every scene, every shot, every montage has its own special implications. The filmmaker may also develop certain ideas or feelings throughout the length of a film. We call these ideas and feelings the *theme,* or themes, of the film. The theme of a film answers the question: What is the film about? A central theme of Francis Coppola's *Apocalypse Now* is the search for the mysterious source of

evil in the human heart and the connection of that evil with the horrors of the Vietnam War. The theme of an abstract film like Hans Richter's *Rhythmus 21* is simply the visual relationships between certain abstract forms—squares, circles, curves—and the development of temporal rhythms of transformation between these forms.

A technique, image, gesture, or event that is repeated throughout a film in such a way as to reinforce one of its themes is called a *motif.* In Coppola's film, the images of irrational and gratuitous violence are an important motif; in Richter's film, the motif is the abstract form of the square. Before the development of sound in film, filmmakers relied on such techniques and devices to suggest abstract ideas and information that could not be conveyed verbally. These devices are *motific* if they recur throughout a film, and may consist of any images, shapes, sounds, camera movements, and the like that bring additional associations of meaning to a film, beyond the basic contributions of plot and characterization.

Many motific devices add meaning to a film by suggesting associations beyond the normal ones created by the editing and narrative (or abstract, or lyrical) structure. For example, in Robert Bresson's *Lancelot du Lac,* armored knights are often shown moving in a camera frame that reveals them from the waist down. This framing becomes a motific device that suggests heaviness, weightiness, and a sense of fatality to the knights' actions. In this section we will concern ourselves with some potentially motific devices that are basically literary in nature—that is, having to do with image content. We will leave discussion of more purely filmic devices to later chapters on photography, sound, and film technique.

Symbol. A symbol is an image that represents something because of a resemblance, association, or convention. The Christian cross, for example, is symbolic because of convention; it can represent not only the suffering of Jesus Christ but also religion or the institution of the church. We have to look at the whole context of a film to know what a symbol like the cross means. In the last scene of Robert Bresson's *Diary of a Country Priest,* the abstract image of a cross, white against a dark background, fills the entire screen. In a voice-over, someone reads a letter describing the last days and the last words of the young priest, who has died of cancer: "Only grace . . ." he says as he dies. Because of the context of the whole film, we

know that in this scene the cross represents not the institution of the church but rather the suffering and anguish of a religious man. Because of its visual simplicity, the image suggests the purity of his religious aspirations.

A symbol can not only suggest an idea but can also give additional meaning to what it symbolizes. In F. W. Murnau's *Nosferatu,* a film based on the theme of the vampire, a seaside graveyard is suggested by a few rickety crosses stuck in the sand. The scene is expressionistic in tone, for who would bury their loved ones in the shifting sand by the sea? Nevertheless, the crosses here suggest by their construction and by their odd angles in the sand the fragile value of human religion in the face of pagan evil, as well as the fragility of human life itself.

A symbol can also work through more subtle or indirect associations rather than conventional ones like that of the cross with religion. In the final scene of another Bresson film, *Au Hazard, Balthazar,* a more subtle religious symbolism is created. Balthazar, the subject of the film, is actually a donkey, whom we have seen kicked, battered, and used throughout his whole life, and who has been called a saint near the end of the film. In the final scene, he has been shot by accident and is dying on a hillside in the Alps. As he lies down to die, a shepherd's flock moves up the hillside, and the milling white woolly sheep surround the dark and ugly donkey. We realize with a start the association of the dying donkey with the image of a holy man, his life marked by suffering and humility, who is surrounded in his last moments by the sheep of the faithful—curious and seemingly respectful but basically uncomprehending and unable to help him in his agony.

In Terrence Malick's *Badlands,* we find another example of a subtle form of symbolism. Holly's boyfriend kills her father, and before running away together, the two of them set fire to her house to destroy the body and the evidence. As the flames spread, the camera explores the house, showing the fiery destruction of its delicate curtains and lampshades and other carefully tended furnishings. The knickknacks of Holly's childhood, and of her whole life up to now, are consumed by flames that suggest the passion of her love for the young outlaw.

Metaphor. A metaphor in literary terms is a comparison, association, or statement of equivalence between two terms that have no

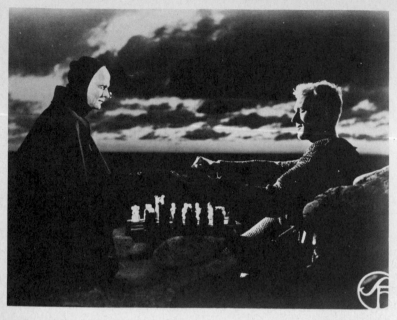

Theme and motif in Ingmar Bergman's medieval allegory, *The Seventh Seal* (1957). The knight returning from the crusades plays a chess game with death: the stakes are life itself. The presence of death and the awareness of mortality are major themes of the film. The chess game is a recurring motif.

usual, literal connection, in order to suggest a resemblance. An example is the title of the Protestant hymn "A Mighty Fortress Is Our God." In film, a metaphorical linkage can be made by simply editing two shot or scenes together in such a way as to suggest their equivalence. Eisenstein's *October* (also called *Ten Days That Shook the World*) has several such metaphors. In one sequence, scenes of a massacre of workers are intercut with a scene of the killing of a bull by butchers. In another, shots of Kerenski (a successful revolutionary, later overthrown) ascending the stairs of the captured palace of the Czars are intercut with shots of a peacock spreading its tail. In this case the metaphor has a symbolic aspect: the peacock is an emblem of pride. Metaphors can of course be easily suggested by dialogue, sound effects, or other aspects of film. In Ronald Gray's short film *Transmagnifican Dambamuality,* the voices of a family

arguing are replaced by the sounds of a battlefield—whistling rockets and explosions—serving as an auditory metaphor for the action.

Unlike symbols, which can be so subtle that we are only aware of them on the second or third viewing of a film, metaphors are usually quite obvious, and often interrupt the film's normal objective and realistic development. In *October,* the butchering of the bull is an impressionistic gesture in what is basically a realistic narrative: The scene is connected to the rest of the action because of its intellectual implications, not because it is supposed to have been actually taking place somewhere in Russia at the same moment as the massacre of the workers. In subjective sequences, metaphors can often be introduced as part of the mental processes of a character. In Coppola's *Apocalypse Now,* the opening scene mixes together images of spinning helicopter blades with images of the spinning overhead fan in a Saigon hotel. Both of these images are perceived to be occurring in the mind of the protagonist, and the metaphor in this case conveys not an intellectual idea but a nightmarish and dreamlike state of consciousness.

Metonymy. "Metonymy" is another literary term that can be applied to film. In literary rhetoric, it means the substitution of a word or concept closely associated with an object for the object itself. For example, instead of "It is the wish of the king," we might say, "It is the wish of the crown." Many kinds of metonymic relationships are possible in purely visual and auditory terms. For example, lighting might be directed in such a way that bars of light and shadow fall across a woman's face, suggesting the bars of a prison. In this case, the image of bars, which is associated with imprisonment, can suggest something about the state of mind or condition of the character. In Hitchcock's *Sabotage,* Sylvia is serving dinner to her husband after he has caused the death of her little brother by giving him a time bomb to deliver across town. She looks up at the birdcage in the dining room, which contains what was her brother's adored pet, and which now by association reminds her of the boy. It is at this moment that she decides to kill her husband in revenge, and it is the birdcage that has served the metonymic function of evoking the presence (or rather absence) of her dead brother.

Synecdoche. "Synecdoche" (si-nek'-de-kee), another literary term, refers to a figure of speech in which a part signifies the whole,

or the whole a part. An example is the slang expression for a car as "wheels." In Hitchcock's *The Birds,* we witness a reign of terror, the war waged by birds of all kinds against the people of a small town. At the end of the film, after a long series of horrific incidents involving malevolent birds, a little girl asks innocently if she can take her two caged lovebirds along with her when she leaves the town. The question is ironic and suggestive, because the two lovebirds represent for us the whole of the flocks of vicious birds we have seen in action. The image of the lovebirds is a synecdoche, in which a part of the race of birds reflects the whole.

Complex Symbols. Partly because "symbol," "metaphor," "metonym," and "synecdoche" were originally literary terms, we sometimes find difficulties in applying them to complex film images. To take the example of the cross used as a symbol, we might also identify it as a synecdoche, because it is a part of a religious tradition that can reflect the whole; or also conceivably as a metonym, an element substituted for an image of suffering because of its close association with the story of the crucifixion. If the cross is edited in association with other crosslike imagery, such as a gallows, we can describe its function as part of a metaphor. We don't have to split hairs on the subject in order to recognize some of the more suggestive and complex ways in which filmmakers can create associations of meaning between images.

VALUES

Strictly speaking, there is no such thing as pure entertainment in film: Every story, every characterization, and every sequence of images implies certain judgments and points of view about the individual and society. In a narrative film, some characters are presented in a more sympathetic light than others, and their behavior and attitudes are implicitly supported. In a nonnarrative film, the choice of images itself suggests that certain kinds of perceptions of the world are more worthy of attention than others.

It is all too common to find a film praised or found wanting because of the values it expresses without consideration of its clarity, coherence, and intelligence as an aesthetic work. On the other hand, we may find a film praised or damned purely on the basis of its technical and aesthetic aspects, with no recognition of its explicit

or implicit ethical message. A balanced and thoughtful evaluation of a film takes both aspects into consideration and establishes a meaningful connection between them.

How to Identify Values. A filmmaker can support or question values through many technical means, including photography, scripting, and sound, and through the choice of which images and events to include and which to leave out. Sometimes we are fully aware of the filmmaker's intentions, as in the case of politically inspired films. Other times we become so involved in the images and events of a film that we accept the underlying point of view unconsciously and unquestioningly. It is, of course, possible to be involved in a film on one level—say the purely aesthetic and dramatic—and remain skeptical of its value content. We can appreciate such films as Leni Riefenstahl's *Triumph of the Will* and D. W. Griffith's *Birth of a Nation* for their aesthetic achievements while withholding our support of their militarist or racist values.

There are several questions we can ask ourselves about a film in order to identify its values, especially if the values are subtly indicated. We can ask, "What does the filmmaker believe is good and bad, what does he think is important or unimportant, and what does he present as truth or falsehood?" Let us take George Lucas's *Star Wars* as an example. In this film, high technology is obviously very important, for it is used by every group within the film. Fighting is important, and the use of physical force is an important way to settle disputes. (Negotiation and persuasion are not important.) Fighting for ideals of individual freedom is good. Domination of others is a good practice when exercised by certain kinds of people, such as wise old men and idealistic young heroes. Certain kinds of beings, such as robots, are in fact ordained to be dominated, and are somewhat silly and ludicrous, even though they have emotions similar to their masters. Individual heroic action is very important, although it should be supported by group loyalty, and the heroic action of an individual (whether human or robot) can change the course of history. Individual skill in the use of technology and weaponry is important. Loyalty and self-sacrifice are good. It is a truth about this part of the universe that men can make use of a mystical force to increase their own personal power, whether for good or for evil. This force is only available to certain individuals, members of a special order of warriors. (Remember—fighting is important.) The

important political struggles are between the more "human" types of the universe; the weird creatures at the interplanetary bar do not seem to have a significant role to play. (Perhaps they represent something like the "third world" of this part of the universe.) One could go on, but the point is clear: Even "pure entertainment" is heavily laden with implicit value structures.

How Filmmakers Create Values. The codes of meaning through which a filmmaker may indicate a value structure are so many and various that a complete catalog might well be impossible. In the area of script and character development alone, the task would be enormous. We must add to this the difficulty that certain images and formal structures have different implications in different social contexts, historical periods, and areas of the world. Acting that was deeply moving in the period of silent films, when basic characterization had to be presented in purely visual terms, seems comically exaggerated and sentimental to modern audiences, used to the more subtle evocation of character through dialogue and tone of voice. A ritual sacrifice that seems weird and primitive to a Western audience may be emotionally and morally stirring to an audience composed of a people who normally perform such sacrifices. Many people today are unable to appreciate the aesthetic achievements of such filmmakers as Stan Brakhage and Andy Warhol because the implicit values are too alien or too unsettling.

Without attempting a thorough analysis of value structures in film, let us indicate a few techniques through which values can be expressed.

THE USE OF BEAUTY. Beauty of visual imagery and composition is an important means of suggesting values in film. We are of course familiar with the use of pictorial beauty in television commercials— idyllic locations, beautiful actors and actresses, glistening images artfully composed—to give value to certain products. Beauty of imagery and composition can be used in more subtle ways to give value to certain political or ethical positions. Leni Riefenstahl's *Triumph of the Will* is a documentary film about the 1934 Nazi party rally in Nuremberg. A crew of 120 people made the film, building elaborate tracks and ramps for the cameras and choreographing shots with the use of elevators, cranes, and mobile extension ladders. The film opens with a sequence showing Hitler's plane skimming the tops of fluffy clouds, appearing in the heavens over Nuremberg, and finally

landing, whereupon Hitler emerges to the welcoming roar of the crowd like one of the gods of old German legend come down to earth. The sounds and images of the film are composed in a style of classical beauty and compositional balance. Perfectly ordered ranks of marching men, swastikas, waving banners, eagles, handsome young boys and girls in neatly ordered rows, clouds, architecture, and the vast arrays of men and women lined up in geometrical patterns—all combine to create an impression of order, enthusiasm, strength, and majesty. The film won top awards at film festivals in Venice and Paris and attracted many to the Nazi party.

Henri Storck and Joris Ivens, in 1932, took another approach to the use of pictorial beauty in making *Borinage,* a documentary about the disastrous living conditions of the Belgian coal miners. Under constant surveillance by the police, the filmmakers had to shoot quietly and simply, using only the simplest and most orthodox camera angles. Far from having tracks and ladders, they had to plan special precautionary measures whereby their camera could be quickly passed from hand to hand in a crowd of demonstrating miners in order to remove it from the scene in case of trouble with the police. They deliberately avoided picturesque images, balanced compositions, and the beauty of light and shade. Through the simplicity, crudeness, and roughness of the visual imagery, the film made a statement about the squalid lives of the miners, their oppression by the mining companies and the state. There are no moments of beauty in their lives, and so there are none in the film.

In his documentary *Man of Aran,* made in 1934, the same year as *Triumph of the Will,* Robert Flaherty takes another approach to the theme of working people. Through beautiful and striking photography, he shows a family trying to wrest a living from the sea surrounding the small, rocky, and barren island of Aran, which lies off the western coast of Ireland. The picturesque figures of the family, the drama of their hunt for a twenty-seven-foot shark in a small open boat, and the grandeur of the sea, the sky, and the towering cliffs of their island all combine to create a romantic, idealized portrait of people struggling to survive against great odds, and succeeding.

SELECTIVITY OF VISION. Another subtle technique for creating value in film is the selective portrayal of people, places, and events. In fact, selective vision is the essence of the filmmaker's craft. The

flow of life and events is much too complex for any filmmaker to hope to present the whole picture. He must constantly pick and choose those elements out of reality that have special meaning for him and for his audience. Indeed, what a filmmaker leaves out of his film can help to define the values and ethical attitudes of the film as much as what he puts in.

In *Man of Aran,* ostensibly a documentary about how people really live on a small, barren island, what is left out of the film about conditions on the island would actually tell another story. In the 1930s, at the time the film was made, Europe and America were in the grip of a great economic depression, and life for the people of Aran was, in the main, one of grinding poverty. The island was torn by religious conflict between Protestants and Catholics, and the islanders suffered from ignorance and superstition. Many families were evicted from their homes by local police acting under orders from absentee landlords in Ireland and England. Daily life in Aran was colored not so much by the struggle against the forces of nature as by the struggle of man against man. This fact does not necessarily negate the values of Flaherty's film. If the noble struggle of a group of people against the forces of nature was not really shaping the lives of the people of Aran in 1934, it is a struggle that has shaped the lives of many communities throughout history, one that has its own meaning and its own ethical connotations.

In scripted films, filmmakers have an even easier task in emphasizing certain values than they do when working in the documentary style. Values can be supported by associating them with sympathetic, attractive characters and denigrated by their connection with suspicious, morally reprehensible types. David Lean's *Lawrence of Arabia,* while not actually glorifying war, presents it as a necessary evil. Indeed, through its rather mystical portrayal of Lawrence as a sensitive, suffering man who felt compelled to find meaning in action, the film also suggests that war is an arena for meaningful self-discovery. On the other hand, in *Dr. Strangelove,* military men are portrayed as weird and crazy types, and war as waged by these men is clearly madness.

Values are often attributed to certain types or groups of people through selective vision. D. W. Griffith's infamous portrayal of American blacks as immoral, childlike creatures in *Birth of a Nation* is notorious. He does this by showing blacks engaged only in

activities of greed, silliness, and viciousness, or occasionally in submission to whites, leaving out any incidents which would suggest that individual blacks are ordinary human beings. The entire genre of western films has a strong bias toward the presentation of American Indians as savage and irrational. There is no significant information about their cultures, or their own ideals and values, nor any recognition of the fact that, for the Indians, the whites were simply foreigners invading their native land, to be attacked or collaborated with as necessary.

Experimental and abstract films also present values, and selectivity of vision has a role to play here as well. Filmmaker Stan Brakhage has produced an immense body of work that supports the value of a highly individualistic, visionary, almost mystical way of perceiving the world. Brakhage uses both technical means and selectivity of vision to suggest these values. His hand-held camera, used in a manner reminiscent of the abstract expressionist painters, creates patterns of light and movement that represent an emotional, intuitive way of seeing. Brakhage in particular questions the prevailing use of camera lenses to reproduce the spatial geometry of Rennaissance perspective. In some of his films, he attempts to create the images of light and pattern that we see when we close our eyes, or visions of the world as seen in altered states of consciousness. In choice of images and subjects, he concentrates heavily on the natural world—insects, mountains, solar flares—and on his own family and surroundings—his wife, his children, his home. He seeks out the primal experiences: One of his films, *Window Water Baby Moving,* presents the birth of one of his children. Another, *The Act of Seeing with One's Own Eyes,* is a poetic vision of death and the destruction of the human body, filmed in the autopsy section of a Pennsylvania morgue. The title of one of Brakhage's longer works, *The Art of Vision,* reinforces this theme of the value of heightened and individualistic expression. The work of many other experimental and avant-garde filmmakers can be read in a similar manner: We can look to their technical approach and to their choice of images and subject matter for a clue to their values.

4

The Image

The flickering images of film have been compared to the images of dreams and trances—only half real, yet evoking intellectual and emotional responses, sensations of beauty or of disgust. The experience of watching a film—sitting in a darkened room, laughing and responding with others who sit around us, yet feeling somehow alone with the image, our attention focused on a screen flickering with light—is one peculiar to our time. Napoleon did not know it, nor did Descartes, nor Michelangelo, nor Homer, although the people of Bali have for centuries presented the stories of gods and demons through the dancing of shadow puppets before an illuminated screen. What is the nature of this strange dream image, born in the century of the motorcar and the atom bomb and just as characteristic of our age? How does it reflect our times and our visions?

THE MEANS OF PRODUCTION

The image itself can be bright or dark, have color or shades of gray, be complex or simple in design, be recognizable or abstract, be moving or still. If we try to identify the basic qualities or potentialities of the film image, we might come up with such variables as light, color, movement, composition, and what we might call *verisimilitude,* or the capability of film to mirror the real world. There are several different means of producing film images, each of which manipulates these variables in a different way.

Cinematography. Before directors, actors, scriptwriters, composers, set designers, there was the cameraperson. The art of film was really born simultaneously with the craft of cinematography, the art of photographing and projecting images, and this craft re-

mains of central importance. Cinematography is the photographing in real time of images in the world. A camera and lens are trained on a subject in the real world, or in a theatrically created world; the subject is lit either by natural light or artificially; film stock is transported through the camera, is exposed, and an image is recorded.

The three essential elements of cinematography are the *camera and lens,* the *lighting,* and the *film stock.* The first type of lighting was of course daylight. The modern sophisticated technology of lighting was slower to develop than the technology of cameras, lenses, and film stocks. Nevertheless, the use of lighting has always been carefully coordinated with the other techniques of cinematography, and within a decade of film's inception, different forms of lighting were used for aesthetic effect.

The *lens,* which makes possible the focusing of an image of the world onto a chosen location—a screen, an area of photographic film, or the eye itself—had been in existence since the time of Galileo and Leeuwenhoek. It was the *motion-picture camera* that made possible the recording of a series of images by presenting a strip of light-sensitive film stock to the image of the world projected onto it by a lens. The first cameras also served as projectors, and by a simple modification would project light back through a developed print of the original film stock onto a wall or screen. Eventually the specialized functions of camera and projector were performed by separate machines, but even now both perform one common function: the transport of a strip of film in intermittent motion past a lens.

Invention of the *film stock,* a strip of celluloid to which a light-sensitive emulsion has been affixed, made possible the projection of motion pictures rather than still images. It was strong enough to be transported through cameras, processors, and projectors without tearing, and its length made possible the recording of separate, successive images that could be projected in rapid succession to create the illusion of continuous movement.

Since the early 1900s, both the technique and the technology of cinematography have become increasingly sophisticated, and most of this chapter will deal with these subjects.

Animation. "Animation" is a general term for any production technique in which the illusion of motion is imparted to images, such as drawings or models, which do not themselves move. Most kinds of

animation are achieved by a specialized branch of cinematography in which artwork is lighted and photographed with a camera in a controlled way. Usually, the subjects are photographed one or two frames at a time and the camera or the subject itself is moved slightly between successive, single-frame shots. In long sequences, which are built up from separate one- or two-frame shots, the subject appears to move continuously.

There are many techniques of animation, including some that do not require the use of a camera. Usually, we can tell what technique was used from the appearance of the film.

DIRECT ANIMATION. Some filmmakers have developed a technique of drawing, painting, pasting, scratching, or batiking images directly onto clear or opaque film stock. In this process, no camera or lighting is required, and the film stock is not photochemically activated. The Canadian filmmaker Norman McLaren has produced many films by direct animation, often with representational images. In the United States, Harry Smith's *Early Abstractions* were produced in this way, as was Stan Brakhage's *Mothlight,* for which small bits of moth wings and other materials were taped directly to the film stock.

OBJECT ANIMATION. Some animators work with three-dimensional objects or materials, which are moved between the shooting of individual frames. A wide variety of objects and materials are used. Sand, string, and clay may be employed to produce what are essentially two-dimensional designs; while clay figures, puppets, models, and other objects can be animated to create a three-dimensional world. For three-dimensional subjects, the lighting techniques are similar to those for live-action films. Animated models are sometimes used for special effects within a live-action film, as in scenes of struggles between prehistoric monsters or a fleet of battleships under bombardment.

CUTOUT ANIMATION. The animator may move and manipulate paper cutouts, building up layers and relationships as children dress paper dolls. Larry Jordan and Harry Smith have both used this technique to create mysterious, surreal and sometimes frightening worlds with images cut out from old engravings.

FLATWORK ANIMATION. There are two basic types of flatwork animation: *full animation,* which requires the drawing of a separate image for each frame or two of film; and *cel animation,* in which

separate layers of images are painted on transparent celluloid and then combined in the shooting process.

Full animation is the most laborious method of creating representational scenes, but it has also been used effectively to create abstract imagery, through the photography of abstract shapes and colors.

In cel animation, portions of an image, such as an individual figure, are drawn on transparent *cels,* which are built up in several layers over an opaque background. The animator creates small groups of cells, called *cycles,* which represent a single image in different stages of motion. Several cycles can be rotated or moved at once in a carefully organized pattern to create an image that contains many complex movements. The opaque backgrounds may also be moved in relation to the camera to create effects of traveling or camera movement. The more complex the original artwork, the more lifelike and natural the movements will appear. Almost all commercially produced animation, especially for animated features and television, is produced by this method.

Both full animation and cel animation usually require a complex camera setup called an *animation stand.* This device includes a horizontal surface on which the flatwork is arranged, *registration pins* for lining up several layers of cels and successive drawings, a vertical column on which the camera is mounted, and an array of lights beside and often below the horizontal surface. Control devices permit moving the camera closer to or further from the subject and allow the flatwork as a whole to be moved in measured increments in several directions on the horizontal surface.

The control systems may be computerized to perform very complex movements, and the same strip of film can be exposed to different subjects in a series of separate *passes,* to create a complex image sequence.

SPECIALIZED TECHNIQUES. Independent animators have developed a number of highly individual techniques of animation, often building special mechanical structures and systems to create their effects. Oskar Fischinger refined a method of animation in which thin slices were cut from a block of multicolored wax to create abstract moving images. Alexandre Alexïeff and Claire Parker invented the system of *pinboard animation,* in which a dense matrix of small pins are pushed back and forth through a board to create a

kind of relief drawing, which can be changed subtly from frame to frame. For *The Room,* Carmen D'Avino gradually added a profusion of painted dots, stripes, and bands of color to the floor, walls, and ceiling of a dingy garret room containing an old piano. Before our eyes, we see the painted shapes transforming the room, the piano turning into a fantasy of gay colors. In *Color Sound Frames,* Paul Sharits created a kind of animated motion by photographing on a homemade optical printer a separate filmstrip composed of variously colored frames. What we see on the screen is a strip of film that appears to slide up and down through the projector gate at different rates of speed. Other specialized animation devices have been built for science-fiction films like *2001, Star Wars,* and *Star Trek.* In these films, animation creates such effects as travel in imaginary space, the approach of one spacecraft to another, and flight through a field of asteroids.

VIDEO PROCESSING AND COMPUTER ANIMATION. Video synthesizers and computers are becoming increasingly popular tools for the filmmaker. They work on principles like those of audio synthesizers and music-generating computers except that they "read out" not through a loudspeaker but on a video monitor. Images that appear on the monitor are then photographed by a motion-picture camera, either in real time or one frame at a time. Video synthesizers and computers may be used separately or in combination. A computer, of course, requires a *program* that will turn its calculations into an image. Both devices are often used to modify a basic image. An image can be made to roll over, stretch, contract, turn inside out, or it can be transformed radically into another image or images that bear no recognizable relation to the original.

Special Effects. The term "special effects" is something of a catchall for a great variety of production techniques, of which some are standardized procedures, while others are invented for a particular production. There are two basic types of special effects—the physical and the photographic—and a separate unit of the production team is responsible for each type.

Physical effects are created directly on the set or location. They include rain, snow, wind, fires, explosions, collapsing houses, and cosmetic effects like bullet wounds or monster faces.

Photographic effects are created through a variety of specialized techniques. Paintings and models can be photographed so as to ap-

pear as reality and often serve as a backdrop or foreground for live action. Model ships may be used for a sea battle sequence; a model town can be used for the effect of an aerial shot. In a *glass shot,* a sheet of glass is set up between the camera and the live subjects, and areas of the glass are painted to add elements to the scene or subtract elements from it.

For the technique of *rear projection* (or *back projection*), live subjects are positioned in front of a translucent screen, and a filmstrip is projected on the screen from behind it. The camera records a combined image of the live subjects and the filmstrip. This technique is often used to create the effect of actors riding in a train, car, or other moving vehicle. The actors are photographed in a vehicle or mock-up of a vehicle, which sits motionless in the studio while a receding landscape is projected behind it. The vehicle may be rocked or jiggled to add to the effect. *Front projection* is a similar technique and can produce a brighter projected image, but it requires a more complicated setup of camera and projector.

Other special effects can be created in the laboratory. In the *matte shot,* a portion of the field of action of a shot is masked or blocked off, so that foreground images shot at one time may be combined with a background scene shot at another. For this complicated process, positive and negative *masks* or *mattes* are produced that have the appearance of high-contrast photographic silhouettes. They are used to either pass or block off parts of images that are to be printed and combined on the final strip of film. The mattes can be produced either by hand, through a kind of animation process, or through special lighting and photography. In the *blue-screen process,* mattes are produced by photographing the subjects in front of a monochromatic blue screen and using laboratory processes to generate mattes from the resulting image. A *traveling matte* is simply a matte that changes shape from one frame to the next, in order to follow a moving image.

There is really no limit to the variety of special effects that can be devised and photographed. For *Star Wars,* George Lucas relied on a number of highly complex special effects to create scenes of battling space cruisers. These included traveling mattes, optical printing, and the combination of animation with live action. For *2001,* Stanley Kubrick relied on many of the standard processes, but he also had a special machine designed to create the "space corridor" effect in

which we seem to be hurtling through an endless tunnel of pure light and energy.

THE FILM STOCK

The basic film material is made of an organic compound called "cellulose acetate." This material, called the *base* of the film, is coated on one side with a thin layer of photochemically sensitive material called the *emulsion*. There are many varieties of color and black-and-white emulsions, and there are many sizes and shapes of the basic strip of film. These different sizes are called *formats*. The major formats (based on the width of the filmstrip) are 8mm, 16mm, 35mm, and 70mm. Different cameras and projectors are used for each format. All film formats have *sprocket holes* or *perforations* running along one or both sides of the strip of film. The engagement of these sprocket holes by the teeth of sprocket wheels in cameras, editing machines, laboratory equipment, and projectors makes possible the regular transport of the film through such machines.

Filmmakers choose a format for a film according, first, to the specific needs of the production and, second, to the planned system of distribution. The 35mm format has traditionally been the one of choice for normal theatrical distribution, and is also used for television commercials when quality of the image is an important factor. The 65mm and 70mm are *wide-screen* formats used exclusively for theatrical distribution, but on a more limited scale than 35mm because only certain theaters are equipped to screen these formats. (A film may be shot in 70mm and reduced to 35mm for wider distribution.) Originally, 16mm was developed as an amateur format, but during World War II it was widely used for military photography because of the lighter weight and greater mobility of the cameras that it fits. It is now used extensively for documentary films, television news photography, and many other professional purposes, including educational and industrial films. Many experimental and independent filmmakers work in 16mm because it is cheaper and the equipment is more readily available. Super-8 (basically the same format as 8mm, but with smaller sprocket holes and therefore a larger image area) was also at first an amateur format and became more extensively used because of the lower cost and greater avail-

ability of its equipment. Super-8 has been used successfully for television news programs, and many independent filmmakers are now shooting feature-length films in this format. Super-8 has even been blown up to 35mm for theatrical screenings!

The Chemistry of Film. Motion-picture photography is based on a chemical process within the film emulsion. The same process is involved both in original photography and in the many procedures for making prints or copies from the original film that was exposed in the camera. Different emulsions have different chemical characteristics, and the filmmaker chooses an emulsion according to the desired photographic behavior.

THE PHOTOCHEMICAL REACTION. In the film emulsion, information and detail are recorded by tiny granules of silver salt that are individually too small for the eye to see. These compounds are

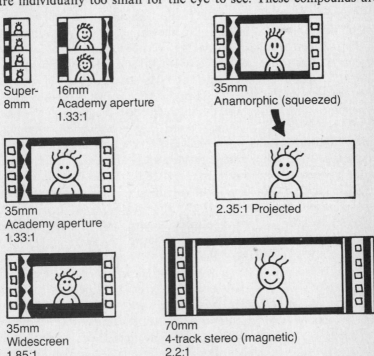

Super-8mm

16mm
Academy aperture
1.33:1

35mm
Anamorphic (squeezed)

2.35:1 Projected

35mm
Academy aperture
1.33:1

35mm
Widescreen
1.85:1

70mm
4-track stereo (magnetic)
2.2:1

Some common formats and *aspect ratios*. Shown are only three of a number of possible wide-screen formats. The aspect ratio is equal to the frame's horizontal dimension divided by its vertical dimension.

light-sensitive—that is, if they are *activated* by the energy of light falling on the emulsion, they can be *developed* and processed in the laboratory so as to reveal an image. This image is in fact a direct impression, a reaction to the amount or intensity of light striking the emulsion. The brighter the light falling on the emulsion, the more granules of silver salt are activated in a given area and can be developed to form the image. If no light, or relatively little light, falls on an area of emulsion, few granules are activated. It is this variation between areas of activated salt and areas of unactivated salt that creates the range of dark to light tones in the film image.

The size and number of these granules per area of film set the limits to the fineness of detail, or the amount of picture information that can be recorded. A frame of film with large and relatively few granules of silver salt can record less picture information and less detail than a frame with more or smaller granules. Since the chemistry of film emulsions is basically the same, no matter what the format, there is a direct connection between film format and the amount of detail that can be recorded. A 16mm frame is about one-fourth the area of a 35mm frame and has one-fourth the number of light-sensitive granules. Exposed to the same scene, it records much less picture information and detail. A Super-8 frame, which is one-sixteenth the size of a 35mm frame, is even more limited in the amount of information it can record. There simply are not as many granules of silver salt available in the Super-8 frame as in the 35mm frame to record the same image, and the granules themselves are larger in relation to the details of the image focused on the emulsion by the camera lens. This is why 16mm and Super-8 films tend to look more *grainy,* to have a rougher texture, and to carry less fine detail than 35mm footage of the same scene.

NEGATIVE AND POSITIVE EMULSION. The kind of emulsion we have just described is a *negative* emulsion. In a negative emulsion, the areas of silver salt that receive the most light become the most activated. When developed, these areas have the greatest concentration of metallic silver or color dye and are thus the *darkest* areas of the emulsion. Areas that do not receive as much light are less highly activated. When developed, they produce much less metallic silver and so are the *lightest* areas of the emulsion. Because of this chemical process, the light values of the original scene are reversed: Light areas appear dark on the negative film, and dark areas appear light.

In order to change the light values of the negative film back to those of the original scene, we can make a copy, or *print,* of the negative on a second roll of film. In the copying process, the light values are once more reversed, this time from the negative to the copy, so that the copy appears light where the original scene was light, and dark where it was dark. This copy is called a *positive* print. If another copy is made from the first copy, it will again appear as a *negative,* and so on. The negative/positive process is the same as that used in the early 1900s by Méliès and Lumière, and is still used for most feature-film production, both in color and in black-and-white.

REVERSAL EMULSION. Another chemical process, developed in the 1920s, made possible the reproduction of the light values of the original scene on the original roll of film exposed in the camera, thus eliminating the intermediate stage. A special emulsion is used, called a *reversal* emulsion. This emulsion is put through a two-stage developing process: First, it is developed as a negative; second, the same strip of film is reactivated and redeveloped to form a positive image. Reversal film is used extensively in 16mm production and exclusively for Super-8 filming. To make a copy of reversal camera original, a reversal print stock must be used in order to maintain the normal light values.

Image Quality. The quality and general appearance of a film emulsion are judged according to a number of factors, including the range of tones from light to dark, the sharpness of the image, and the graininess of the texture. Different emulsions and formats have different qualities, and the filmmaker must often make compromises among the characteristics he desires from a film stock.

CONTRAST AND LATITUDE. "Contrast" refers to the degree of variation between light and dark. A *high-contrast* emulsion has brilliant whites and deep blacks; a *low-contrast* emulsion tends toward shades of gray. "Latitude" refers to the range of tones between black and white. A film that can produce many subtle tones of gray has a *wide* latitude; a film that can reproduce only a few tones between black and white has a *limited,* or *narrow,* latitude. High-contrast emulsions tend to have a narrower latitude than low-contrast emulsions.

SHARPNESS. Every emulsion is rated according to its *resolving power.* Resolving power is measured by the number of lines per

square inch that an emulsion can reproduce before the lines start to blur. The more lines per square inch, the higher the resolving power and, usually, the sharpness, or *resolution*. The effect of sharpness depends also on formats; the larger formats appear sharper because there are more grains of silver salt per area with which to reproduce the image. A high-contrast emulsion often appears sharper than a low-contrast emulsion because the edges of the image are more sharply defined.

FILM SPEED. The degree of sensitivity to light varies from emulsion to emulsion. This relative sensitivity is referred to as the *speed* of the film. A *fast* emulsion requires less light for an exposure and can be shot under low-light-level conditions, such as streetlights and normal house lighting. A *slow* emulsion requires more light and is usually limited to the studio and to daylight shooting on location. An emulsion can be *force-developed,* or *pushed,* to enable shooting under low light levels.

The speed of an emulsion has a great effect on its overall quality and appearance. The slow emulsions tend to have a crisp look, show a great deal of detail, permit subtle shadings of light and dark, and have an overall smooth or *fine-grained* texture. The fast emulsions tend to be more contrasty, grainier, and display less detail and fine shading. (A slow emulsion that is pushed, or force-developed, begins to take on the characteristics of a faster emulsion.) The slow emulsions are used extensively for feature films and commercials; the faster emulsions are generally used for documentary and news work.

Black-and-White Versus Color Filmmaking. Black-and-white photography has been developed to an extremely high level of refinement and artistry, although it is now infrequently used for motion pictures. Good black-and-white photography offers a crispness of detail and a subtlety of shading that color photography cannot match. Because color film has become such a firmly established convention, producers find it increasingly difficult to finance and find distribution for black-and-white films. Still, some filmmakers like the pure, abstract quality of the black-and-white image; others wish to evoke a sense of nostalgia, or a period feeling. In contemporary filmmaking, because black-and-white photography draws attention to itself as a technique, it often has an expressionistic effect.

Despite the fact that color photography has become an almost obligatory convention of contemporary filmmaking, there remain so

many possibilities for the expressive use of color that the convention does not seem too restrictive. In realist filmmaking, color can be used to give a subtle emotional tone or atmosphere to a scene or to an entire film. Warm and cool tones, dark colors and light colors, can be used for their emotional effect. Scenes shot in neutral colors and tones of gray can be contrasted with scenes shot in vivid, saturated colors. A small area of color can be used for accent in a composition of neutral or somber tones. The possibilities are virtually limitless for the filmmaker who chooses to explore them, and he can draw on the whole history of painting for inspiration. The expressionist filmmaker may use color in a flamboyant, extravagant way, as in the heightened and vivid palettes of the early Technicolor musicals and historical epics of Hollywood. A contemporary expressionist like Jean-Luc Godard is much more restrained in his style. The color scheme of Godard's *La Chinoise* is based on simple, bold primary colors—red, green, yellow, blue—often used singly, and contrasted with pure black or white. Michelangelo Antonioni, another contemporary colorist, has been known to have lawns painted green in order to get a precise, lush shade for a scene.

THE CAMERA

The camera is the filmmaker's most important tool. With it, he can create and shape spaces and images, movement and time. The camera is to the filmmaker as the brush to the painter, the piano or violin to the musician. In a 1948 article, writer/filmmaker Alexandre Astruc envisioned a *Caméra-Stylo,* a way of writing with the camera as a writer does with his pen.

How the Camera Works. All motion-picture cameras, no matter how simple or complicated, make use of a few basic principles of design. Like any other camera, the motion-picture camera is designed to expose photographic film to light in a controlled way. In addition, the motion-picture camera must transport long strips of film past the lens at a very rapid rate, and stop the film repeatedly so that individual still frames may be photographed. All cameras have the following elements: a shutter, intermittent movement, a transport system, and a lens (often combined with a viewfinder). Many motion-picture cameras use in addition a mounting device to move the camera in various directions.

THE SHUTTER. The shutter is the device that controls the *expo-sure time:* the length of time that light is allowed to fall on the film. As the film moves through an opening behind the camera lens, called the *gate* or *aperture,* the shutter can either open to allow light to pass through the gate or close to cut off the light. While the shutter is open, the film is held motionless against the gate by a *pressure plate,* and is locked into position by the *pulldown claw* or by *registration pins.* When the shutter closes, the film is advanced to the next frame, which is in turn held in place and exposed to light.

Projectors also make use of a shutter, which serves the same pur-pose as in the camera: to control the passage of light. In the projec-tor, the film frame is held in place while the shutter is open, and the image is projected on the screen. When the shutter closes, the next frame is moved into place.

THE INTERMITTENT MOVEMENT. This is a device that allows the continuous movement of a motor to be translated into a regular stop-and-go movement. In the camera, the intermittent movement is linked to both the shutter and the *pulldown claw* that engages the film perforations. The intermittent movement advances the film through the gate while the shutter is closed, and holds it motionless for an exposure while the shutter is open. This stop-and-go motion takes place only at the gate; in other parts of the camera, the film is transported smoothly and continuously by various sprocket wheels.

Projectors also employ an intermittent movement, which serves the same function of linking the opening and closing of the shutter with the movement of film through the gate.

THE TRANSPORT. A camera may be loaded with several hun-dreds of feet of film. The film transport moves this film through the camera in a regular, continuous fashion. A system of rollers and sprocket wheels gradually carries the film from a *feed roll* of unex-posed film, past the gate, to a *take-up roll* of exposed film. The feed roll and take-up roll may be contained either within the camera body itself or within a separate *magazine,* which can be preloaded and quickly attached to or detached from the camera body. The driving force for the film transport and the intermittent movement can be supplied by either an electric or a spring-wound motor. The earliest cameras were powered by human muscle turning a crank.

LENS AND VIEWFINDER. All motion-picture cameras have a lens or lenses. The lens may be permanently attached, in which case it is

most likely a zoom lens. Most cameras have a *lens mount* by which a variety of different lenses can be attached to the camera. A *turret* is a special type of lens mount that allows two or three lenses to be attached to the camera at the same time, so that the desired lens can be quickly rotated into shooting position.

Most cameras also have a *viewfinder* system that allows the cinematographer to compose the shots while looking at the subject. There are two types of viewfinders. In the *reflex* system, light entering the lens is split off through prisms or mirrors into the viewfinder. This means that the cinematographer sees through the camera lens itself exactly what the lens "sees." In the older *parallax* system, a separate viewfinder system is mounted on or in the camera. It has no connection with the optical path of the camera lens and so must be adjusted as different lenses are used to approximate the field of view of each lens.

CAMERA MOUNTS. Some system of mounting or moving the camera is essential to its operation.

The simplest means of mounting or moving the camera is to hand-hold it if the camera is small and light enough to be controlled in this way. A hand-held camera can be moved freely in any direction to focus on different subjects or on different parts of a scene. It can be carried or walked through space to follow a moving subject, to approach or draw away from a subject, to explore an environment. The hand-held camera, however, has a tendency toward unsteadiness or shakiness, and it is most often used in documentary or news work where flexibility and speed of response are more important than strict control over the image. Sometimes, of course, the shaky quality of the hand-held camera is exploited in fiction films to suggest a newsreel effect or to create a desired roughness or tension in the image.

Most often, the hand-held camera is carried on the shoulder, but special *orientable* viewfinders may allow one to hold it in many other positions. The camera may be mounted on some type of *body brace* to steady it against the shoulder or waist. A specialized type of body brace is the *Steadicam,* a large and heavy gyro-controlled device that allows one to walk or even run with the camera while maintaining an extremely smooth, steady image.

More control over the image, but less flexibility, can be achieved with the *tripod,* a three-legged support with a *tripod head,* on which

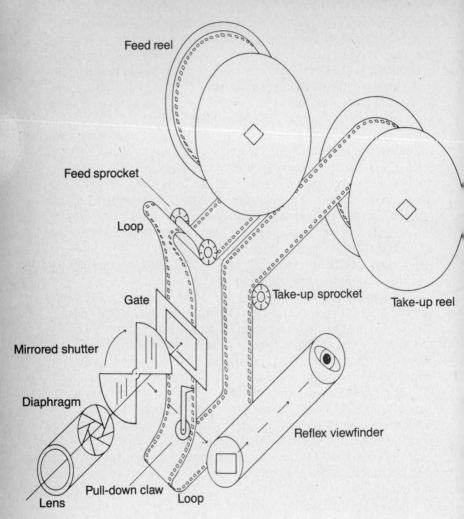

The basic elements of a motion-picture camera. The mirrored shutter design is one of several possible reflex viewfinder systems.

the camera is actually mounted. The tripod head can be locked into different positions or can be moved smoothly during a shot. It is called a *friction* head or a *fluid* head according to the means used to control the movement. A special tripod called a *baby legs* can be used to mount the camera closer to the ground than would be possible with a regular tripod. A *high hat* is a short, three-legged metal casting that will support a tripod head and camera and permits mounting the camera about a foot above floor level.

A number of devices can be used to move the camera through space. An early technique was to place it on a special platform and roll it over tracks, like miniature railroad tracks. From this procedure we get the term "tracking," or "tracking shot." Tracks are still used outdoors or over an uneven surface. A *dolly* is a special cart mounted on rubber-tired wheels to move the camera smoothly over a level surface, hence the terms "dollying" and "dolly shot." A *crab dolly* has special controls that can turn all four wheels simultaneously, making possible an instantaneous change of direction in a small space. All dollies are equipped with some sort of movable column or hinge that raises or lowers the camera. A tripod head is mounted on the dolly to support and orient the camera.

A *crane* is a movable vehicle with a long boom arm on which the camera, and often the cameraperson, can be supported, thereby enabling the camera to be raised and lowered through a much greater distance than is possible on a dolly. A crane can be moved through space both horizontally and vertically with great flexibility.

A number of other camera mounts have been designed for special purposes. A helicopter mount, for example, is designed to absorb the vibrations of the helicopter and to hold the camera steady during aerial shots. Cameras may also be fixed to the hoods or doors of automobiles, to the wings of planes, or the handlebars of motorcycles.

THE LANGUAGE OF CINEMATOGRAPHY

Cinematographers, editors, directors, and other filmmakers use a special language to indicate what the camera does. Some terms, like "close-up" and "focus," are part of our common speech. Others, such as "tracking shot" and "depth of field," are specialized terms. This specialized language performs three basic functions.

One function is to describe *how* the camera treats its subject. We might call this the *compositional* language, which can describe how the camera frames its subject, how it moves, how the choice of lenses can affect the image, and the like. The director and cinematographer use these terms when talking about the look of a film. Another function of specialized language is the description of *what* the camera photographs. Language used in this way is *subject-oriented:* It describes what the camera views in terms of the characters, props, and action of a scene. This subject-oriented language is often used by writers, directors, and editors in discussing how the shots of a scene fit together to develop the action. A third function of specialized language is to refer to detailed processes of cinematography and to specialized techniques, including *special effects*. This use of language is called *technical*.

Composition for the Camera. Since the use of different camera positions and different lenses allows a great deal of flexibility in how a scene will be presented, the filmmaker usually begins to compose a scene by thinking about how the subject will be arranged for the camera—how many shots will be used in the scene and what elements will be shown in each shot. The filmmaker can make use of certain standard types of shots to compose the subject. The terms used to designate some types of shots refer to the camera's point of view; others refer to the subject's actions or position.

Long Shot (LS). A long shot presents a scene from a great enough distance to reveal most of the scene's elements, showing the players and something of the setting. It employs a relatively wide angle of vision, and ranges in scope from a shot that presents a whole crowd of people to a *full shot,* which might present two or three people so that their full figures, from head to toe, are just included within the frame.

An *extreme long shot* gives an epic scope to a film. We might see an entire army massing on a field, or a vast expanse of landscape through which the performers are traveling.

The long shot is used often as an *establishing shot*—that is, a shot that presents the principal elements of a scene and orients us for closer shots in which only a part of the larger space is seen. It is well suited to the realist style, since it shows the relationship between subject and environment, and also to mise-en-scène technique, since it allows for the continuous development of action in a single space

and a single shot. The long shot provides enough room for relationships to be established within the shot, rather than through a montage of separate closer shots.

MEDIUM SHOT (MS). This shot is defined in terms of human subjects. It is an angle of view and a distance that show a person (or persons) from knees or waist up, including chest and head, with room for hand gestures. The medium shot begins to shut out background and context, and focuses attention on the players themselves. It is, however, still suited to mise-en-scène, particularly if the camera or performers move within the shot so as to develop action within a continuous shot. The medium shot can be used to intensify a confrontation or relationship between two characters, and can serve as a transition between long shots and *close shots*. The *two-shot* and the *three-shot* are varieties of the medium shot; they present respectively two or three figures from the waist up.

CLOSE-UP (CU), CLOSE SHOT (CS). A close-up magnifies the subject and fills the frame with the image of the subject or an important or significant part of the subject. For actors, a close-up would usually present the face and head, and perhaps part of the shoulders. An *extreme close-up* of a clock would fill the frame with the clock face; an extreme close-up of a face might show the eyes or mouth only.

The close-up emphasizes details of expression or movement. A lifted eyebrow becomes a bold gesture. A tear rolling down a cheek can cover almost half the height of the screen. The close-up gives symbolic or emotional weight to the subject. In many films it is used sparingly and only at moments of great emotional or dramatic tension. Close-ups can also evoke a kind of fascination with the motion or appearance of inanimate objects, and can emphasize the significance of small movements or details.

Close-ups are most useful in montage technique and in expressionist styles of filmmaking. Carl Dreyer's *Passion of Joan of Arc* relies heavily on close-ups, which build to a sense of almost unbearable physical constriction and emotional intensity. Only in the last scenes of the film do we really see any long shots. These show the peasants' violent reaction to the execution of their beloved Joan and give a kind of release and catharsis.

POINT-OF-VIEW SHOT (POV). A point-of-view shot, or *subjective shot,* is any shot that, after editing, presents what an actor is

seeing as if through his own eyes. A POV shot is defined by the spatial relationship of the camera and the other players to the player whose point of view it represents.

REACTION SHOT. This is a shot of an actor, often a close shot, in which the actor reacts to an event or to the words or actions of another actor. Often the actor in a reaction shot really expresses nothing at all. We read an emotion into his expressionless face based on what we know about the character and what has just been said or done. Again, a reaction shot is defined by its spatial relationship to the event that causes the reaction.

OVER-THE-SHOULDER SHOT. This is just what the term implies. We see the action over the shoulder of and from behind one of the actors. Unlike the subjective shot and the reaction shot, this is defined by the visual elements within the shot, not by its position in the edited film.

The Camera Angle: The Image in Space. The use of a variety of camera angles emphasizes the three-dimensionality of cinematic space. The frame becomes a "window" that allows us to peer into reality from any angle. This "window" can be placed high or low, can look down or up, can view the action frontally or obliquely.

NORMAL ANGLES. The first filmmakers tended to photograph their subjects from eye level and from a *frontal angle,* the angle closest to a theatrical perspective. These frontal, eye-level angles are used by realist directors to present the action in a direct way so that the film technique does not call attention to itself. The use of relatively normal eye-level and frontal angles tends to leave psychological and moral judgments up to the viewer—the shots themselves don't comment on the action.

A *high angle* is significantly above the eye level of the subjects, whatever their position. We are looking down on the subjects, with all of the psychological implications of that stance. They are depersonalized, belittled, made vulnerable, etc.

A *low angle* is significantly below the eye level of the subjects, so that we are looking up at them, with all of the implications of looking up at someone. They seem to loom larger in the scene, to be more dominating, more threatening, more in control.

These angles can be used to reinforce or suggest a psychological subtext within a scene.

A *side angle,* or *oblique angle,* is defined in relation to the props,

furniture, or architecture of a scene and in relation to the direction in which subjects are looking. If a subject is looking straight ahead, a frontal angle intercepts his gaze so that he appears to be looking directly into the lens. A side-angle or profile shot of the same person would present him on the screen so that he appears to be looking directly to the right or left side.

A *three-quarter angle* would present the same subject from a position halfway between the frontal angle and the side angle.

A *reverse angle* would show the same subject from behind; we would see the back of his head. A reverse angle can also be any shot that is turned 180 degrees from the direction of the previous shot in a sequence.

Oblique angles are also determined by spatial relationships. If two subjects are seated side by side on a sofa or in the back seat of a car,

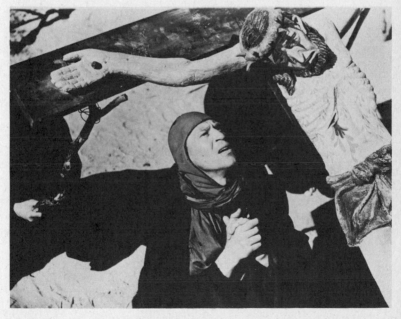

An extreme high angle from Bergman's *The Seventh Seal*. We are looking down on the supplicating priest (the leader of a band of flagellants) as the crucifix towers ominously above him. Both the priest and the crucifix form diagonals with the edges of the frame, adding to the feeling of disturbance. The harsh light and the brutal contrast of light and dark echo the severity of the priest's message.

Kane looks down with an air of concerned authority in Orson Welles's *Citizen Kane* (1941). We see his colleagues from normal eye level, but Kane himself is seen from a low angle and dominates the frame. His face stands out against the blank walls and ceiling; the other two faces tend to interact with the busy background and are almost equivalent in compositional weight to the large lamp in the foreground.

the frontal shot would be set up on a line perpendicular to the line of the sofa or car seat, looking directly at the characters, no matter in what direction they were looking. Any other angle would be *oblique*.

Or, to cite another example, if the two subjects were seated facing each other across a restaurant table, the frontal shot would show both of them in profile when they were talking to each other. A frontal close-up of one of them, however, would show that person looking directly or almost directly into the camera lens.

Unlike the high and low angles, the various frontal, side, and reverse angles do not have psychological implications; they are used to connect subjects and events in film space, principally by drawing our attention to the direction in which a character is looking or about to move. However, the frontal angle, in which a subject looks almost directly into the camera lens, does tend to evoke a greater sense of that character's intensity, vulnerability, or sincerity than does a side or three-quarter shot.

The filmmaker may also combine the high or low angle with the frontal, oblique, or side position and thus add a psychological component to the shot.

EXTREME ANGLES. Extreme angles call attention to themselves, and for this reason are usually avoided in realist films. They are more appropriate to the expressionist style, in which the transformation or distortion of reality is part of the filmmaker's purpose. Even in realist films, these angles tend to impose a moral or psychological point of view.

The *extreme high angle,* or *bird's-eye view,* presents an omniscient point of view. It reduces the apparent height of the subjects, makes movement appear slower, and (since it is almost always a wide shot) increases the importance of the environment in relation to the characters.

There are definite psychological implications to this type of shot. It often suggests the powerlessness or vulnerability of the subject, and can also suggest destiny, fatality, and the insignificance of humans in the overall scheme of things.

The *aerial shot* is the most extreme high angle. This is often a *moving-camera* shot, and the camera setup is a special helicopter mount.

The *extreme low angle* increases the threatening, dominating implications of the low angle to the point where the subject on the screen may appear as a towering figure looming over us. The extreme low angle minimizes the environment by framing the subject against the simple background of ceiling or sky. The figure tends to dominate the frame even more without the competition of other elements in the frame. This type of shot can cause a kind of spatial disorientation and heighten the subject's psychological importance, increasing the evocation of power, heroism, or threat.

The *tilt angle* sets the camera so that the vertical edges of the film frame are tilted away from the vertical lines in the subject. This angle represents an extreme psychological or physical dislocation, such as the point of view of a drunken person or the tilting deck of a sea-tossed or sinking ship. It is used rarely—perhaps once if at all in the course of a film.

Composing with the Camera: Framing the Image. The film frame is a two-dimensional shape that contains and sets limits to what is within it. Unlike the frame of a painting, which can be of any shape and proportion, the rectangular shape of the film frame is

fixed by convention. The ratio of the height to the width of a frame
is called the *aspect ratio*. Super-8, 16mm, and some 35mm formats
have an aspect ratio of three to four. This standard, also identified
as the ratio of 1:1.33, is called the *Academy aperture*. The television
frame was standardized on this same ratio of three to four. There
are a number of *wide-screen* systems using 35mm, 65mm, or 70mm
film, which go by such names as Cinemascope, Panavision, and Vis-
tavision, and which employ different ratios of screen height to
screen width. Some of the more common wide-screen ratios are
1:1.66, 1:1.85, and 1:2.35. In some wide-screen systems, the width of
the frame is thus more than twice its height.

We most often see the frame as a window into a field of action, a
two-dimensional border to a three-dimensional space. The frame
can also define a two-dimensional space; we can see the field within
the borders as flat. Whether the space is flat or deep, the frame
defines it in several ways: Subjects are inside or outside the frame,
and lines within the frame run parallel with or diagonal to the edges
of the frame. The frame also defines certain areas within it: the
upper and lower portions, the left and right areas, the center and
edge areas.

COMPOSING LINES WITHIN THE FRAME. Lines within the frame
may either echo the vertical and horizontal lines of the frame or
oppose them with diagonals. The use of horizontal and vertical lines
suggests a feeling of rest, solidity, equilibrium; the use of diagonal
lines creates a feeling of unrest, conflict, movement. Diagonals in
one shot can move in the opposite direction from diagonals in a
previous shot to create a stronger sense of movement and unrest. A
cinematographer may compose lines within the frame by using
either natural or architectural lines of the subject—such as horizon
lines, doors, walls—and can choose a camera angle that will make
those lines appear parallel or diagonal to the edges of the frame. The
same location can thus be shot for a feeling of repose or of unrest.

Lines within the frame can also be used to give a new shape and
proportion to the frame. A cinematographer may shoot through a
doorway to compose the action within the narrow, more vertical
shape of the door. Objects within the scene can be used to block off
portions of the frame, thus changing its effective shape. Mirrors and
windows can also be used to create a "frame within the frame."

A *matte* or masking device may be used directly in front of the

camera lens to change the shape of the frame. The *iris* is a special
kind of matte, which darkens most of the frame except for a small
circular portion in which the desired image appears. This convention
was once popular but is rarely used in contemporary filmmaking.

COMPOSING AREAS. Within any visual composition, there are
certain focal points or centers of interest. In film, they may be points
of intrinsic interest, because of the subject or the visual composition,
or points of dramatic interest, details that have a special meaning in
the film's context. Motion itself can create visual interest, and
bright areas in a dark frame have a strong visual interest. In looking
at a composition, our eyes tend to move from one point of interest to
another, often being led by the subject's compositional lines. These
successive points of interest are sometimes called *eye-stops*.

The arrangement of these points of interest in the frame can cre-
ate a sense of repose and balance, or tension and imbalance. A
central position in the frame contributes to the interest of an image,
and it is also a position of rest. (This effect is less significant in the
close-up or medium shot than it is in a long shot.) Positioning a
point of interest near the edge or extreme top of a frame creates a
feeling of tension and unrest. A glance or movement outside of the
frame also creates imbalance. A point of interest near one side of a
frame can be balanced or weighted by another point on the other
side.

Since we are accustomed to reading from left to right, a move-
ment in that direction seems natural, and the opposite movement
creates tension. Positioning a subject near the left side of a frame
creates tension, since our eyes want to move away from it to the
right.

There is also a psychological component to the upper and lower
portions of the frame. Subjects in the upper portion seem to domi-
nate; they may also make the frame top-heavy, or unbalanced.
Movement upward in the frame seems natural and easy; movement
downward creates a feeling of unease.

OPEN AND CLOSED FORMS. The frame can be used in two basic
ways. First, it may be a window into space, a movable window, like a
periscope or telescope, which can follow action throughout a space
and pick out details and areas within an infinitely extensive space.
Second, it may act as a proscenium arch within which the action
unfolds, a motionless frame that defines the field of action and en-

closes the whole world of our attention, without reference to any action or space beyond the frame. We may call these two styles the *open frame* and the *closed frame*.

Elements that make for an open frame include lines that extend beyond the frame line; diagonal lines; action near the edge of the frame; action that crosses the frame line; forms and figures that are partially cut off by the edges of the frame; the moving camera; sounds and events that occur offscreen. Elements that create a closed frame include lines that echo or run parallel to the edges of the frame; vertical and horizontal lines; action and points of interest concentrated in the central areas of the frame; action completely contained within the frame; forms and figures that appear completely within the frame; the fixed camera; the absence of offscreen events, looks, and sounds.

We must remember that the open and closed forms are not absolutes. Within an essentially closed composition, we still may have a figure that crosses the frame line or an offscreen look. Open and closed forms of course have psychological components. They can be used to reinforce the emotional tone of a scene or to create an emotional contrast with a previous scene. For feelings of imprisonment and claustrophobia, a filmmaker would normally compose in closed forms; and for feelings of freedom and exhilaration, in open forms.

Breaking Down the Action. It is rare (though not unknown) for a scene to be shot in a single long camera take. Usually, the filmmaker will compose a scene out of different shots and different angles. *Breaking down the action* is a way of analyzing a larger action into separate, smaller components, each of which might be filmed in a separate shot or from a different angle. Filmmakers may employ one of several distinct approaches in setting up a scene for the camera.

THE MASTER SHOT. Many filmmakers approach a scene by first shooting a *master shot*—a long, continuous camera take of the entire scene, at an angle wide enough to show the whole setting of the scene and to present all the players in the scene in full or nearly full figure. After the master shot is completed, close-ups, two-shots, and three-shots are taken of individual players, who repeat bits of action or dialogue for these shots. Sometimes the action is filmed simultaneously with several cameras, one of which takes the master shot, and the others the close-ups. In the editing, the master shot carries

the scene, while the close shots are cut in to emphasize or punctuate dramatic moments. The exact balance between mise-en-scène and montage can be determined in the editing after both kinds of shots have been made.

The master-shot technique tends to support the classical Hollywood style of editing, in which a scene begins with a long shot (or *establishing shot*), progresses toward medium shots like two-shots and three-shots, features close-ups at the dramatic moments or climax, and returns at the end to medium shots and long shots.

MULTIPLE ANGLES. Another way of composing a scene is to repeat the action several times, shooting each time from a different angle. Of course, the same scene might be shot simultaneously from several different angles by using a multiple-camera setup. This is frequently done when an action, such as a stunt or an explosion, is difficult to repeat. Whether one or more cameras are used, the different angles may include long shots, medium shots, and close-ups, as well as high and low angles and different points of view. As in the master-shot technique, small bits of action or dialogue may be repeated for extreme close shots.

This approach offers the editor a great deal of flexibility in composing a scene, allowing him to strike a desired balance between montage and continuous action.

SINGLE-SHOT TECHNIQUES. Some filmmakers, including Ernst Lubitsch and Alfred Hitchcock, have preferred to design a precise shot sequence before the shooting stage. This technique calls for many editing decisions before the film is shot. Using diagrams, storyboards, sketches, and architectural plans, the director works out a sequence of shots that will flow together smoothly for the editing. These shots are then filmed one at a time, often out of sequence. The single-shot technique requires precise communication between the cameraperson and the director so that the shots will be correct for editing. In addition, careful notes must be kept of the actors' positions, dress, and pacing, and of the direction of their looks, so that the separate shots will match. The beginnings and endings of actions must be extended to overlap in time so that the editor can find the precise cutting point between shots.

In the single-shot technique, the filmmaker must decide on the use of mise-en-scène or montage before the shooting begins. He may choose an elaborate single moving shot that will present the entire

scene; he may prefer to break down the action into a series of short, individual shots; or he may use both kinds of shots. In any case, the editor will have relatively little choice in the matter; he will simply have to follow the storyboard as it has been photographed.

CONTINUITY. In planning shots, the director or cinematographer always considers how the shots will be edited. In an edited sequence, both editor and cinematographer must observe certain rules of composition in order to maintain the illusion of continuous space and time. On the most basic level, the content elements of a scene must remain consistent from shot to shot. An actor wearing a blue shirt in one shot of a scene can't be wearing a red shirt in the next. The positions of actors and set elements can't be shifted drastically from shot to shot. In addition, such elements as pacing and direction of the action, camera angles, lighting, and sound may all affect the apparent continuity of a scene.

Although the cinematographer and the editor must follow the same rules of continuity, it is the editor who gives final shape to a scene and makes the final decisions that create continuity or discontinuity. (We will deal with continuity in chapter 6.)

DEPTH AND DISTANCE: THE EFFECT OF THREE DIMENSIONS

Although in viewing a film we tend to think of relative distance or closeness to a subject in terms of close-ups and long shots, our awareness of distance is actually more complicated, and includes a sense of the dimension of a space—whether it is relatively deep and extensive or relatively flat and shallow.

Filmmakers and cinematographers make use of a number of techniques to suggest three-dimensionality of screen space. The design and use of lenses, the arrangement of subjects and locations for the camera, the choice of camera angles, the techniques and special effects of lighting—all these factors can affect our perception of depth and three-dimensionality.

Use of the Lens. The principal instrument for composing images in depth is the camera lens. We might, in fact, think of a lens as a device for making a two-dimensional image of three-dimensional space. Although other factors can affect our impression of screen depth, the choice of a lens is critical.

The construction of the lens is simple in principle, although so complicated in practice that modern lenses are often designed by computer. The basic components of a camera lens are the glass lens *elements,* the *diaphragm,* the tube in which the lens elements and the diaphragm are mounted, and the *focus ring,* which allows a slight movement of the lens elements within the tube. The diaphragm is a circular device made of overlapping metal leaves, which can be opened or closed to control the amount of light that passes through the lens. The actual opening is called the *aperture,* and its size is measured in *f-stops.*

The *focal length* is a basic design characteristic of a lens and determines both its angle of view and the size or magnification of the projected image. A lens of long focal length has a relatively narrow angle of vision and will greatly magnify a distant subject, making it appear quite close on the screen. A lens of short focal length has a wide angle of vision and does not magnify the subject.

Focal lengths of lenses are measured in inches or millimeters. A 50mm or two-inch lens is considered a normal medium-length lens in the 35mm format. In the 16mm format, the projected image on the film plane needs to be smaller, to fit within the smaller frame size. Accordingly, a range of smaller focal lengths is used than for 35mm cinematography, and an equivalent "normal" lens for 16mm use would be 25 millimeters, or one inch long.

A lens of fixed focal length is called a *prime lens.* In order to vary the image size on the film plane, cinematographers have traditionally made use of a collection of different prime lenses of different focal lengths. One lens would be chosen for each shot; to vary the image size, the cinematographer would have to use a different prime lens, or move the camera. A long lens, or *telephoto lens,* would be used for great magnification or to bring a distant subject nearer. Prime lenses make sense only when the cinematographer has time to stop and carefully set up each shot.

Many films today are shot with *zoom lenses.* These are complicated lenses made of many separate lens elements, which allow the cinematographer to change the focal length by turning a ring or crank on the side of the lens. The focal length can be changed very quickly, either to set up a shot or, even during a shot, to change the size of the image projected on the film plane.

There are many instances in which a camera position is imposed

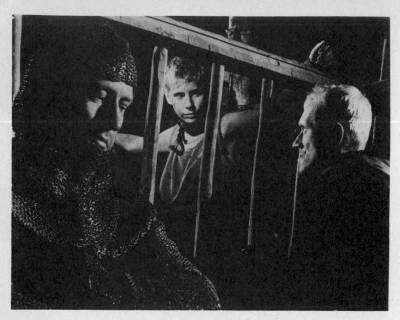

Again from *The Seventh Seal*, the knight speaks to the young woman who has been accused of witchcraft, while a guard stands by. The young woman dominates the frame because of her position in the upper central portion and because of the frontal angle. Although the soldier in the foreground is the larger figure, we do not engage his glance, and our eye is carried by the diagonal of the cart to the knight, whose glance we follow back to the young woman. The composition is perfectly balanced and closed by the two figures of the soldier and the knight, but the diagonals give a feeling of unrest to the confining space. (This is low-key lighting.)

on the cinematographer and the choice of focal lengths is his only means of creative control of the frame and what is in it. In *Man of Aran*, Robert Flaherty used extremely long lenses to film scenes of a small boat at sea simply because he could not practically get any closer to the action.

A cinematographer shooting in a small room will be forced to use relatively wide-angle lenses if he wants to get even a medium shot of the action. A documentary-film maker whose mobility in a location is limited, who can't stop the action to change lenses, and who can't move closer to the action without unduly affecting it, must rely on the changing focal lengths of the zoom lens in order to create varied compositions.

Focal Length and Depth. The other important reason for using

lenses of different focal lengths has to do with the way lenses create the illusion of three-dimensional space on a two-dimensional film plane. If we look at the kinds of images projected by wide-angle lenses and by telephoto lenses, we find that they create very different impressions of depth of space. In general, we might say that the long lenses tend to *flatten* depth, while the wide-angle lenses tend to *exaggerate* the impression of deep space.

Wide-angle lenses tend to exaggerate the convergence of parallel lines in the distance, and therefore exaggerate our sense of depth. In an extreme wide-angle lens, this exaggeration is so great that straight lines actually appear to curve as they approach the camera position. Wide-angle lenses also exaggerate the difference in image size between objects that are near the camera and those farther away. Close objects appear much larger than they would in our field of vision, and distant objects appear proportionately smaller.

When a wide-angle lens is used, the effect of these two exaggera-

In this production still from Mike Nichols's *The Graduate* (1967), we can see the effect of a wide-angle lens: exaggeration of depth through the increased convergence of parallel lines, and the extreme difference in image size between foreground and background figures.

tions is to increase our impression of depth and to separate figures in the foreground from figures in the background. When viewed through a wide-angle lens, the distance across a room will appear to be much greater than it actually is. In most cases the exaggeration is not noticeable, although it is sometimes used for effect. With a wide-angle lens, if a character reaches toward the camera, his hand may appear to grow huge and out of proportion to the rest of his body. If he leans toward the camera, his head will seem large compared to his body; his nose and forehead will bulge grotesquely. The extreme wide-angle lens (sometimes called a *fisheye lens*) also exaggerates movement; movements toward or away from the camera appear to be speeded up, since they are crossing a greater apparent distance.

Telephoto lenses and long lenses in general have the opposite effect of flattening or compressing space. They tend to *reduce* the convergence of receding parallel lines and also to reduce the difference in image size between objects closer to and farther from the camera. As a result, objects that are actually at a great distance from each other in depth can appear to be about the same size and quite close together. This compression can be rather subtle or, in the case of extreme telephoto lenses, quite exaggerated. Filmed with a telephoto lens, people on a crowded sidewalk seem to be pressing against each other and to be almost jostling in place rather than moving toward or away from the camera. In the final sequence of *The Graduate,* Dustin Hoffman is filmed running along the side of a road after his car has run out of gas. The telephoto lens makes him appear to be running in place no matter how hard he runs, reinforcing our sense of urgency and frustration.

"Normal" lenses, of course, exaggerate depth the least—that is, they come closest to reproducing space in the way that the lenses of our eyes do.

Depth of Field. There is another way in which lenses can affect our perception of three-dimensional space, and that is in their ability to selectively focus on objects at different distances from the camera.

Actually, our eyes do the same kind of focusing at different distances, but so quickly that we don't notice. As we glance back and forth between near and distant objects, our eyes change focus so rapidly that our entire field of vision appears to be "in focus."

A lens, as we have noted, can be focused at different distances by adjusting the focus ring, which causes the lens elements to move very slightly within the tube. There is another part of the lens that affects focus, however, and that is the *diaphragm,* the opening at the rear of the lens, which can be made smaller or larger to let more or less light pass to the film plane. (The f-stop setting indicates how much the diaphragm is opened or closed.) A secondary effect of opening or closing the diaphragm is to alter the range of focus of the lens. The particular range of focus that is affected by the f-stop setting of the aperture is called *depth of field.*

"Depth of field" can be defined as the range of distance in front of the camera and its lens throughout which objects are in apparent sharp focus. If a given camera lens, set at a given f-stop, is focused on an object ten feet away, there is a certain distance closer to the camera, say as close as seven feet, and a certain distance farther away, say up to fifteen feet, in which other objects will appear to be in acceptably sharp focus. Closer than seven feet, and farther than fifteen feet, objects will appear blurred. On the screen, the effect is to emphasize or select out this area, from seven to fifteen feet, and to concentrate our attention within it, since only within this area do we see sharp images. In effect, the depth of a field represents a kind of framing device within the three-dimensional space.

Depth of field is affected by several factors, including the focal length of the lens, the aperture, the distance at which the lens is focused, and our definition of acceptably sharp focus.

CIRCLES OF CONFUSION. The standards for acceptably sharp focus, which vary with the film format (16mm, 35mm, or 70mm) and with the conditions of projection, are defined in terms of the maximum size of what is called a "circle of confusion." The image of a small dot or point in space, when filmed and projected, tends to be seen as a circle if it is blurred or out of focus. The more blurred the image, the larger the circle of confusion. A circle that is small enough to fit within the standards of sharpness will actually be perceived as a point.

DISTANCE OF FOCUS. The distance at which the lens is focused affects depth of field by affecting how shallow or how deep is the range of acceptable sharpness. A lens focused at a distance very near to the camera position will have a relatively shallow depth of field. As the lens is focused at greater distances, the depth of field

increases, until the far limit of focus reaches infinity. This proportion is true of all lenses within a certain range of focal lengths: The nearer the lens is focused, the shallower the depth of field; the farther it is focused, the deeper.

FOCAL LENGTH. The focal length of the lens also affects depth of field. Telephoto lenses and long lenses tend to have a relatively shallow depth of field; whereas short lenses and wide-angle lenses have a deeper range. A telephoto lens set at a certain f-stop and focused at a certain distance might have a depth of field of only a few inches. A wide-angle lens set at the same f-stop and focused at the same distance might have a depth of field of many hundreds of feet. Some wide-angle lenses have so great a depth of field that they are not even provided with focusing rings! They are essentially in focus for any distance a cinematographer might normally use. A zoom lens takes on the characteristics of whatever focal length it is set at.

APERTURE. The final factor that affects depth of field is the

The effect of a telephoto lens, in Peter Yates's *Breaking Away* (1979). Deep space is compressed and flattened, and the figures of the cyclists in the background seem nearly the same size as those in the foreground. There is little or no separation in depth between the cyclists who are grouped together.

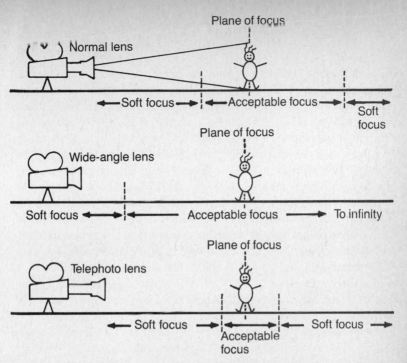

Depth of field: Only those subjects that lie in the *plane of focus* will be in the sharpest possible focus for the lens; *depth of field* refers to the range of acceptable focus on either side of the plane of focus. Note that the range of acceptable focus is somewhat greater in the direction away from the camera than in the direction toward the camera. Telephoto lenses generally give a narrower depth of field, whereas wide-angle lenses may provide such deep focus that the whole range of vision from a few feet in front of the camera to infinity is acceptably sharp.

aperture of the lens, the amount of opening of the diaphragm. A large aperture (and a smaller f-stop setting) causes a relatively shallow depth of field; a small aperture (and larger f-stop) causes a much deeper one. For a given focal length, then, and a given distance setting, we can vary the depth of field by opening up or closing down the diaphragm. Cinematographers may consult depth-of-field tables for different focal lengths of lenses; these tables plot the depth of field in terms of the f-stop and the distance at which the lens is focused.

COMPOSING THE IMAGE IN DEPTH. All these factors that affect depth of field provide the cinematographer with a rather sophisticated set of tools for creating aesthetic affects. As we have said, depth of field acts as a kind of framing device in three-dimensional space.

The cinematographer may choose to limit the depth of field in

order to confine our attention to one plane of focus. The effect on the screen might be to focus our attention on a subject, say two lovers embracing, while objects in the foreground and background are slightly blurred. This kind of composition will reinforce our sense of the emotional obsession of the two lovers with each other, and their obliviousness to their surroundings. Sometimes a shallow depth of field is used in a more obvious way. The cinematographer might *pull focus* from a figure in the background to a figure in the foreground, so that first the background figure is sharp and the foreground figure blurred, and then the reverse. A shallow depth of field is thus being used as a means of directing our attention from one subject to another. This technique is also called *rack focusing.*

Cinematographers can also make use of an extended depth of field, called *deep focus,* as an aesthetic device to expand our perception of depth and to establish connections between foreground and background. In deep focus, all objects from close foreground to extreme background are seen in equally sharp focus. Orson Welles's *Citizen Kane* is celebrated for its deep-focus effects, created by cinematographer Gregg Toland. In this film, deep focus is used in several ways. In the banquet scene, an oversize dining table stretches from near foreground to deep background, laden with sumptuous dishes and lined with guests. Here the magnificence of Kane's generosity is suggested by the exaggerated length of the table, extending in depth.

In another scene shot in Kane's mansion, Xanadu, we see Kane's head in the foreground, and across the vast distance of the room we see in the background his wife Susan working on a jigsaw puzzle. The deep-focus photography keeps both figures in sharp focus, and suggests a spatial metaphor for their emotional distance and separation from one another.

In other scenes of the film, deep focus is used to connect images and people, or to suggest a background presence that affects a foreground event. In a significant flashback, we see in the foreground Kane's mother and father talking with the banker Thatcher, and through a window we see the boy Kane outside playing in the snow. Here, deep focus allows us to see Kane, the subject of the conversation, and thus to connect the speakers and the boy. At the same time, the framing device of the window and the fact that the boy is playing alone in the cold snowfall suggest his emotional isolation.

Deep focus is related to mise-en-scène, because it allows the action to take place in a single frame and a single shot rather than throughout separate shots in a montage. Since the lenses are stopped down to a higher f-stop in order to increase the depth of field, thus reducing the aperture and the amount of light that passes to the film plane, a very high level of lighting must be used throughout the scene. Deep-focus shots are therefore more easily executed outdoors in sunlight. (The deep-focus photography of *Citizen Kane* is remarkable in that so many of the scenes are interiors.) Faster film stocks and high-intensity lighting fixtures have made deep focus more technically feasible.

(The terms "depth of field" and "deep focus" should not be confused with *depth of focus,* which is a technical term referring to the distance from the rear element of a lens to the film plane of a camera on which the lens is mounted. The depth of focus has to be adjusted to very close tolerances, on the order of thousandths of an inch, but these adjustments are made in the shop and are not part of the filmmaker's or cinematographer's daily practical concern.)

CREATING DEPTH THROUGH MISE–EN–SCÈNE. A number of techniques are used to overcome the essential flatness of the movie screen. Many of these are based on the arrangement of the subject in space for the camera—what we call "mise-en-scène."

A visual composition that has diagonal lines receding into depth gives a much greater sense of deep space than does a composition in which the lines are horizontal or vertical and parallel to the edges of the frame. The arrangement of people or objects at successive distances from the camera can reinforce an impression or spatial depth and our sense of separate planes of action. Objects thus placed can serve as points of reference for movement in deep space when no other clues exist in the scene. A scene may be lit with pools of light at different distances in depth, creating *planes of action* and points of reference through the lighting. The camera can frame the action so as to include a branch of a tree or some other object in the extreme foreground, or with an object partly obscuring the main subject, so as to give a sense of space between the observer and the subject. (Movement of the camera or of the subjects in space is of course another means of creating the impression of depth, but we will deal with this technique in a later section.)

Mise-en-scène can be used for some striking and extreme spatial

effects. In *Stagecoach,* John Ford creates a sense of deep space by using almost every clue to depth perception except binocular vision. In long shots taken with a wide-angle lens, we see a road extending diagonally into the frame, with great rock formations providing points of reference at different distances in space. The shots are in daylight and deep focus, and the tiny size of the stagecoach on the road is a further clue to its great distance. Halfway along the road, it represents a plane of action that exists at a great distance from our point of view, but still not anywhere near the limit of the horizon.

In *La Chinoise,* Jean-Luc Godard sometimes uses mise-en-scène to deliberately flatten the space. Subjects are photographed against a plain white wall, with no diagonals, points of reference, or foreground objects to suggest space or indicate distance from the cam-

Deep focus cinematography in Alfred Hitchcock's *North by Northwest* (1959). The fathers of our country appear to be eavesdropping on the conversation in the foreground.

era. Godard may suggest offscreen space by having objects or people enter and leave the frame, but they do so within a single plane of action. Sometimes there is writing on the wall, which emphasizes the flatness of the surface. The effect is to make us aware of the scene as part of a film, by calling attention to the flatness of the movie screen, as well as to suggest a feeling of entrapment, of being hemmed in. The flatness of the space is perhaps also a reference to the abstract and one-dimensional nature of some of the political ideas that are discussed.

COMPOSITION OF MOVING IMAGES

Movement—whether we perceive it as movement in space or simply as the motion of images succeeding each other in time—is the essential phenomenon of film. Even a film made of a succession of still images exhibits motion at each edit point (the moment when one image replaces another). The fact is that we cannot really perceive film as film unless the strip of film stock is itself actually in motion, winding its way through a projector or a Moviola.

The Psychology of Motion. All appearance of movement in film is created by projecting a succession of separate still images on the screen. The appearance of movement in space is really a perceptual illusion based on two psychological principles.

The first is the *phi phenomenon,* which is the psychological sensation of movement created when one still image rapidly replaces another on the screen, with a slight shift in position. We can demonstrate this effect by projecting a dot of light in one position on a screen, then removing the first dot and simultaneously projecting a second dot in another position on the screen. Instead of two separate dots, what we see is a single dot that appears to move between the two positions.

The second phenomenon is called *persistence of vision.* It allows us to see a succession of separate images, interrupted by short intervals of time, as one continuously appearing image. In effect, there is a time delay between the perception of an image by the eye and by the brain. We continue to see an image for a short time after it has been physically removed. If a new image replaces the first before the perceived image has had time to decay, we are not aware of any interruption. If the separate images are projected at the rate of at

least sixteen frames per second, persistence of vision creates the effect of a continuously appearing image. (In fact, when we are watching a movie, we are sitting for half the time in total darkness, since the shutter cuts off light to the screen while each new frame is moved into place. During this time, we are watching afterimages retained by our own brains.) There is still a slight flicker effect at sixteen frames per second, which is reduced in modern projectors by having each frame projected twice, interrupted by a moment of darkness. The higher projection speed of twenty-four frames per second, which is now standard, also reduces the flicker effect.

Varieties of Motion. There are really two kinds of apparent motion in space: the apparent motion of images within the frame and the apparent motion of the frame itself. Both kinds of motion depend on the same psychological principles and mechanisms to exploit them. The movement of the frame also requires that the camera be physically moved in space or that a zoom lens be operated during the shot.

MOVEMENT WITHIN THE FRAME. Filmmakers and cinematographers can compose movement within the frame in the same way they compose with other design elements. Movement in the frame, in fact, is always closely related to the cinematographer's compositional choices, including composition within the shape of the frame, composition through camera angles, and composition in depth.

Movement is often a center of interest within the frame, whether of intrinsic interest because of the energy of motion or of dramatic interest because of the meaning or implications of the motion. Movement within the frame can be large and obvious, like the passage of a train across the screen; or delicate and subtle, like the rustling of leaves in a tree. In a close-up, a small movement may appear greatly magnified.

The *direction* and *angle* of movement in the frame follow rules similar to those governing the composition of fixed elements. Diagonal movement seems more energetic than movement parallel to the frame edges; movement from left to right (in most Western cultures) seems to meet with less resistance than movement from right to left. Movement near the edges of the frame creates a greater sense of tension than does movement in the center of the frame. Movement downward in the frame seems ominous; movement upward creates a feeling of lightness and ease.

Movement can reinforce a sense of *closed* or *open* space by being contained within the edges of the frame or by crossing frame lines. Movement in and out of the frame creates an awareness of space beyond the frame. Movement across the frame line can create surprise by breaking an apparently closed space and opening it to intrusion, perhaps revealing an unsuspected presence.

Camera angle affects the direction of movement in the frame. The same movement might be horizontal or diagonal in direction and might go from right to left or left to right, depending on which camera angle is chosen. Camera angles and close-ups can be used to reveal to the audience certain movements that are hidden to some of the players in a scene, thus building a dramatic tension.

High angles tend to de-emphasize the importance of movement, whereas *low angles* tend to exaggerate it. This is so partly because of the differences in background and setting between high and low angles, partly because in a low-angle shot, movement is placed higher in the frame, where it calls more attention to itself.

Different *focal lengths* of lenses create very different impressions of movement in depth. The *longer lenses,* which flatten space, also reduce the effect of movement toward or away from the camera. The *wide-angle lenses* tend to exaggerate movement in depth; an object moving toward the camera seems to pick up speed and energy when filmed with a wide-angle lens.

Depth of field also affects movement toward or away from the camera. A relatively *shallow* depth of field causes subjects to become blurred as they move out of the plane of focus, and therefore to lose some intrinsic and dramatic interest. Often, the cinematographer will *follow-focus* a moving object—that is, change the focal plane of the lens as an object moves toward or away from the camera in order to keep the object in sharp focus and to keep the audience's attention on it.

In *deep focus,* a moving subject will stay in sharp focus as it moves toward or away from the camera and will thus retain our interest. Deep focus also permits a movement in the extreme background of the scene to be seen sharply and clearly, and play an important dramatic role.

Movement as part of mise-en-scène may be used to reinforce a sense of *spatial depth*. A subject that moves from background to foreground can tie together different planes of action in a scene so

that we perceive them as continuous space. It can also provide a kinetic sense of depth of the scene, since the figure will appear to grow larger as it approaches the camera.

Mise-en-scène and camera angle can be used together to reinforce the feeling of depth in a scene. If a subject moves toward (or away from) the camera along a diagonal, the feeling of depth is much stronger than that produced by a straight-line movement toward the camera. In fact, this movement toward or away from the camera is also the hardest one to invest with kinetic energy. A movement across the screen from right to left usually covers more actual distance on the screen, and therefore it seems more energetic and faster. (A wide-angle lens can of course be used to exaggerate the sense of movement in depth.)

MOVING THE FRAME. There are three important techniques for moving the edges of the frame in relation to the subject: masking or optical printing; zooming; and moving the camera itself.

A *mask* or *matte* can be used to actually change the shape of the frame during a shot. An early form of masking was the *iris* technique, implemented by placing a mask directly in front of the camera lens in order to block off part of the image. For the *iris in,* the outer portions of the image would be darkened, leaving a circular image area that could be tightened or contracted to focus our attention on one small portion of the image area. An *iris out* would begin with this small circular area and expand its size until the whole area of the frame was revealed. Iris effects and other matte effects are now created not in the camera but in the optical printer, which can generate a great variety of iris and other frame shapes, including keyholes, binocular effects, split screens, grid patterns, and the like. Any of these new frame shapes can move in relation to the subject, and in fact several subjects can be combined within different divisions of the frame's basic rectangle. In the *wipe* effect, we see the right or left edge of the frame move laterally across the screen, so that one image seems to push the other off the screen.

The *zoom* can be used to expand or contract the frame in relation to the subject. Changing the focal length of a zoom lens during a shot can make the subject appear larger or smaller within the frame and can expand or narrow the angle of view. Since the focal length changes, the depth of field and the illusion of depth of space also change during the shot. A *zoom in* to a longer focal length flattens

space; a *zoom out* to a wider focal length deepens it. The zoom in also decreases depth of field, whereas the zoom out extends it. Most often, however, the zoom is used simply as a convenient way of quickly focusing our attention on a detail of larger image (the *zoom in*), or of revealing the larger context of a detail (the zoom out).

Perhaps the most important means of moving the frame is simply to *move the camera,* either by hand or with a tripod head, dolly, or other device. A tripod head can be moved either horizontally to the right or left or vertically in an upward or downward direction. The horizontal movement is called a *pan,* and the vertical movement a *tilt up* or *tilt down.* The two movements may be combined so that the camera tilts up or down at the same time that it pans right or left. The terms "tracking shot," "dolly shot," "traveling shot," and "trucking shot" all refer to a shot in which the camera is moved horizontally through space. Although a dolly can lift or lower a camera a few feet, a *crane shot* is any shot during which the camera moves vertically in space through a greater distance than is possible with a dolly. Although a number of these terms apply to special equipment and camera mounts, many of the same movements can be effected with a hand-held camera, and in this case the same terms are applied. Thus we can speak of a hand-held camera that pans, tilts, or even tracks or travels through space. Several movements can be combined within a single shot, so that the camera might perhaps track and pan at the same time, then begin to tilt up while the panning movement continues and the tracking movement stops.

There is an important difference between the tracking shot and the zoom shot. Although a zoom in and a track toward a subject might both make the subject appear larger in the frame, the spatial effect is quite different. As the lens *zooms in,* the focal length is increased, space is flattened, and depth of field contracted. Objects between the camera and the subject will be thrust out of the frame by the narrowing angle of vision, and objects behind the subject may either disappear into a blur, because of the shallower depth of field, or appear to be quite close to the subject, because of the flattening of space. *Tracking* toward a subject while maintaining the same focal length will have a quite different effect. Since the angle of vision remains wide, we are aware of passing other objects as we move through space toward the subject, and thus we have a more

vivid sense of spatial depth. As the camera draws near, the subject appears larger in the frame, but the surrounding space appears different from that in the zoom shot. Because space is not flattened, objects behind our subject will appear at a more normal distance. They are more likely to appear in sharp focus, since the depth of field has not decreased.

The zoom can be combined with tracking shots, pans, tilts, and other movements to create a complex and subtly shifting sense of space. A zoom combined with a pan seems a much smoother and more natural movement than does a simple pan or zoom alone.

Composition by Camera Movement. The camera can move continually throughout a scene, focusing on different players, ascending or descending to view the action from different angles, tracking a moving subject and then coming to a halt on another element in the scene, moving closer or farther from the scene, zooming through different focal lengths, penetrating or circling through space. In fact, almost any composition that can be framed by the camera can be reached by moving the camera rather than by taking a separate shot, and thus compositions can be changed throughout the course of a shot.

Some directors and cinematographers use the moving camera throughout their work; others prefer to save camera movements for special moments or for special cases, like tracking a moving subject. Some directors, including Yasujiro Ozu, have developed highly refined and subtle visual styles with a stationary or rarely moving camera.

As a compositional device, camera movement can connect images and build their impact in a more subtle way than is achieved simply by cutting. It can also allow a gradual change in perspective, as when the camera pulls back from a close shot of two players to show them lost in an immense space. Used as a part of mise-en-scène technique, camera movement can create a flowing together of spaces, players, and events to evoke a feeling of unbroken time and space, a fluidity of life, and even a kind of inevitability of events.

Altered Rates of Motion. We are all familiar with the two most common variant forms of motion: slow motion and fast motion. *Slow motion* is achieved by photographing an action with the camera running at a faster-than-normal speed. When the footage is projected at a normal twenty-four frames per second, the action ap-

pears slowed down. Slow motion is often used for a lyrical effect, and it can turn normal actions into dance movements. Sam Peckinpah has used slow motion to give a sense of arrested time in the middle of a fast action scene: For example, he likes to have his gunfighters fall to the ground in slow motion. The same technique can prolong an explosion or bridge collapse, so that we see the details of flying objects; the event is thus made to seem inevitable and inexorable. High-speed cameras, which are capable of exposing hundreds of frames per second, are sometimes used in scientific films for analysis of very rapid events.

Fast motion is achieved by the reverse technique: photographing an action with the camera running at a slower-then-normal rate. When projected at normal speed, the action appears speeded up. Fast motion can be used for comic effect, mimicking the movements of the silent comedy players. One type of extreme fast motion is called *time-lapse photography,* because single frames of film are exposed at intervals of seconds, minutes, or even hours. Extreme fast motion can create a strange new world: We may see clouds scudding by at an incredible rate, swirling and unfolding; we may watch a building being built or torn down in a minute; we can watch a flower unfolding into bloom.

Normal motion can also be slowed down or speeded up after the shooting on an optical printer, by skipping frames or printing frames several times. This process is called *step-printing.* A kind of extreme slow motion can be built up of separate images, each a few frames long and each representing a slightly different stage of an action. The effect is like a succession of still frames. Another kind of "slow motion" can be created by dissolving between actual still frames, each of which represents a different stage of a scene.

LIGHT AND SHADOW

In the strictest sense, what we experience as the film image is actually the shifting pattern of light and shadow on the screen. Whether it shapes light and shadow into recognizable forms or into abstract patterns, the strip of film is in fact a way of modulating a beam of light. Our experience of the film image is defined by the modulation of light energy, just as our experience of music or the spoken word is based on the modulation of sound energy. The camera, the lens, the

film stock, and all the other tools and materials of cinematography are simply means of recording and shaping patterns of light and shadow.

From the very first, filmmakers have paid special attention to the evocative power of light, whether as a means of reinforcing mood or symbolic effect or as a subject in its own right and for its own sake. Some contemporary filmmakers, including Stan Brakhage in his *Text of Light* and Tony Conrad, Paul Sharits, and Peter Kubelka in their "flicker films," have explored the purest and most basic relationships of film and light. Other filmmakers and cinematographers use light to serve a setting or story, to "paint" an image, or to suggest nuances of emotion and meaning within the basic mise-en-scène.

Tools of Lighting. To record an image, the cinematographer needs enough light on his subject so that light will be reflected into the camera lens and activate the photosensitive chemicals of the film stock. To achieve this, he must be concerned with such practical matters as having a source of light, a way of measuring the intensity of the light, and a way of controlling the amount of light that falls on the film stock. He must also take into account the variations in reflectivity of different subjects.

SETTING AND EXPOSURE. The cinematographer uses two types of *light meters* to measure the intensity of light. The *incident meter* measures the amount of light actually falling on the subject. A *foot-candle meter* is a special type of incident meter that measures light intensity in terms of a standard unit of light energy. The other type of light meter, a *reflected-light meter,* is directed toward the subject to measure the intensity of light after it is reflected from the subject.

The cinematographer then refers to a special set of tables, or to the light meter itself, to determine the optimum exposure rating for the film stock being used, in terms of the *f-stop* or *aperture* of the camera lens. Sometimes a specific f-stop setting of the lens is desired, because the lens is sharper at some apertures than at others or because a certain depth of field is necessary, or simply to get an exposure. In this case, the cinematographer can choose a film stock with the right *speed,* or sensitivity to light, to give him the desired aperture. He can also place a *neutral-density* filter in front of the lens to decrease the amount of light falling on the film while maintaining the same aperture.

The amount of light coming from the light sources may have to be decreased or increased. In the studio, this is a matter of adding or removing light sources or of using light sources of different intensity. In fact, a cinematographer in the studio has so much control over light sources that he can specify a given f-stop and ask the lighting crew to light the set to the appropriate foot-candle level.

LIGHT SOURCES. Practically speaking, there are two basic kinds of light sources: *available light* and *artificial light*. Available light includes natural light such as sunlight, skylight, firelight, and whatever artificial lights are a given part of a setting, such as streetlights, car headlights, or existing interior lighting. A documentary cinematographer shooting inside an office might find the available light to consist of daylight from a window mixed with artificial light from the overhead office lighting fixtures. A sports photographer might find the available light at a night football game to consist solely of the floodlights on the field. Artificial light to a cinematographer means also the use of light sources specifically set up for filming. Light sources specially designed for photography are called *luminaires*. They range in size and intensity from the portable, battery powered *sun gun,* which can be attached to a hand-held camera, to the 10,000-watt *Brute,* which can illuminate a large studio area.

Luminaires are of two basic types: the *spot* and the *flood*. Spot-type lights produce a relatively narrow, well-defined beam of light that casts a distinct, hard-edged shadow. Spotlights usually have glass lenses to focus the beam, as well as special focusing reflectors within the luminaire. Floodlights create a broad, diffuse pattern of light, cast softer shadows, and are used to illuminate a large area. They are designed with some kind of reflective surface behind the lamp, which broadcasts the light without focusing it.

Luminaires come in many sizes and in a wide range of intensity of light output. The earliest luminaires were *carbon arcs,* which generated a bright white light from the spark of electricity that jumped between two electrodes. Modern *quartz halogen* lamps contain a filament within a gas-filled quartz envelope and produce a great intensity of light for their small size. '

OTHER LIGHTING TOOLS. In addition to luminaires, there are many devices available for shaping and directing light. Lights can be equipped with *barn doors,* which look like a set of shutters around the opening and can be adjusted to cut off light from por-

tions of a scene and direct it to a specific area. *Flags* are like large shutters that can be mounted on stands and placed between the light source and the subject to put certain areas in shadow. A *snoot,* or funnel, can be placed on a luminaire to narrow its beam. A *cookie,* or *cukaloris,* is a sheet of opaque material with openings cut out to cast a pattern of light and shadow.

There are also various types of *scrims* and other diffusing materials that can be placed in front of a luminaire to soften the light and sometimes reduce the intensity. *Reflectors,* broad sheets of reflecting material, can be strategically placed to cast light into the shadow areas of a scene, reflecting either natural or artificial sources.

Techniques of Lighting. Cinematographers use lighting to suggest the mood and meaning of the film image in three basic areas. The first area is the *contrast range* from light to dark, which is affected not only by the reflectivity of the subjects but also by the relative intensity of the lighting in different parts of the scene. The second area is the *direction of lighting* within the scene, relative to the camera position. Different directions of lighting can create suggestive, evocative, and visually striking effects as well as simple, naturalistic ones. The third area is what we might call the *texture* of the image. Hard, spotlike lighting can create crisp edges, distinct shadows, and clearly outlined details within the image. Diffuse, floodlike lighting gives a softer texture to the image, de-emphasizes shadows, softens edges, and emphasizes broad washes of tones.

CONTRAST EFFECTS. Control of lighting contrast can create some of the cinematographer's most striking effects. In *high-key* lighting, a scene is given an overall high level of illumination, whether by the natural light of the sun or the sky or by luminaires. There is not much contrast between light and dark areas of the frame. The lighting is relatively shadowless, and what shadows exist are not dark and do not hide details. High-key lighting is used extensively in comedies, and in other films when a mood of optimism, joy, or excitement is desired.

In *low-key* lighting, there is a greater contrast between light and dark, with few tones between. The overall scene appears in darkness and deep shadow, with distinct pools of light or with just enough edge light so that we can distinguish subjects, perhaps only in sil-

houette. Details are lost in the deep shadow. The emotional effect is mysterious, and may be threatening or ominous.

In *high-contrast* lighting, the scene is more evenly balanced between light and dark, and ranges in tone from bright highlights to deep shadows. A high-contrast scene can display many shades of gray from light to dark. It may also emphasize only the lightest and darkest shades, with few middle tones. The emotional effect lends itself to tragedies and melodramas. *Low-contrast* lighting means a relatively even overall level of illumination: There are no extremely light or dark areas; and the range of tonalities, of shades of gray, is limited. The effect is calm, sometimes melancholy or oppressive.

The contrast and variations of intensity of light in a scene can be controlled through the use of luminaires and other lighting equipment. Even natural and available light, however, provides some opportunities for creative lighting effects. Scenes shot in direct sunlight in midmorning or midafternoon tend toward high contrast, with brilliant highlights and deep shadow areas. Scenes shot at dawn, dusk, or on a dark and overcast day, using the diffuse skylight as a source, tend toward lower contrast and a more limited range of tonalities. Scenes shot at night, using available streetlights as a source, tend toward *low key,* with pools of light and lighted silhouettes. The light from an overcast but bright sky tends toward a *high-key* effect, with an even level of illumination, few shadows, and a full range of tones.

DIRECTIONAL EFFECTS. The directional control of lighting is an extremely sophisticated technique that balances light coming from different identifiable directions against general, nondirectional levels of illumination. The directional control of lighting allows a kind of sculptural modeling of a subject and a scene. The play of light and shadow can give a sense of the three-dimensionality of subjects and of varying surface textures. There are a few important technical terms that describe ways to control the direction of lighting.

Base lighting is a general, relatively low level of diffuse, nondirectional light that illuminates an entire scene or set. It raises the overall light level of a scene without having any distinct modeling effect.

Key lighting is the strongest modeling light (that is, the source of the highest intensity), which creates the effect of light falling from a specific direction. The key light (or lights) is often positioned so as

to imitate the effect of some natural source of light, such as daylight streaming through a window, or of artificial light in the scene, such as that cast by a bedside table lamp. In fact, the lamp in such a scene might well be a *practical*–that is, a fixture illuminated just enough from within to give a natural look, while the true key light is set up outside the compositional frame.

The key light tends to produce strong shadows, and thus gives a three-dimensional effect to a scene. Spot luminaires are often used for the key light. They are usually positioned fairly high so that light falls downward at an angle toward the subject. The key light can be used to emphasize centers of interest within the frame and to create contrasts between highly illuminated subjects and those in shadow.

The *fill light* is a source of relatively diffuse illumination that is added to the key light to fill in and soften shadows and to illuminate details in the shadow areas. One or more flood luminaires may be used for the fill light. The ratio of the key light plus the fill light to the fill light alone, as measured by a foot-candle meter, is called the

High-key lighting in Michael Kurtiz's *Casablanca* (1943). The Café Americain is brightly and evenly lit from the foreground to the far wall.

Low-key lighting in the same establishment. Bogart and Bergman are brightly lit, but the background drops off into silhouettes and shadows. The shallow focus further separates the figures from the background; they are crisp and sharp while the shadows are soft and blurred.

lighting ratio, and is one way of controlling the contrast range of the image.

The *backlight* is a source of illumination placed high above the subject to light the subject from behind, relative to the camera position. The backlight illuminates the edges of the subject and, if it is intense enough, can create a kind of halo effect. By illuminating the edges, the backlight tends to visually separate a subject from the background, emphasize its shape, and suggest a sense of depth. A backlight can be used independently of front illumination to create the effect of a silhouetted figure whose shape is outlined with light and whose face and body are in shadow.

Set lights are sources positioned to illuminate the background areas of a scene. They can erase shadows cast by subjects in the foreground and illuminate details of the background. By using flags, cookies, and luminaires, patterns of light and shadow can be cast on the background to increase visual interest and to evoke a mood.

Shadows may imitate realistic elements, such as the patterns of ve-
netian blinds or window bars. The lighting of the set can in fact
become part of the set design itself, and patterns and shadows be-
come a kind of painting with light.

Natural light and available light can also be used for directional
lighting. Direct sunlight creates a strongly directional key light,
while general skylight acts as a fill. A subject can be backlighted by
shooting toward the sun, which is behind the subject. Sometimes
filmmakers improve on nature by using large reflector sheets to fill
in shadow areas outdoors.

TEXTURAL EFFECTS. The textural quality of lighting is usually
described as *soft* or *hard*. Spot sources and direct sunlight produce
hard lighting, with distinct shadows and crisp edges; flood and dif-
fuse sources produce a softer effect, with edges of shadows and
subjects not so sharply outlined. The soft or hard quality of the
lighting is also related to the contrast range of the images. Subjects
of limited tonal range, with middle tones of gray, appear softer than
subjects with deep blacks and brilliant whites.

The texture of light is controlled primarily through the choice of
luminaires. If the key light is a spot, its focused beam produces a

A powerful backlight with little front fill creates a high-contrast effect and an eerie
mood in Stanley Kubrick's *A Clockwork Orange* (1971).

hard effect. If the key light is a powerful flood, it produces a softer, more diffuse effect. As noted earlier, scrims and diffusing materials can be used to soften the light of luminaires.

Styles of Lighting. Controlled lighting can give an emotional tone or feeling to a scene, or to a figure or element within a scene. It can also be used to emphasize certain elements of a scene and to create a kind of symbolic subtext. Light and darkness have strong emotional and symbolic overtones, which can be exploited from scene to scene or within a single shot.

Even before any action has occurred, high-key or low-key lighting gives us a feeling for a scene, and may contrast it with adjacent scenes. Or within a single shot, one character may be modeled in bright tones and another in shadows and dark tones to suggest something about their individual characters or their emotional or dramatic situations.

The contrast range of a shot can also evoke mood and meaning. A high-contrast image, with many jagged edges of light and shadow, can evoke a sense of energy or unrest. A low-contrast image, composed of a few shades of middle tonality, can convey a feeling of calmness and repose.

Cinematographers may bring individual styles to the lighting of a film. Some are better at a theatrical, stylized kind of lighting; others rely on a simple, naturalistic style. Some cinematographers work best with studio lighting and special luminaires, while others draw striking effects from available and natural light. Cinematographers also differ in the kinds of risks they take with lighting. Many films are shot in a bright, high-key style with a limited contrast range, so that all details can be seen and so that all the images have a consistent quality. Sven Nykvist, who has photographed many of Ingmar Bergman's films, emphasizes a high degree of contrast between light and dark. He likes to work with the effect of darkness as much as that of light, choosing to leave parts of the image in shadow for emotional effect.

We can distinguish realist and expressionist styles in lighting, although it is not always possible to pinpoint a given technique as belonging to one or the other style except in the context of a specific film. Realist styles tend toward a general, diffuse supply of light or the use of a key light that imitates a natural source of light. The contrast depends on the scene, but is usually in the middle range.

Expressionist styles of lighting tend toward extreme contrast ranges or a brilliant high-key style of lighting that makes no attempt to reproduce the effect of available lighting sources. Extreme contrast ranges may be used to emphasize the symbolic nature of light and dark. Contrast, directionality, and texture of light can emphasize or exaggerate characterizations, making beauties more fair and monsters more horrible. Light and shadow in the background areas can create mysterious or evocative shapes. Players may be lighted for the most romantic and glamorous appearance, and special lights may be used to create, for example, highlights on a player's hair or a sparkle of light in the eyes. Expressionistic, high-key lighting is sometimes used even outdoors, where powerful luminaires or large reflectors are set up to create a brilliant, heightened image.

5

The Sound Track

With some exceptions, sound has always been part of the film experience. Some of Edison's first films were sound films, with the sound recorded separately on a phonograph record. This system proved too unwieldy for efficient production and distribution, so films were shot without sound from Edison's time to the late 1920s, when a new technology made sound recording for film more practical.

Even during the "silent" period, however, the exhibition of a film was usually accompanied by live music, whether played by an orchestra, a great organ, or simply a piano, and whether written expressly for the film or improvised by a local piano player according to hackneyed formulas. In Japan and other parts of Asia, film showings were often accompanied by a narrator, or *benshi,* who would explain the action and even mimic the voices of the characters.

With the advent of the new sound-recording techniques in the 1930s, another craft was born. The film sound track was now capable of accurate synchronization with the film image, and it was possible to combine and mix several different sound sources to create a smooth unfolding of music, dialogue, and natural sounds. Sounds could be emphasized, faded in or out, and blended with a high degree of control.

The technical term "sound track" seems almost too banal for this complex and subtle creation, which has a range of emotion and meaning equal to the visual image, and which is a more complex example of sound art than are many musical compositions.

THE TECHNICAL PROCESS

The art of film sound is a recording art, in which the essential qualities of sounds not only are registered in a reproducible form but may be altered, arranged, and manipulated into new forms and combinations. To understand these processes, we must have some idea of what sound itself is, and knowledge of the basic tools of sound recording.

The Nature of Sound. Sound is a periodic, wavelike vibration of molecules of the air. Every sound has an *amplitude,* a measurement of the relative intensity or energy of vibration, which we perceive as *loudness.* Amplitude is measured in units called *decibels.*

Sounds are also characterized by *frequency,* which is the rate of vibration of the sound wave. A rapid rate of vibration means a high frequency, and a slow rate of vibration means a low frequency. Frequency is measured in cycles per second (cps) or *hertz* (abbreviated: Hz.). We perceive differences in frequency as differences in the pitch of a sound. We would hear a frequency of 100 hertz as a low-pitched sound and a frequency of 1,000 hertz as a high-pitched sound.

Most sounds are made up of a mixture of different frequencies of varying strengths or amplitudes. Often one frequency dominates and is heard more clearly than the others. If we strike a guitar string or a piano key to produce the pitch called "middle C," it is that particular frequency which is heard most loudly and clearly, even though other frequencies, higher than middle C, may be heard if we listen carefully. These higher frequencies are called *overtones,* and the basic pitch of middle C is called the *fundamental.*

It is the particular combination of fundamental tones and overtones that gives a musical sound its individual quality and allows us to distinguish between the sounds of, say, the flute and the clarinet. This mix of frequencies is called the *timbre,* or *tone color,* of the sound. Every sound-producing instrument, whether it be a musical instrument, the human voice, an automobile engine, or a breaking windowpane, has its individual timbre.

It is the first goal of the art of sound recording to accurately record these different qualities of a sound—amplitude, pitch, and timbre—so that they may be stored in some way and accurately reproduced.

Sound Recording. The basic tools of sound recording are microphones, recording machines, playback systems, and loudspeakers.

When sound strikes a *microphone,* a flow of electric energy is produced whose intensity and rate of vibration follow the changing amplitudes and frequencies of the sound. This flow of electricity is carried to a recording machine through a microphone cable.

In the *recording machine,* the flow of electricity is transformed into magnetic or light energy that records a pattern on a magnetic tape or on a strip of photosensitive film stock. In this form, the recorded sound can be stored or edited.

In a *playback system,* the magnetic tape or film stock is moved mechanically past a device that turns the recorded pattern back into a flow of electricity. This new flow of electricity, which still mimics the original flow pattern from the microphone, can be used either to make a copy of the original recording on another recording machine or to drive a loudspeaker.

In a *loudspeaker,* the electric energy causes a diaphragm to vibrate in the same pattern, thus creating a sound wave that mimics the original recorded sound in both amplitude and frequency.

MICROPHONES. There are many sizes, shapes, and designs of microphones. They differ primarily in their sensitivity to sound and in their *directionality*—their ability to pick up sounds from certain directions and to suppress sounds from other directions. An *omnidirectional microphone* picks up sounds equally well from all directions. A *directional microphone* picks up sounds with great sensitivity from one or two directions and with less sensitivity from others. The degree and the pattern of directional sensitivity vary from one microphone design to another.

RECORDING MACHINES. The first recording machines generally used in sound films were *optical* recorders. In this system, the electric wave pattern produced by the microphone is transformed into light energy, which makes a pattern of light and dark bands or waves on photographic films of the type used in motion-picture cameras. The optical pattern is recorded on a narrow band at the edge of the strip of film, which is called the *optical track* or *optical stripe.* These recorders were large, noisy, and bulky, and of limited fidelity in reproducing the quality of the original sound. Nevertheless, they worked, and an improved design of these same machines is still used in making the sound-track portion of film release prints.

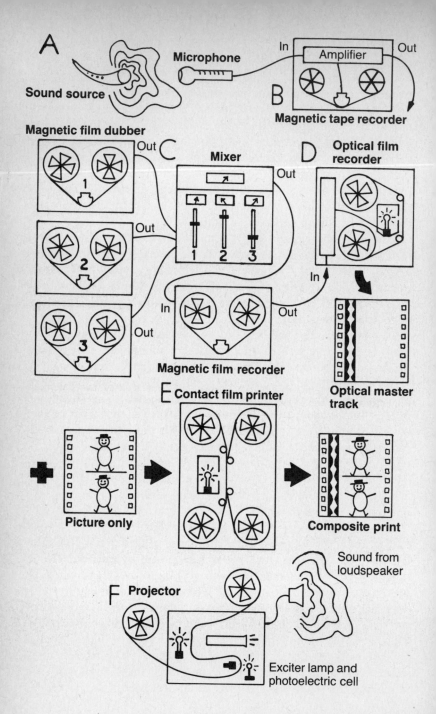

A
Sound source → **Microphone** → In **Amplifier** Out
B **Magnetic tape recorder**

Magnetic film dubber
Out
C **Mixer**
Out
D **Optical film recorder**

1
2
3

Magnetic film recorder
In Out

Optical master track

E **Contact film printer**

Picture only → → **Composite print**

Sound from loudspeaker

F **Projector**

Exciter lamp and photoelectric cell

The process of transformation from live sound to movie sound: The pattern of sound waves in air produced by the *sound source,* at *A,* is transformed into several electrical, magnetic, and optical analogs or counterparts before it is reproduced again as sound waves in air by the *loudspeaker,* at *D.* First, in the *microphone,* the pattern of sound waves is transformed into a pattern of electrical impulses, which is fed to the *magnetic tape recorder,* at *B.* In the tape recorder, an amplifier boosts the signal from the microphone and sends it to the *record head,* where the electrical impulse pattern is transformed into a changing magnetic field. This changing field magnetizes particles on the *magnetic tape,* thus making a record of the original sound. In a separate process (not shown in the diagram), the sound pattern recorded on the magnetic tape is transferred to magnetic film, which can then be edited to match the picture. Several separate tracks can be built up in this way.

These separate tracks can then be placed on the *magnetic film dubbers, 1, 2,* and *3,* and the recorded magnetic signal can be played back—that is, transformed again into a pattern of electrical impulses. The electrical impulses are fed into the *mixer,* at *C,* where the three separate signals may be adjusted, filtered, and amplified and combined into a single mix signal. The mix signal is then recorded on a separate *magnetic film recorder,* and the resulting track is called the *master mix track.* Note that at each stage of playing back and recording from one recorder to another, the sound signal pattern is changed from a magnetic mode to an electrical mode and back again.

At a later point, the master mix signal may be fed into an *optical film recorder.* In this device, the amplified signal controls the brightness of a *printing light,* which records a visual pattern on the edge of a strip of film through the normal photochemical process. This strip of film is called the *optical master track,* and contains a new counterpart or analog of the original sound pattern, this time recorded as a clear area of film that varies in width along the length of the optical track.

In the next stage, both the optical master track and the actual camera footage are printed separately through a normal photochemical process onto a single strip of film in the *contact film printer,* at *E.* The resulting film is called a *composite print,* because it contains both the picture image and the optical record of the mixed soundtrack.

Finally, the composite print is transported through the projector, at *F,* where the picture image is cast on the screen by the projection lamp, and the optical sound track is passed near a separate *exciter lamp.* The varying area of the optical stripe allows different amounts of light to pass through it, and to fall on the *photoelectric cell,* which transforms the changing light energy into a pattern of electrical impulses. These impulses are amplified and fed to a loudspeaker. In the loudspeaker, the electrical signal powers an electromagnet, which moves a diaphragm, which pushes the air back and forth in the loudspeaker and thus creates a pattern of sound waves in air. It requires an advanced technology, and much quality control along the way, to ensure that the sound pattern at the end of the process resembles the one recorded at the beginning.

Magnetic sound recorders turn the electric energy produced by a microphone into magnetic energy. The *record head* of a tape recorder is actually a small electromagnet that generates a pattern, or *flux,* of magnetic energy in response to an electric impulse. The pattern of magnetic polarity is recorded on a tape that is coated with a thin layer of iron oxide. It is this iron oxide that can be magnetized; the tape merely serves as a base.

Tape recorders are now highly sophisticated devices capable of extremely *high fidelity* in recording and reproducing the wave patterns that began as sound waves. Tape recorders for film come in a variety of sizes and designs, making use of different formats of magnetic tape. Location sound recorders generally use magnetic tape one-quarter-inch wide. They can be battery-powered and are fairly rugged. Some studio sound recorders are designed to use wider tape, from one-half inch up to two inches, and can record several separate tracks, or independent sound patterns, on a single tape.

Some special recorders use sprocketed film stock that has been coated with a magnetically sensitive iron-oxide emulsion. This magnetic film track is produced in both 16mm and 35mm gauges and can carry either a single track or several separate tracks. Original quarter-inch recordings are usually transferred to sprocketed magnetic track for editing, since this track can be run through editing machines locked in synchronization with the picture, and can then be cut on the frame line to match the picture.

PLAYBACK SYSTEMS. These can be either optical or magnetic. Optical systems work by shining a small light through the pattern of light and dark recorded on the optical track. The variation of light energy is picked up by a photosensitive cell, which transforms the light energy into electric current that can then drive a loudspeaker. Most 16mm and 35mm projectors are equipped with an optical playback system for playing the sound tracks of release prints, which carry an optical stripe along their border in addition to the photographic image.

Magnetic playback systems work by passing the magnetized tape across a magnetic *playback head,* which also generates an electric current for either rerecording or playback through a loudspeaker. Sounds for film sound tracks are often rerecorded several times in the process of editing and mixing.

MIXERS. Mixers are electronic devices in which impulses from several sources are combined into a single impulse, which can then

be fed into a recorder. They allow the independent control of the *level,* or amplitude, of each separate signal that is fed into the mixer. Mixers are designed for different purposes. In the field, a mixer may combine the signals from several microphones into one signal, which is fed into a tape recorder. In the studio, a mixer may combine signals from several edited sound tracks into a single master track.

SYNCHRONIZATION SYSTEMS. These provide different ways of establishing a fixed relationship between sound and picture, so that they can be edited together and remain locked in the final release print. *Single-system sound* is a type of synchronization in which sound is recorded directly on a magnetic stripe (or optical stripe) on the edge of the film stock. It is used primarily for newsreel shooting, since it does not allow for much flexibility in the editing. In *double-system sound,* the sound is recorded on a tape or magnetic film recorder separate from the camera. In most cases, some sort of *sync signal* is recorded on the magnetic tape to serve as a reference for the speed of the camera. In transferring the sound to sprocketed magnetic track for editing, the sync signal makes possible an exact frame-to-frame matching of sound and picture, and this relationship is maintained throughout postproduction editing and mixing stages. Double-system sound is used for most sound-film production because it provides much higher fidelity and more flexibility in editing than does single-system sound.

Recording Techniques. The visual image is given its basic shape during the shooting process by the cinematographers working directly with the camera and the subjects. The sound track, on the other hand, is shaped mostly during the editing and postproduction process.

The sound-recording process itself may be dedicated only to getting the cleanest, clearest sounds possible for use in editing. Alternatively, the sound recordist may attempt to record a realistic, lifelike "location sound" quality, with all the background sounds of the environment, even if they are somewhat obtrusive. The choice of one approach or the other has to do with aesthetic considerations and with the film's overall style.

MICROPHONE PLACEMENT. This is an important technique for shaping the quality of recorded sound. A microphone placed close to a subject will record a sound in which the speaker's voice seems to be in the foreground and other sounds more in the background. When the microphone is placed at a greater distance, the voice will

be closer to the background sounds and may even be obscured by them. In a boomy, acoustically "live" room, *close miking* makes a voice more intelligible by reducing the resonant effects of the space. In order to reduce unwanted background effects, a microphone often has to be placed quite close.

Varying the distance from microphone to subject changes the *sound perspective,* giving the impression that we are closer to or farther from the subject. Microphone placement is often coordinated with cinematography to create a sound perspective that matches the apparent visual perspective.

MICROPHONE CHOICE. Sound recordists generally work with a kit of several microphones, using different ones for different situations. Microphones do not reproduce all frequency ranges equally: Some emphasize low or high frequencies; some give a warm, resonant sound, others a thinner, drier quality. Every sound recordist has a few favorite microphones, as well as microphones with special functions, such as extreme directionality for picking out specific sounds at a great distance. Since microphones do vary in tonal quality, the sound recordist usually chooses a single microphone for all the shots or takes that will make up a single scene. This ensures continuity of sound quality throughout the scene.

DIRECT SOUND. This is the technique of recording sound simultaneously with image. The effect of direct sound varies considerably, depending on the location and the extent to which the filmmakers can control the action. On a *sound stage*—a large, quiet studio where the filmmaker exercises a great deal of control—direct sound recording can produce clean, strong dialogue tracks with little or no distracting background noise. In many exterior locations, such as city streets, direct sound recording will pick up a great deal of background noise in addition to dialogue: Traffic, voices, the noise of airplanes flying overhead—all become part of the track. A filmmaker may choose this kind of sound deliberately, or he may be unable to avoid it. In some locations, such as back lots or rural scenes, the filmmakers have enough control of the environment so that direct sound more resembles the effects of a sound stage.

ISOLATION RECORDING. Even if some sound, such as dialogue, is recorded directly, many elements in a sound track can be recorded separately from the picture and added during the editing. These include general background sound, or *ambient sound,* as well as

specific *sound effects*. Voice-over and even some dialogue may also be recorded separately from the picture. Music tracks are usually recorded at a different time from the actual photography. Ambient sound is usually recorded on location; voice-over, additional dialogue, and music tracks are usually recorded in a soundproof studio. Sound effects can be recorded either on location (surf, birds in a forest) or in the studio (footsteps, breaking glass).

SLATES AND IDENTIFICATION. With the advent of sound recording, the *slate* became an essential part of filmmaking, because of the necessity to locate and match separate takes of picture and sound for synchronization in the editing. At the beginning of a take, a slate is presented to the camera with information such as the scene number, the take number, etc., written on it. The person presenting the slate announces the information verbally, adding the number of the sound take, and then bangs closed a pair of hinged boards, or *clapsticks,* which are attached to the slate. The bang on the sound track and the image of the clapsticks provide a synchronization reference between sound and picture. The slate is normally removed from the final cut of the film, but we sometimes see it left in a scene to remind us that we are watching a film, to make us conscious of the fictional illusion, or to present a "film within a film."

FILMING TO PLAYBACK. A common technique for presenting popular-music performances is called "filming to playback." This technique is employed, for example, when a pop group has a highly processed "studio sound," difficult or impossible to achieve in live performance, or when the musicians are called upon to sing while engaged in dancing or other strenuous activity that might adversely affect their performance. During this kind of filming, a master recording of the music track is played back over loudspeakers, and the musicians mime their own performance, matching the lip movements and guitar strums of the track. They can actually sing along with the playback track without worrying about mistakes, since the live singing is not recorded. In the editing, the master track and the recorded image are synchronized to give the effect of an authentic musical performance.

In another kind of filming to playback, dancers in a discotheque or nightclub scene may be given a rhythmic *click track* to dance to. In this way, dialogue can be recorded without the background music, and many shots can be taken without concern for the continuity

of a musical piece. The actual music, added later in the sound mix, will be a piece with the same rhythm as the click track.

Sound-Editing Techniques. It is in the editing that the overall composition and structure of the sound track is created, by building up layers of sounds on separate tracks, each of which is carefully synchronized to exact frames of the picture. (It is of course possible to make a film with a single layer of sound, also synchronized to the picture.)

As a first step in most editing, sounds are *transferred* to 16mm or 35mm sprocketed magnetic film track. This track is then threaded through an editing machine that can transport both picture and sound track, either independently or locked into synchronization. The sound track is moved back and forth in relation to the picture until the desired synchronization is found, and then *leader,* or blank film stock, is added to both picture and sound so that they can start from a common sync point and play back always in the same fixed relationship to each other. When directly recorded dialogue and picture are matched in this way, the process is called *syncing up.*

Any kind of sound can be synchronized to the picture in the same way. If it is desired to have several sounds play at one time with a given picture, each sound can be laid in on a separate track and synchronized to the *picture start* with its own start mark. These separate tracks will be combined into one during the mix. Each track may contain a continuous flow of sound, or may consist of many separate moments of sound, each separated by an exact length of leader. The number of separate tracks may range from one or two to as many as thirty or forty for a big-budget feature film.

Unlike picture cuts, the sound cuts are easily concealed, either by making the cut during a moment of silence or by *fading up* or *fading down* the sound during the mix. This whole process of sound editing is called *building the tracks.*

The Sound Mix. It is during the *sound mix* that the sound track is given its final shape, and the final creative decisions are made. The sound mixer has a great deal of control and flexibility in manipulating the final product, probably more flexibility than is possible at any other stage of the recording process.

Mixes are performed in a sound studio, which is equipped with a number of separate playback machines, or *dubbers.* Each of the separate tracks to be mixed is placed on its own dubber, and the playback signal from each is fed into a *mix board,* where the signals

can be separately controlled and combined. A print of the edited picture is *interlocked* electronically with the playback dubbers, so that all the dubbers and the projector can roll forward and backward, starting and stopping in synchronization. The picture is projected into the same room that contains the mix board, so that the sound can be mixed in relation to the picture. (The playback dubbers are in a separate room.)

The mixer can play the mix board the way a musician performs on his instrument, changing the levels and qualities of sounds, combining them in various ways, stopping, and remixing to achieve a precise effect. On the mix board, each separate track can be controlled by its own volume control, or *fader*. The tracks can be combined and recorded onto a separate recording machine, either as a single track or onto two, three, or four separate tracks, each with a particular combination of sounds. The recording thus made, whether composed of one track or several tracks, is called the *mix,* or the *mix master*.

Sounds may be recorded onto separate tracks of the mix master according to their function in the film. For example, all dialogue might be recorded on one track, all sound effects on another, all music on a third, and all narration on a fourth. This format allows separate parts of the sound track to be remixed without redoing the whole mix. For example, a narration track in a different language might be recorded on the mix without changing any of the other sounds. Multiple tracks can also be used for stereo effects, with the right channel, the center channel, the left channel, and a rear channel each on its own separate track.

The final mix track is thus a highly processed creation—each sound has been carefully recorded, accurately matched to picture, mixed in relation to all other sounds on the track and in relation to the picture, and *equalized* or *filtered* to achieve a specific tone quality.

LEVEL CONTROL. The amplitude, or volume level, of each track being mixed can be controlled independently—raised or lowered in relation to other sounds on other tracks, and faded up or down as desired. This allows the mixer to control the exact foreground/background relationship of the sounds, to adjust the sound perspective for each shot, or even to change it during the course of a scene by changing the levels in response to the picture. Level control also permits a simple fade-out or fade-in of sound to match a picture

fade or a *cross-fade,* similar in effect to a lap dissolve of the picture.

EQUALIZATION. Each track can also be fed independently through several *equalizers,* or *filters,* which can change the timbre, or the tone quality, of a sound. Equalizers and filters work by emphasizing or reducing frequencies of sound, such as the high or low frequencies. Since the specific quality of a sound is determined by its particular mix of fundamental tones and overtones, boosting and reducing certain frequencies will change the sound's overall quality.

Equalizers can achieve a number of effects. A kind of *presence,* or a resonant quality, can be added to a flat or thin-sounding voice. Voices recorded by different microphones can be matched to sound more alike. A sound can be muffled so that it seems to come through a door or from behind a wall. Music can be given a tinny quality to resemble the sound of a car radio. Resonance, or echo, can be added to change the feeling of a space. Various kinds of background sounds, such as the rumble of traffic, the humming of air conditioners, or the whirring of a noisy camera, can be removed or reduced. There is, however, a limit to the kinds of sound that can be removed. In order to be controlled by equalization, the offensive noises must be limited to a narrow frequency range, whether high or low.

ELEMENTS OF THE SOUND TRACK

Sound tracks are made up of at least one of several basic elements: directly synchronized dialogue, postdubbed dialogue, sound effects, voice-over or narration, and music. Many films include all these elements in the mixed sound track; others employ only one or two, such as music and narration or directly synchronized dialogue and sound effects.

Directly Synchronized Dialogue and Effects. This form of dialogue is common in American and British productions, where sound stages and sophisticated recording equipment make the control of background noise quite feasible and actors usually speak a common language. Many documentary-film makers, especially those who work in cinéma-vérité and direct-film styles, are committed to this type of film sound because of its powerfully realistic effect. Even in theatrical films, directly synchronized dialogue has this effect, but in these films, only those sound effects that are an immediate part of the action are recorded on the same track as the direct dialogue. Ambient sound is reduced or controlled as much as possible.

Postsynchronized (Dubbed) Dialogue. Postsynchronized dialogue is recorded after the shooting of a film. In a dubbing studio, loops of film are projected on a screen, and actors practice saying their lines in close synchronization with the moving lips of the actors on the screen. They need not be the same people; one actor may play the role for the camera, and another dub in the voice.

Postsynchronized sound has often been used in European films, for a number of reasons. In Italy after World War II, only the crudest film equipment was available—sophisticated sound equipment was simply nonexistent. Postsynchronization thus became standard procedure for the Italian film industry. The technique still makes possible a simpler production process than the use of direct sound. A smaller crew is needed, with no sound-recording technicians, and it is not necessary to control the shooting environment so carefully to screen out unwanted background sounds.

There are other, nontechnical reasons for using postsynchronized dialogue. In many international productions, the players do not speak a common language, and postdubbing allows the film to be dubbed into a single language for release. Films may also be dubbed into several different languages for distribution purposes. In these cases, it is the job of a dialogue writer to come up with lines in the dubbed language that will match as closely as possible the original lip movements of the language spoken in the filming. Usually one can spot a dubbed film by watching the synchronization closely, although the illusion may be so good that we are not constantly aware of it.

Other reasons for postdubbing include poor quality of original direct sound recordings, a professional singer dubbing in a song for a nonsinging player, and the need to rewrite dialogue because of script changes after the film has been shot.

Postsynchronized dialogue is generally not as realistic as directly synchronized dialogue since it never matches exactly the actors' moving lips on the screen. It works best with an expressionistic style, and is almost never used in documentary films.

Sound Effects. Although sound effects are sometimes recorded as direct sound, they are often recorded separately and added to a dialogue track in postproduction. Sound effects may come from many different sources. They can be recorded on location or in the studio; they can also be provided by special libraries of sound-effects records and tapes. Sometimes sound effects are produced in the

studio so as to synchronize with projected loops of film, exactly in the manner of postdubbed dialogue tracks. Such sound effects are called *foleys* and are often produced by ingenious means, such as knocking coconut shells to produce the clop-clop of horses' hooves or rattling a piece of sheet metal to make the sound of thunder. Many dubbing studios have removable floor panels above different kinds of surfaces, such as gravel, dirt, and wood, which can be walked on to produce various sounds of footsteps.

Sound effects are not just icing on the cake. They often provide a scene with a sense of the presence or reality of an acoustically "live" space. They can evoke a mood or feeling: Effects of distant traffic noise will create a very different mood from the chirping of birds in the same roadside scene.

Sound effects may comment on the action or even compete with it. In a carnival scene, the laughter of merrymakers can contrast with a serious moment between two performers, or can even begin to drown out their conversation.

Sound effects can be mixed with great complexity and subtlety. For *L'Avventura,* Michelangelo Antonioni collected many effects of the sea—of breakers on the beach or on the rocks, of stormy and calm days. They were mixed with other effects as a composer mixes the sounds of an orchestra.

Voice-over and Narration. We are all familiar with the kind of narration that accompanies an educational or travel film to explain what we are seeing or provide additional information. Theatrical films and documentaries can also employ a narration to bridge transitions between scenes and provide information that is not brought out in the dialogue or the visual image. Sometimes a distinct "narrator's voice" is used; sometimes the narration is spoken in the voice of one of the players, whether an actor or a participant in a documentary. The latter type is called a *voice-over.*

Narrations and voice-overs are usually recorded in the studio, with great attention to the quality of the voice. They may be written as part of a preshooting script, or they may be written after the shooting to change the development of a narrative, to give an explicit narrative structure to documentary footage, or to add further clarification or implications to the footage.

Voice-overs may also be recorded on location or excerpted from direct sound recordings when the accompanying visual image is not used. For example, a documentary crew might shoot an extended

interview or dialogue sequence with direct sound and then use part of that direct sound to accompany other images.

Voice-over can also be used to give an effect similar to that of postsynchronized dialogue. In D. A. Pennebaker's *David* (1961), a documentary film about a musician being treated for drug addiction at Synanon, David goes to a beachside carnival with his wife and infant son, who are visiting him. Various shots of David and his wife smiling at each other and at the baby are edited together with voice-overs of their conversation about whether or not it is good for David to receive these visits. There is no attempt to synchronize the voices with the images; yet as they look at each other, we almost feel that they are really speaking to each other on film.

Voice-overs can be in the third person or first person—can describe events objectively or speak subjectively in the voice of a person involved in them. They may take a literary, storytelling tone or a subjective, psychological tone that suggests or hints at feelings and reflects the speaker's emotional state. A narration may come from a literary work, as when in Robert Bresson's *Diary of a Country Priest* the voice-over quotes from the priest's diary and thereby from the book on which the film is based. In Jean-Luc Godard's *A Married Woman,* the voice-over presents an extreme subjectivity: Isolated words, expressions, and fragments of thoughts in the woman's whispering voice suggest her nonrational stream of consciousness. In Michael Rubbo's documentaries *Waiting for Fidel* and *Solzhenitsyn's Children,* the filmmaker both enters into the filmed action and explains the process of making the films in a voice-over.

The quality and tone of voice of a voice-over are extremely important. A booming, resonant voice can give a false sense of importance to banal events. A dry, literary tone can create a storytelling mood. Simple, unaffected speech can give a sense of immediacy and reality.

Music in Films. Music in film is of two basic types: that performed directly before the camera, and that added separately to the sound track, as is a narration or sound-effects track. We are familiar with the first variety in concert films, musicals, films about musicians, and other films that include musical interludes. Music added to the sound track to create an effect or a mood is what we usually think of as film music.

SOURCES OF FILM MUSIC. Filmmakers sometimes embed a musical "background" in an actual source that we can see on the screen, such as a phonograph or radio. Once the source is estab-

lished, the musical background can work like an independent musical accompaniment. In Pennebaker's *David,* we see the Synanon combo playing a jazz piece in one room, but the film soon cuts away to other images and locations in the house, while keeping the music going as an accompaniment. We forget about the source of the music and begin to accept it as simply background. When the film returns to the musicians, we are almost surprised to find that they are still playing. The same music is also used over opening titles and end credits of the film, and at transition points throughout.

In Francis Ford Coppola's *Apocalypse Now,* the music of Wagner's *Ride of the Valkyries* is established as played through loudspeakers in the attacking helicopters of an American force. The music heightens the sense of the commando officer's theatrical madness—it is as if he were creating his own movie music within the film. In Werner Herzog's *Aguirre, Wrath of God,* the flute music of the South American Indian accompanies many scenes. There is an Indian in Aguirre's exploring party who actually plays the flute, sometimes on camera, and we often have the feeling that he is somewhere nearby playing even when we don't see him on the screen.

Film music that is added to the sound track with no apparent source on the screen can come from several sources. There are libraries of recorded music that stock great numbers of musical themes and interludes of many different styles, moods, and orchestrations. These recordings, available for purchase by filmmakers with rights included, can be transferred to magnetic track and edited to match scenes in the film.

Sometimes filmmakers make use of prerecorded music, such as the Simon and Garfunkel songs of *The Graduate* or the rock songs of *Coming Home.* Commercial popular music is much more expensive to buy than music-library recordings, but it adds a topical feeling to a film, linking it to a particular time and atmosphere. Classical music can also be edited into a film: for example, the Mozart of *Elvira Madigan,* the Handel of *Barry Lyndon,* the Beethoven of *Clockwork Orange,* or the Strauss of *2001: A Space Odyssey.* This music may be transferred from commercial recordings, or an orchestra may be hired to play it specifically for the film.

A distinctive source of film music is the original composition, written and recorded especially for the film. This kind of music is an art in itself, and there are composers who specialize in it. Original music for film can be played by one or two instruments or by a

whole orchestra. In Bernardo Bertolucci's *Last Tango in Paris,* the principal source of music is a solo saxophone, which sometimes plays a complete melody and sometimes only one or two notes of the theme. The music for Satyajit Ray's *Distant Thunder* was written by the composer and played on a solo sitar. It consists sometimes of melodies and sometimes of only one or two lingering tones. On the other hand, the music for a Hollywood epic like *Gone With the Wind* is rich and elaborate, composed of a number of different themes played by a large orchestra.

As an independent composition, film music can be played and recorded and then edited into the film in the same manner as commercial or music-library recordings. Or it can be timed and written to match exactly the rhythm and events of the edited picture, and recorded to synchronize with the picture, with as much care and technical craft as are devoted to postsynchronized dialogue. In the most elaborate process, an orchestra watches the projected film while playing, and the conductor listens through headphones to a *click track,* which provides him with precise audio cues for synchronizing his tempo to the predetermined rhythm.

USES OF FILM MUSIC. Music is part of the overall structure of a film, and is used in the same ways in many films. It often accompanies the main titles, to create a mood and sometimes to provide information about the time or place. Music may also accompany the end titles and credits, to sustain the mood of the last scenes or to recall an earlier mood. Musical interludes are used at the beginning of individual scenes for the same purpose: to establish a mood or suggest something about the content of the scene. The music often plays over the establishing shots of a scene, over the first actions, and is faded down as dialogue begins.

Music is often used as a substitute for dialogue: for example, over scenes in which subjects are traveling, engaged in nonverbal activities, or relating to each other in a nonverbal way. In such scenes, music may communicate moods or give a sense of narrative continuity to a series of shots. Music can even set the pace of the action. The suspense of a chase scene can be reinforced and the energy sustained by music with an urgent tempo. Romantic music over a montage of two lovers on an outing can reinforce a continuity of feeling across a number of different locations and activities. Music over a montage of landscape shots can enrich our feeling about the character of a place.

Music is of course an extremely effective means of suggesting mood and emotional content at any point in the film. It may either reinforce the mood of a scene or contrast with it. In fact, film music can become a kind of character or *dramatis personae,* interacting with the images and action and commenting on them. This kind of dramatic effect may be achieved by using music of contrasting moods throughout a film. It can also be created by the use of *themes:* specific melodies and orchestrations that we associate with a feeling, or a character, or an event.

A film can either have a single theme, as in Bertolucci's *Last Tango in Paris* or Marguerite Duras's *India Song,* or it can have a number of themes, each associated with different moods or activities. In William Wyler's *Ben Hur,* there is one theme associated with love scenes, another with battle scenes, another with pomp and circumstance.

The use of musical themes in a film is not very different from their use in opera, particularly when the theme is a motif associated with a specific character or idea. A theme associated with a character in a narrative can identify or suggest feelings about that character. A theme may also identify an idea or a psychological force, like that of fate in Georges Bizet's opera *Carmen.* In *2001,* Richard Strauss's *Thus Spake Zarathustra* becomes a theme suggesting man's transcendence of his earthly condition.

Once a theme has been established, it may be used to recall or suggest an idea, or a feeling, or a character that we have become familiar with, even if the idea or character is not present on the scene. In Fritz Lang's *M,* a few bars of whistling become the trademark of the child molester played by Peter Lorre, and signal his offscreen presence. A musical love theme might remind us of a previously established mood or relationship, or might cue a change of mood in the middle of a scene. The music can thus remind us of earlier events or prefigure coming events. In fact, if the mood of a musical gesture is obvious enough, it need not have been previously established to convey this message; a mysterious, ominous musical passage can prefigure danger, even though events on the screen appear innocent and normal.

STYLES OF FILM MUSIC. An onscreen source of music, such as a radio or jukebox, reinforces a realist approach. The use of any kind of film music other than that from a source on the screen tends toward the expressionist style. In fact, certain directors choose not

to use "film music" at all, finding it old-fashioned or melodramatic. They prefer to build a kind of "music" out of natural sounds and sound effects, evoking a mood and creating emotional effect in indirect ways.

Other filmmakers use music in a direct way, calling attention to its presence for humorous or other effect. In Mel Brooks's *Blazing Saddles,* we hear violins as we see a cowboy riding across the plains. Suddenly the camera pans to reveal an entire symphony orchestra sawing away amid the sagebrush!

Even unabashed movie music may vary in its degree of expressionism. A few chords and simple themes may be sparingly used to comment on or flavor the scenes. On the other hand, a strong, continuous music track may be used to motivate, support, and strongly emphasize the mood, to cue emotional response in a more direct and obvious way.

COMPOSITION WITH SOUND

A few basic principles of composition apply to almost any sound track, whether composed of directly recorded or dubbed dialogue, voice-over, sound effects, music, or any combination of these elements. Since film sound does not really exist separately from the picture, these principles often have to do with the relationship between sound and picture.

Density of the Track. A track may be heavily layered and processed, composed of many different elements mixed together, or it may consist of only one or two elements, such as a simple dialogue track and a few sound effects. Within the same film, the track may be very dense in some parts and very spare, or even silent, in others. In fact, silence can be a powerful element of the sound track, particularly when contrasted with noisy scenes in the same film. In Werner Herzog's *Nosferatu* (a remake in 1979 of F. W. Murnau's classic of the Twenties), the silence of Count Dracula's castle and of the plague-ridden death ship seems heightened and full of tension, making the occasional sounds that break the silence all the more shattering.

Sound Perspective. As we have noted, the sound track can create a sense of spatial dimension through the positioning of sound sources in film space. The sound perspective is the apparent spatial relationship between a given sound and the visual image.

If the apparent source of a *primary sound* is on the screen, the sound perspective may confirm or distort its apparent distance from the audience. A person talking in the foreground would normally be associated with a relatively loud, clear tone of voice, whereas the voice of a person at some distance would normally be mixed to sound somewhat fainter and less clear. In film, normal sound perspective is occasionally distorted, so that we can hear the conversation of two people quite clearly even though on the screen they appear to be some distance away. The same principles also apply to other sound sources: sound effects, music whose source is in the visual image, even narration.

Ambient sound, or background sound, is also mixed according to the principles of sound perspective. An aerial shot of a cityscape would normally be linked with only the faintest of street sounds, whereas a wide shot from street level would call for louder sounds of traffic and other noises. Normal perspective might, however, be ignored in an aerial shot, by mixing in loud traffic sounds to give a sense of the seething activity of city life behind the apparent calm of the panoramic shot.

Ambient sound can change from shot to shot, to conform to our apparent spatial position. In Josef von Sternberg's *Blue Angel,* many scenes take place in a crowded, noisy nightclub. When the camera follows Marlene Dietrich to her dressing room, or when we see her enter the room and close the door behind her, we hear the noisy ambience of the nightclub drop in volume. When the impresario opens the door and sticks his head into the dressing room, the nightclub ambience comes back on the sound track.

Sometimes, in a scene with noisy ambience, a cut to a new shot with a different spatial position allows the editor to reduce the level of background sound so that significant dialogue can be heard. For example, the characters may pause for breath just around the corner of the town square where the riot is taking place, and a quieter ambience will accompany the shot. The ambient sound may also be established at the beginning of a scene, then gradually and imperceptibly be faded down or made less dense so as not to compete with the dialogue. Sometimes the ambient sound is kept deliberately loud, as in a factory or battle scene, so that characters must shout to be heard. Background sound then becomes in effect a foreground sound.

Sound perspective also plays a role in the use of *offscreen*

sounds—that is, sounds whose apparent sources do not appear on the screen. The volume and the tone quality of the sound can make it seem fairly close or quite distant from the onscreen space. The voice of one character talking over a close-up reaction shot of another player may appear to be coming from a few feet away, whereas a weaker, more muffled voice might seem to originate in another room or the street outside. Offscreen ambience or background sound can also contribute to the feeling of a particular space or environment, can locate it in space, and can give a sense of vastness or of intimacy.

Thematic Effects. The great range of available sounds and sound sources makes possible an equally great range of themes and levels of meaning within the sound track. On the simplest level of directly recorded synchronous sound, we can have the basic realistic level of meaning, sounds recorded as they are produced within the scene. Once the filmmaker begins to control or add to the location sound, or even to do without it, whole new layers of meaning become possible. The effect of realism may be maintained or even reinforced by added sounds, but a new world of expressionistic meaning may also be opened up. Music, narration, and some kinds of sound effects can create a more artificial, theatrical kind of aesthetic experience, with its own powerful emotional effects and connotations. A subjective narration, for example, can create a kind of internal, thoughtful presence that is impossible within a strictly realistic style. The ease with which sound qualities can be changed and shaped in the mix makes possible the kinds of expressionistic and symbolic effects that are also achieved in the picture by special lighting and compositions.

In fact, since the sound track can support both theatrical or expressionistic elements simultaneously with realistic ones, the film can at the same time sustain several levels of meaning, integrated into an aesthetic whole. The sound track thus makes possible a richer and more aesthetically complex work than does picture alone; in fact, these simultaneous layers of meaning are perhaps more easily constructed in the sound track than in the picture.

Indirect Use of Sound. The potential for constructing simultaneous layers of meaning in picture and sound makes possible an *indirect use* of the sound track to evoke feelings or content that seem independent of or even contrary to the apparent content of a scene. Throughout Mike Nichols's *The Graduate,* we hear on the sound track several of Simon and Garfunkel's songs, which were written before the film was conceived and bear no direct relationship to the

action. Nevertheless, the lyrics, which suggest feelings of alienation and loneliness, or of mystery or joy, contribute a new layer of meaning to the shots of the young college graduate returning to his empty, consumer-oriented California home life. In Peter Handke's *Left-Handed Woman,* a few bars of a Bach sonata are repeated occasionally throughout the film, which depicts a woman who falls into a crisis of solitude and speechlessness. The grace and clarity of the Bach music, which seems to occur almost at random, suggest the moments of grace and beauty that the woman experiences even in the depths of her depression and alienation. In Jean-Luc Godard's *A Married Woman,* the whispered, stream-of-consciousness fragments of the voice-over, which often have little direct bearing on the action, nevertheless suggest that the character has a certain calmness and poise in the midst of her restricted and alienated existence.

Sound effects can also be used indirectly. In Paolo and Vittorio Taviani's *Padre Padrone,* a film about a young man who grows up in a remote and backward region of Sicily, there is a sequence in which it seems that all the beasts of the fields and barnyards, as well as the shepherds, the farmers, and the townspeople, are simultaneously copulating. On the sound track we hear a gradual crescendo of braying sheep and goats, panting and moaning humans, mixed together so as to suggest the universal animal pleasure of lovemaking.

Sound/Picture Counterpoint. There are a few basic principles of composing sound in relation to picture that can be discussed independently of the content of the sound track. In fact, we might break down the possible functions of the sound track into three major categories.

DOMINANT SOUND. The sound track can support or carry the continuity of the action. Sound and picture may contribute equally to developing the scene, or one or the other may predominate. Sometimes the dominant role will switch back and forth between sound and picture several times during the course of a scene. For example, in a scene involving a great deal of dialogue, the action might be sustained partly by the content of the dialogue; partly by the actions, gestures, and expressions of the actors; partly by the presence of other images or sounds. We may imagine watching the picture without the sound track, or listening to the track without the picture, to estimate how much each element is sustaining the action at any given moment. Sounds other than dialogue, whether sound ef-

fects, music, or narration, can sustain the action. A series of almost unrelated landscape shots can be edited together, with the editing rhythm determined by a musical score, to give a sense of traveling or of time passing.

CONTRIBUTING SOUND. Sometimes the sound track will color the action, suggest a particular mood, or comment on the situation. In these cases, the action would be quite clear, and the scene quite intelligible, without sound, but the track adds nuances that contribute to the overall effect. Music or sound effects can contribute a mood or presence to a scene. A few lines of banal dialogue can enrich the presentation of a character or a place, and even a narration may be used more for the emotional effect of the tone of a voice or the rhythm of speech than to sustain the action or provide information.

Also, as we have noted, sound can be used indirectly to contribute an additional nuance or meaning to a scene. In *Dr. Strangelove*, Major Kong's riding to earth on the atomic bomb that he has just wrestled out of the bomb bay would make perfect dramatic sense with no sound at all, or with the most ordinary sound effects. The happy popular song that is played over the action contributes an additional sense of irony and of the obsessive lunacy of the character.

TRANSITIONAL AND CONNECTIVE SOUND. The sound track can be used as a transitional device, to lead the action into a new location or development, or it can sustain a presence while the picture leads the action. Music, dialogue, or sound effects can anticipate a new scene or sustain a presence across several shots. We might introduce a character by an off-camera voice, which leads our attention to the character, who is then seen speaking on-camera. The camera may cut away to a listener or to some other image while the first speaker's voice continues or flows across the cut, linking the images in time and space or illustrating the dialogue. In Pennebaker's *David*, the music of the jazz combo lingers over images of a young woman going through "cold turkey" withdrawal from drugs, and the music's gentle mood suggests the supporting presence of the other Synanon House residents.

6

Editing and Postproduction

Many filmmakers consider editing the most significant aspect of creative filmmaking, the crucial creative act. Visual compositions and rhythms that are composed and recorded by the camera are given their final shape in the editing. Sounds recorded on location and in the studio are orchestrated and mixed into a continuous, seamless flow of sound. Finally, the sound and picture are balanced in a kind of counterpoint to reinforce the effect and meaning of each scene.

The stage that includes editing is called the *postproduction* stage of a film because many technical and creative operations are performed besides simply splicing picture and sound. Additional dialogue and narration may be written and dubbed in; music may be composed and recorded to fit the picture; portions of the script may even be rewritten and shots edited to conform to the new script.

In some documentary films, much of what we would call "writing" takes place after the film is shot. The ordering of scenes in time, the introduction and development of characters and moments of crisis, the selection of dialogue—all these may actually be determined during the editing process.

THE EDITOR'S CONTRIBUTION

Although, technically speaking, editing simply means the physical joining together of separate strips of film and sound track, it is in the editing that many of the film's codes of meaning—including montage, film space and time, symbols, metonyms, and values—are actually composed.

From an aesthetic point of view, we might define the editing pro-

cess as the selection, timing, and arrangement of shots and sounds into a continuous, unified unfolding of sound and image. The unity of the edited film may be provided by a narrative, by dramatic structure, or by a visual or auditory theme or structure.

Both the cinematographer and the sound recordist are to some extent able to direct the attention of the film audience and to establish various points of view. The editor, too, has this power, through the selection and arrangement of shots. In addition, the editor has the responsibility for the final shaping of filmic time and space. The editor can also give structure to a film, can shape a dramatic development, can establish or gradually build up an idea or an effect, and can shift gradually or suddenly to a new idea or emotion.

THE TOOLS OF EDITING

In the earliest days of filmmaking, the tools of editing were relatively simple, the most important being scissors and glue. A reel of original negative film would be mounted on a spindle with a crank attached and then rewound onto another spindle, passing near a light between the two. The editor would find the cut point by looking directly at the negative, cut the film with scissors, and glue it to the next desired shot.

Since then, a number of devices, including some very sophisticated ones, have been developed for viewing the picture and auditing the sound track. Even computers can be used as an aid to the editing process. The spindles with cranks are, however, still in use. Called *rewinds,* they are usually mounted in pairs, one on each end of an editing table, so that film or sound track can be wound between them. Rewinds often have shafts long enough to accommodate several reels of film or track at once.

Picture Editing. The simplest kind of picture editing is done with a pair of rewinds, a viewer, and a *splicer.* The viewer contains a light source, and when film is passed through it, a small image is projected on a glass or plastic screen mounted in the viewer. On the splicer, small registration pins hold a strip of film in place while a blade makes a precise cut between two frames. The same pins can then hold two separate strips of film so that they may be attached with a piece of tape. Tape splices can easily be pulled apart and remade, so that it is possible to try out various shots and cuts.

A glue splicer is used for more permanent splices. These provide

some means of clamping two pieces of film together while the glue splice sets.

A *film counter* or *synchronizer* is used to measure exact lengths of film. The counter consists of a sprocketed wheel, on which each frame space is numbered, attached to a counter that counts the feet, or footage. A synchronizer consists of several (usually two to six) of these sprocketed wheels ganged together on a single shaft, so that several strands of film can be transported together, locked in exact frame-to-frame relationship.

Sound Editing. For editing sprocketed sound track, the same pair of rewinds can be used as for the picture. The sound track can be passed through a *sound reader,* on which is mounted a *magnetic sound head.* The signal picked up by the sound head is fed into an amplifier/speaker device, sometimes called a *squawk box.* By winding the film through the sound reader, the editor can listen to the sound track, either forward or backward.

A magnetic sound head can also be mounted on one or more gangs of a synchronizer, so that one or several sound tracks can be listened to through a single squawk box.

Splicers for the sound track have a design similar to picture splicers except that only tape splices are used for the sound track.

Sound and Picture Editing. The simplest system for editing picture and sound simultaneously consists of a synchronizer of at least two gangs, one of which has a magnetic sound head. A viewer is placed next to the synchronizer, and film is threaded through the viewer and through one gang of the synchronizer. Sound is threaded through the other gang, and both sound and picture are transported simultaneously, locked together between two rewinds in frame-to-frame synchronization. (Each rewind supports one reel for the picture and one reel for the sound.) Either picture or sound track can be removed from the synchronizer and moved to adjust the picture/sound relationship. Film leader can be added to either picture or sound track as a spacing device in order to keep several takes in synchronization when the picture and the sound are not exactly the same length.

To achieve more precise control of the rhythm and timing of scenes, it is essential that picture and sound be transported at exactly the proper speed. For this purpose, there exist a variety of editing machines with motorized transports, which can play picture and sound tracks either separately or locked together.

For many years, the standard motorized editing machine was the *upright Moviola*. Picture and sound tracks could be mounted on reels and transported through the machine, which could play them in synchronization, at precise sound speed. Picture or sound alone could also be edited on the same machine. A Moviola would normally have one *picture head* and one *sound head,* although a second sound head could be added in order to work with two tracks at once.

Upright Moviolas have been gradually replaced by horizontal editing machines, called *flatbeds,* which transport film and sound track between horizontal round plates past various picture and sound heads, without the use of reels. These machines can transport film and track at extremely high speed, so the rolls can be kept rather large and the editor can quickly search for shots and sounds.

Horizontal editing machines have now become the industry standard. They come in a variety of configurations of sound and picture

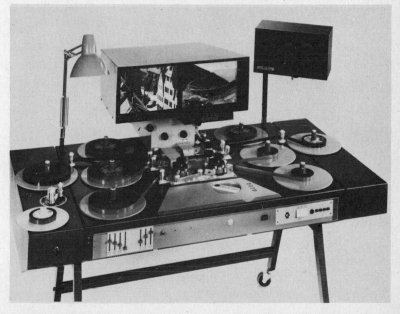

A typical *flatbed* editing machine can transport several separate sound tracks in synchronization with the picture. The model shown here can transport two picture tracks at once. It may be used not just for editing split-screen sequences but also for previewing material on one screen as the rough cut is built up on the other, or for looking at alternate shots.

heads, including models with interchangeable heads. Two or more tracks can easily be played with a single picture, and some models even allow the editor to play several picture rolls at once. A concert film such as Michael Wadleigh's *Woodstock* owes much of its split-screen imagery to the use of horizontal editing machines with several picture heads.

Because all these editing machines have a relatively small viewing screen (from three or four inches wide for a viewer to a maximum width of perhaps twelve inches for a flatbed), it is essential at certain stages in the editing process to project the film in order to evaluate its effect on a large screen. Since picture and sound track are still separate during the editing process, an *interlock* projection facility is used. The picture is mounted on a projector, and one or more sound tracks are mounted on special dubbers, or playback units, identical to those used in the sound mix. The projector and dubbers are electronically locked together, so that picture and tracks can be played in synchronization. In this way a nearly completed film can be shown to a selected test audience before final editing decisions are made.

Video Editing. Video editing systems can be used either for material shot directly on videotape or for film that has been transferred to videotape. In the latter case, picture and sound are synchronized before the transfer to tape, and all material is electronically coded and the codes stored by computer. By pushing buttons, the editor can review the footage, recall selected takes, make preliminary cuts, store those edits in the computer memory, and make desired revisions more quickly than would be possible through the physical manipulation of actual film and sound track. When the final edited version is decided upon, the film itself can be edited to match the video version, and further sound editing may proceed in normal fashion.

In addition to speed and the ease of assembling different versions of the film, video editing makes possible the mixing of multiple layers of visual images much more quickly and easily than can be done through actual optical printing. In fact, images can be mixed and remixed almost as easily as sound tracks. Francis Ford Coppola's *Apocalypse Now* owes many of its multiple-image optical-effect sequences to the fact that the film was edited on videotape so that these sequences could be easily tested in the editing. They were then

reproduced in an optical house, using the original film, to match the video edit.

TECHNIQUES OF EDITING

The editing of most films follows a standard procedure, which is nearly the same for fiction, documentary, and sponsored films, no matter who does the actual editing. A filmmaker may both direct and edit a film, either single-handedly or with assistance. Often, however, the director feels too "close" to the raw footage, and prefers to hire an editor who can deal with the material more objectively. A director may give the editor a great deal of creative freedom, or may control and supervise the whole process very tightly. An editor may work alone, but he sometimes supervises a whole group of assistants and apprentices. The sound editor is often a specialist, who goes to work only after the picture and principal dialogue have been shaped.

Preliminary Steps. From the *camera original* film, a copy is made called the *work print*. It is this copy that is cut and spliced, in order to save the precious original. A copy is also made on magnetic film stock of the original sound recordings. The director may order the printing and sound transfer of only selected takes, so that the editor does not work with all the material that was shot.

The editor organizes and logs all material, and groups together all sync-sound sequences, all *MOS picture* (picture shot without sync-sound, or "mitout sound," a term attributed to an early Hollywood director of German origin), and all *wild sound* (sound without picture). On a major feature production, each day's takes of film and sound are immediately printed, synchronized, and organized by the editor so that they can be projected during the shooting process. These camera and sound takes are called *dailies* or *rushes*.

Assembly. When shooting is completed, the editor organizes all material according to scenes and arranges all material for each scene in the script order or, in the case of some documentary films, into chronological order or some other meaningful order. This arrangement of all the footage is called the *assembly*. Even in montage films, experimental films, or compilation films, all footage is arranged in some order for purposes of evaluation.

Evaluation. The assembly is viewed by the editor, the director,

and any other interested parties, and each camera take is evaluated in terms of acting quality, photographic quality, emotional tone, and its potential for meaningful connection to other takes. A basic plan of editing is determined, and certain takes are selected as potentially useful for the building of the film.

In many documentary films, a transcript of all recorded dialogue in the footage is made at the assembly stage. This transcript is used in preparing an editing script; it is much faster to choose sections from the written transcript than from viewing hours of footage.

Rough Cut. Slates and excess material are trimmed from the selected takes, which are then arranged, scene by scene, into a *rough cut*. The rough cut will have the basic shape and overall structure of a film, but will be perhaps twice as long as ultimately desired, possibly with "holes" where material will have to be added. Scenes may be deliberately left long, and the rhythm and timing of edit points may be only roughly determined. All material that does not find its way into the rough cut is carefully catalogued, because it may be needed for a later version of the film. Whole takes that are stored in this way are called *outs;* portions of shots are called *trims*. From now until completion of the editing, all outs and trims, even pieces of a few frames in length, are arranged in order. They are usually replaced into the rolls from which the selected shots were taken, in exact sequence. This is called *reconstituting* the work print.

Fine Cut. The rough cut is evaluated, and further decisions are made on the overall structure of the film. Some scenes are recut; rapid montage sequences are edited; shots are edited to precise lengths; rhythm and timing of sequences are more precisely determined. Much material is removed. This shorter version is called a *fine cut*. The fine cut of a fiction film may represent only one-fifth of the actual footage, or in some documentaries as little as one-thirtieth. The fine cut is again evaluated for its effect, and may still be revised several times. When the filmmakers decide that no more revisions are needed in the fine cut of picture and sync sound, the picture is said to be *locked*. At this point, most of the editing left to do will be sound editing—although the picture can still be revised if desired.

Opticals and Sound Editing. The locked fine cut is evaluated for sound editing. At the same time, any special optical effects, such as freeze frames or superimpositions, are ordered from an optical house so that they can be inserted in the fine cut.

OPTICAL PRINTING. This is a technique for rephotographing camera-original film, one frame at a time, under carefully controlled conditions, to produce special visual effects. In the freeze frame, which is a common optical effect, one frame of camera original is rephotographed for a number of frames. The effect is to see the action suddenly freeze and appear on the screen as a still photograph. The action can also be speeded up or slowed down on the optical printer, by photographing only every other frame of a shot or by photographing each frame two or three times. The optical printer also allows special combinations of separate shots. In a *wipe,* one shot replaces another by appearing to push it off the screen from right to left or from left to right.

The optical printer also allows for the precise positioning of one image within another and for *masking* or *matting* parts of a frame. In this process, parts of an image drop out and can be replaced by another image. In a normal double exposure, we see two images overlapping and apparently filling the same space. The masking function of an optical printer allows the filmmaker to superimpose two images so that there is a distinct outline or boundary between them within the frame and neither image shows through or overlaps the other.

Portions of shots can be inserted within other shots in many different ways. For example, in Richard Myer's *American Death Styles,* surrealistic images are placed on billboards and inside windows and mirrors by combining shots. Titles can also be framed and positioned inside a shot through optical printing.

In addition, optical printing may be used to create scenes that simply cannot be photographed in a studio. For example, George Lucas's *Star Wars* has many scenes built up from multiple layers of superimposed images that are combined to create the illusion of battles between rocket ships or skirmishes with light-emitting weapons.

In feature films, the optical printer is used for special effects and transitions between shots, for freeze frames, and for title sequences. The editor may also employ the optical printer to "reframe" shots by optically printing a small portion of a medium shot in order to create a close-up. The optical printer can also be used as the principal tool for combining and structuring images. The films of Patrick O'Neill combine images in a sort of surrealistic collage, which is

carefully controlled and structured through the optical printer. Paul Sharits has made films based on moving frame lines, sprocket holes, and colored frames through the gate of an optical printer to create a vision of film that is impossible to achieve through normal photography and projection.

SOUND EDITING. The sound editor "cleans up" the sync tracks by removing unwanted sounds, adds background ambience and sound effects to fill holes, and makes cuts in music, narration, and dubbed dialogue in precise counterpoint to other sounds and to the picture. Finally, he arranges all sounds on several tracks for the mix, and prepares detailed *cue sheets* that show where each sound is located on each track.

Final Stages. The film is mixed at a sound studio, and an *optical sound* copy of the master mix is made for printing at the lab. The camera-original film, from which the work print was copied, is now matched to the edited work print and is cut and spliced. This edited original film is then delivered to the laboratory, and copies are made that include the *optical stripe* (see page 127) of the mixed sound track. These are called *composite prints* because they include both picture and sound on a single strand of film. The first composite print, called the *answer print,* is used as a starting point and a guide for making further *corrected prints*. In the corrected prints, the color balance and light values are precisely adjusted for each shot. Only when a corrected composite print is made that finally meets the requirements of the filmmakers in terms of color balance and light values is the film considered completed.

This adjusting process is referred to as *timing* the film, and the editor generally works very closely with the laboratory technician, called the *timer,* who makes the adjustments. The editor also supervises the production of any *printing masters* (copies of the film from which other copies are to be printed), and any *blowups* to a larger format (as from 16mm to 35mm).

SPECIALIZED TECHNIQUES

The normal editing process as described in the previous section applies to most documentary, feature, and sponsored films, with variations depending on the specific production. For example, a film may be shot with no synchronized dialogue, in which case the first stage

of *syncing up* the rushes is skipped. On the other hand, there are a number of specialized techniques that can be employed in film editing but are used more rarely.

Contact Printing. This is the normal printing process used in making copies of film footage. The film to be copied is placed in direct contact with a roll of unexposed film, and a light is shined through the original film to expose the print stock. Laboratories generally reproduce the original film image as accurately as possible or make only the subtle color or light changes desired by the filmmaker. It is possible, however, to make copies that appear radically different from the original material, through use of color filters and special print stocks. The technique of *bipacking,* which involves placing a third strip of film between the original film and the print stock, makes possible a controlled combination of images different in effect from a simple double exposure. Loops of film may be used in the printing process to create a rhythmic cycle of movement and imagery.

Copies can be made of the altered copies, and other copies can be made from those copies, until film is generated that is many *generations* removed from the original and radically altered in appearance. This process may produce complex visual effects. Standish Lawder's *Raindance* and *Corridor* are examples of the kind of visual music that it can achieve.

Editing in Camera. Sometimes a film is so carefully planned that little or no editing is required after the shooting. This is more easily done with short films, such as D. A. Pennebaker's five-minute *Daybreak Express,* a visual study of New York's Third Avenue El. The shots appear in this film in almost exactly the same order as they were made in the camera. The technique can also be applied to longer films. Alfred Hitchcock's *Rope* is a feature film made of only twelve actual shots, each one a complete camera roll, ten minutes long. The film was shot so as to appear to take place in real time (120 minutes), and the cut points between each take were concealed so that the film appears to have no cuts at all. Hitchcock called *Rope* a "stunt"—it is in sharp contrast to his normal way of working. (*The Birds* contains over 1,300 separate shots!)

"Found Footage" and Compilation Films. Sometimes films aren't actually shot as such; instead, they are compiled in the editing process from *found footage,* shot either for other films or for some

MIX TRACKS AND PICTURE

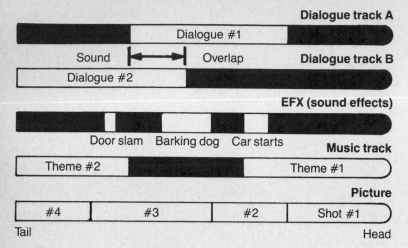

Edited sound tracks and picture, ready for the sound mix. The black indicates leader or filler without an audio signal. Note the overlap of sounds on separate tracks. The Dialog and EFX tracks may include ambient or background sound, so that "silent" portions of the final mixed track will still have an audible "presence." Twenty or more separate sound tracks may be mixed for a feature film.

other purpose. In this case, it really is the editor who almost single-handedly creates the film. Compilation sequences may be combined with other footage shot specifically for the film. During World War II, both German and American propaganda films used some of the same footage, which was edited to suggest a very different message.

Found footage may have little intrinsic coherence. Bruce Baillie's short film *A Movie* combines sequences from radically different sources, including war films, love stories, comedies, even printed film leader, to make an absurd and lighthearted collage that actually tells a little story. Standish Lawder's *Dangling Participle* employs footage from several "educational" films of the 1950s made to instruct teen-agers about sex, manners, and morals. The result is a wildly funny parody of social attitudes on these subjects.

THE ART OF EDITING

The art of editing draws upon skills similar to those required for many other arts. It is like graphic design in its arrangement and

framing of shapes; like sculpture and architecture in its presentation of three-dimensional spaces and spatial relationships; like music in its rhythms and counterpoint; like theater in its dramatic movements; like literature in its verbal shapes and content.

Still, editing is a unique art. This is so in part because the editor works not with a blank page or an empty canvas or a virgin block of stone, but with materials that have already been given form by the cinematographer, the sound recordist, the director, or by other film artists. Editing is also unique as a collage of many elements and as a process that involves making many different kinds of aesthetic decisions for simultaneous effect.

Creating Sequence, Time, and Space. The editor usually begins to work with a given number of elements—the camera takes and recorded sounds—and must determine the order in which to present them. In most fiction films, some of these decisions have already been made at the scriptwriting stage. Still, the editor has the freedom to arrange shots in different sequences within the broad framework of the scripted action. Sometimes he may decide to change the order of events from script order, or even to rearrange the shots in order to create new events out of the same footage. In this case, the editing becomes a kind of direct writing with film. In editing documentaries, the arrangement and ordering of footage is especially important—this is the stage in which the film is really "written." The same footage can be arranged so as to communicate entirely different messages or "realities." Compilation films are also "written" in the editing through the arrangement and ordering of shots.

The precise timing of shots and the selection of portions of a series of actions make possible the creation of an unfolding film time, which may be either speeded up or slowed down relative to the real time in which events take place. The careful selection of shots can also effect a flashback or flash-forward from the apparent "present" time of a narrative. These leaps in time usually involve a leap in space and environment as well. A number of visual and sound cues are needed to clearly identify the new time and place.

The selection of shots also makes possible the impression of a space and environment in which events take place. Details can be presented and camera angles combined to give an emotional atmosphere to a space, or even to create a special film space out of elements shot at several different locations.

Inserts and *cutaways* are useful for the creation of both film space and film time. These are short shots inserted into the continuity of a longer shot or between separate shots that are to appear as continuous in space or time. They can be used to stretch or accelerate the duration of an action or to add elements to an environment.

Selecting Images and Sounds. Editors usually begin to work with much more footage and sound than they will ultimately use in the finished film. Accordingly, one of the essential decision-making processes of editing is the evaluation and selection of a limited number of images and sounds out of all the available footage and recorded sound. The selection is based not only on the content of sound and picture takes but also on the emphasis and implications of different takes of the same subjects or the same action, and on the effects of different camera angles, visual compositions, and sound perspectives. Images and sounds are also selected in part because of the way in which they can be connected with other shots and sounds. Perfectly good shots often go unused because they break continuity or would result in *jump cuts* (see "Editing for Continuity" later in this chapter). Although the practice of editing requires considerable experience and technical knowledge, the basic principles an editor employs to suggest meaning are relatively simple. All are based on the combination of separate shots, images, and sounds to convey meaning.

CUMULATIVE EFFECTS. One approach to editing a sequence is the building up of a series of images or shots that has a cumulative effect, that develops a theme, or that leads our attention and our emotions from one point to another. For example, a scene that includes both action and dialogue may gradually be developed as a confrontation between two characters, as in the classic face-off of a western. In such a scene, we might see in wide shot two gunslingers approaching each other from opposite ends of the street. We could cut to the face of each one, looking grim and determined, and to shots of townspeople taking cover or peering from behind shuttered windows. We then cut to close shots of the feet of the stalking gunslingers, then to their grim faces again. The sequence begins to build a feeling of suspense, danger, and impending doom. One of the gunslingers stops and calls a challenge to the other. In a new shot, we see defiance in his opponent's face, which turns to pain as he is hit. A new shot shows that he is holding his wrist: The gun has been

shot out of his hand. A shot of the challenger shows him satisfied, but indecisive; a new shot of the wounded man shows him terrified and helpless, but holding his ground. In the next shot, the attacker turns away, mounts his horse, and rides off. Each new shot in the sequence has thus built upon the action developed in previous shots, added something new, and carried the confrontation further toward its conclusion.

REPETITION/REINFORCEMENT. The editor may reinforce or reiterate a single theme throughout a series of shots. This kind of movement is often used to introduce a major sequence or a new location. For example, the opening sequence of Robert Flaherty's *Louisiana Story* is a series of shots of elements of the natural world of the bayous: leaves floating on water, egrets, trailing Spanish moss, alligators, and the like. These shots gradually build up a mood and a feeling for the world in which the protagonist, a young Cajun boy, is finally introduced as he glides along the bayou in his narrow canoe.

CONTRAST. The editor may contrast shots, to create either a direct and emotional shock or a more subtle idea. He may contrast the content of images as such, or their more purely visual aspects, such as composition, lighting, or position of subjects in the frame. In the "Odessa Steps" sequence of Sergei Eisenstein's *Potemkin,* the rigid, implacable, and relentlessly advancing line of expressionless soldiers is contrasted with shots of the chaotic and frenzied retreat of the terrified and vulnerable demonstrators; the inexorable and mechanical massed movement of troops is contrasted with the struggles of lone individuals in their pain and death. In a scene such as a boxing match or a gladiatorial combat, we might see a series of individual shots of the spectators, showing contrasting expressions and emotions of hope, delight, or dismay. The editor may also contrast two separate scenes by *intercutting* between them.

ABSTRACT MONTAGE. The editor may contrast or compare shots with no direct connection in order to suggest an abstract idea or a deeper metaphorical connection. In Vsevolod Pudovkin's *Mother,* one sequence combines shots of the revolutionary hero in prison, of workers in arms, and of blocks of ice sweeping down a thawing river to suggest a revolutionary and emotional thawing or breaking free.

THE TWIST. The editor may lead us to anticipate something in one shot, or in a series of shots, which is then denied and shown to be a false expectation. The effect may be comic, frightening, ironic, or

just a visual surprise. In Maya Deren's *Choreography for Camera,* the male dancer takes a running leap in an interior setting, there is a cut to another angle at the height of his leap, and he lands in an outdoor setting.

Establishing Rhythms. The editor controls rhythms of cutting, rhythms of action, and rhythms of sound. A sequence can be edited with many short shots or a few longer ones, or it can gradually move from longer shots to shorter ones or vice versa. Such cutting can create a subliminal feeling of tempo, perhaps of urgency or of stateliness. These cutting rhythms can work in counterpoint to the rhythms of the action, which may itself be slow or fast. The tempo of sounds or music adds a third rhythmic element, which may reinforce or contrast with the pace of cutting and the pace of the action. Slow, majestic music could reinforce the effect of slow-paced action edited in long shots. A quicker musical tempo, or tempo of sound effects and dialogue, could help sustain a quicker tempo of action, cut in shorter shots. A fast tempo on the sound track could also contrast with a slower pace of action and cutting, for an ironic, dissociated effect.

Quick cutting is much more effective in picture than in sound. A single long take of music is often laid over a montage sequence of short shots. A good example of quick cutting in the sound track would be a battle scene, in which sounds of artillery, whining missiles, explosions, shouts, and perhaps music are edited together to form a dense, urgent layer of sound. Since sound cuts are inaudible, we are usually unaware of the rhythm of sound cutting and perceive the sound track as a single seamless movement of sound. We do, however, perceive a rhythm of individual sounds, which can have a slow or fast tempo.

A classic technique of editing is *intercutting,* the alternation of shots that present actions occurring simultaneously in different locations. In this case, we are usually quite aware of the rhythms of the editing, since each edit point presents an image and action that is clearly different from that of the previous shot. Chase scenes are often cut by this method, with the editor alternating shots of the pursuer and the pursued, frequently using shorter and shorter shots as the chase goes on, to build frenzy and suspense.

In fact, any sequence built of shots that appear noticeably different from each other calls attention to the rhythm of the editing, even

if there is only one location and a single flow of action. The edit points can be emphasized by differences between shots in subject, camera angle, lighting, and composition.

Editing for Continuity. Filmmakers have developed a set of rules of cinematography and editing that support the illusion of continuity. These give guidelines for creating apparent continuity of space, time, and action. They are, of course, not absolute rules; filmmakers are perfectly free to break them for a desired effect. They are based partly on our habits of perception and partly on the composition and movement of shots at the point where two shots are spliced.

JUMP CUTS. If the camera angle or distance from the subject changes slightly between two shots of the same subject, splicing the two shots together will create a *jump cut:* The subject will appear to jump slightly toward us or away from us, or to jump suddenly to the right or left. The jump cut tends to call attention to itself, appearing as an unnatural, mechanical motion. A jump cut can sometimes be avoided by making sure that the subject appears *significantly* larger or smaller in one of the two shots. A cut from a medium shot to a close-up will not appear as a jump, whereas a cut from one medium shot to another might. The jump cut can also be avoided by choosing camera angles that are significantly different. A cut from a frontal angle to a full three-quarter or side angle will not appear as a jump. However, if the camera is shifted only a few degrees to one side between two shots, a jump will occur at the edit point.

Another kind of jump cut can occur if the subject moves between two shots that show the change in position against a common background. A shot of a person bending over will jump when spliced to a shot of the same person standing. The editor can avoid this kind of jump cut by splicing an *insert shot* or *cutaway* shot of another subject between the two shots so as to cover the elapsed time of the movement. Documentary cinematographers shoot cutaways and inserts as a matter of course, since they often cannot direct the action for smooth continuity.

CUTTING ON THE ACTION. The smoothest transition between two shots is often achieved by cutting from one shot to another in the middle of a continuous action. Our eye tends to follow the movement itself, without noticing the change of angles. The opposite is also true: A cut from a frame without motion to a shot in which a

motion begins tends to emphasize the abruptness of the action.

In order for the editor to cut on the action, the cinematographer must *overlap the action* so that the exact edit point can be found for the smoothest possible transition. To do this, the entire action may be repeated in shots from two different angles. Alternatively, a performer may carry an action partway through in one shot, and then in the second shot repeat only part of the same action and carry it through to completion.

SCREEN DIRECTION. The rules of screen direction apply both to the direction of movement through the frame and to the direction of performer's looks and glances within the frame.

If a horse or a train is seen traveling through the frame from right to left in one shot and from left to right in the following shot, we would assume that the subject has somehow turned around and is going in the opposite direction. In fact, the camera may simply have shifted position from one side of the subject to the other between the two shots. To guard against this effect, cinematographers follow the *180° rule* in photographing motion: They always photograph a moving subject from only one side of its axis of motion. The editor will then be able to keep the subject always moving toward screen right or screen left throughout a series of shots and thus can preserve the illusion of continuous progression. To maintain continuity, the editor may also use a shot of the subject moving directly toward or away from the camera. This kind of shot can be inserted between two shots in which the subject moves toward opposite sides of the screen in order to suggest that our angle of view, rather than the direction of movement, is shifting.

The same principle applies to the direction in which performers appear to be looking. If a close-up of one performer looking toward screen right is followed by a close-up of another performer looking toward screen left, we tend to assume that they are looking at each other, talking to each other, or confronting each other. If the performers in both shots are looking toward the same side of the screen, we assume that they are looking in the same direction. If a performer is seen looking toward screen right in one shot and toward screen left in the next shot, we tend to assume that he has turned around, when in fact the camera may simply have changed position. Therefore, the cinematographer follows the 180° rule in photographing performers, staying always on one side of the performers' direction

of looks. A direct frontal or rear shot can be used to change the angle without making it appear that a performer has turned around. Also, the camera may move around the performers during the shot, thus setting up a new 180° axis to be followed in subsequent cuts. In shooting close-ups, the performer is often directed to look to the right or left of the camera in order to maintain proper screen direction.

LIGHTING, COLOR, AND TONE. The cinematographer tries to maintain a consistent color balance and overall tone of lighting throughout a scene, so that the editor can maintain the shot-to-shot continuity of tone and atmosphere. Some shifts in color balance and exposure can be corrected in the laboratory (for example, a bluish shot and a reddish shot can sometimes be printed to the same hue, and a dark scene can be printed lighter). Severe color contrast, however, cannot be corrected, and consequently the editor may be unable to use an otherwise good shot that does not match the other shots of a scene.

CONTINUITY OF SOUND. The tone quality, or timbre, of sounds or voices must be continuous throughout a scene unless there is a change of placement. If the sound recordist has not been able to maintain this consistent tonal quality, differences can sometimes be corrected in the mix through the use of filters. In general, continuity of the sound track is relatively easy to achieve, because of the inaudibility of actual sound cuts and the possibilities for mixing several sounds together to create an effect.

BREAKING THE RULES. The rules of continuity are useful for maintaining an apparent continuity of space, time, and action, and also for creating an effect of "smooth" editing, in which cuts are concealed or made less noticeable.

In some films, however, other aspects become more important than simple continuity. Filmmakers sometimes find an effect of energy, of discontinuity, or of roughness more appropriate than the smooth and unobtrusive style. Jean-Luc Godard's first feature film, *Breathless,* is notable for its jump cuts, which occasionally sacrifice continuity of time and of space for an urgent, energetic, and indeed "breathless" effect. Jump cuts can also evoke humor, as when we see a rapid succession of shots of a single character wearing different costumes and disguises, or engaged in different activities, in a kind of frenzied catalogue.

Other kinds of films do not really concern themselves with continuity of space, time, and action. Stan Brakhage's *Dog Star Man: Prelude* combines images from different times, places, and points of view in a continually shifting mosaic of poetic energy. Views of nature and of man seem to tumble past at an incredible rate, giving an impression of a mystical connection of the vast and the infinitesimal, of the natural and the human worlds, linked by a pulsing, vibrating flow of energy.

Editing Dialogue. In dialogue sequences, the action is composed both of actual speech and of nonverbal actions and reactions. Cutting possibilities are somewhat more limited in dialogue scenes because of the need to stay focused on the verbal exchange. Editors often try to strike a balance between the verbal and the nonverbal aspects of a dialogue sequence. It is rare, for example, to see only the player who is talking while he is talking. A more common technique is to begin a piece of dialogue with a shot of the player who is talking and then to cut to a shot of the other player who is listening and showing his reaction. Such a shot is called a *reaction shot,* and the technique is called *overlapping sound.* This technique is so convincing that most of the visual content of a dialogue sequence might actually be composed of reaction shots!

The editor may emphasize certain lines of dialogue, or the reaction to certain lines, by cutting from a wider shot to a close-up on the line to be emphasized. The emphasis is created whether the close-up is a reaction shot or a close-up of the speaker.

One of the peculiar aspects of film dialogue is that it is the editor, not the actors, who has final control over the rhythms and timing of the scene. Through such devices as reaction shots, emphatic close-ups, and acceleration or expanding of film time, the editor can significantly alter an actor's performance—change the timing, cover for poorly delivered lines, and improve mediocre acting. Close reaction shots at the right moment can create the impression that an actor is responding subtly and with deep emotion, when in fact he is not doing anything at all.

STYLES OF EDITING

The earliest films were unedited. They ran for the length of a single reel, perhaps five minutes, and usually consisted of a single, wide-angle shot in which the action took place.

Certain subjects, however, could not be presented in this way. In Edwin S. Porter's *Life of an American Fireman,* produced in 1902, we see a fireman's office, a horse-drawn fire truck leaving the firehouse, the exterior of a burning building, and a bedroom interior of the burning building. Obviously, all these locations could not be filmed in a single shot—hence the need for editing separate shots together. (Incidentally, this was in part an early compilation film. Porter made use of some existing *stock footage* of fires to fill out his story.) Still, this kind of editing was basically utilitarian; it simply connected the actions and events, and was not really a style.

Dramatic Effect. It was another American filmmaker, D. W. Griffith, who from 1909 through the 1920s developed a style of true editing in which shots were used not simply to present different locations and actions but also to build dramatic impact. Griffith was a master of the dramatic close-up of a face or of a significant detail, which could be cut in at a critical moment in the action to heighten emotional tension. Griffith also developed the technique of intercutting two actions, as in a chase, to increase suspense and further intensify our identification with the drama.

Montage Theory. In Russia in the 1920s, Vsevolod Pudovkin and Sergei Eisenstein were in the vanguard of an exciting postrevolutionary boom in filmmaking. The Russians were especially concerned with the art of editing, which they saw as essential to good filmmaking. They looked to Griffith as a master, but soon developed their own approach.

Pudovkin developed a theory of editing based on the use of individual shots as the "building blocks" of a film. For him, the meaning of film derived from the relationships established through the linkage of shots. His films, such as *Mother* (1926), broke down actions and events into many separate shots.

Eisenstein went even further in his theories of editing. He maintained that meaning in film derives from a collision, or shock, between two independent and even unrelated images, and that a third meaning is thereby created that is separate from the content of the two individual images. Eisenstein's films would often fragment the action in an extreme manner, combining realistic and expressionistic content and stretching or accelerating film time in striking ways.

Eisenstein also developed a theory of "intellectual montage," in which images unrelated in space or time are combined to evoke an idea. For example, in *October,* as the Russian leader Kerenski as-

cends the steps of the csar's palace, Eisenstein cuts to the image of a peacock, to symbolize Kerenski's pride. Intellectual montage can also be used within the realist style by embedding images within a scene so that they not only seem a natural part of the environment but also have symbolic content.

In a variation of intellectual montage that might be called *psychological montage,* images are edited together to represent a character's dream, vision, or fantasy and to suggest his feelings and state of mind. The opening sequence of Coppola's *Apocalypse Now* is such a montage—images of the spinning overhead fan of Captain Willard's hotel room dissolve into the spinning blades of army helicopters to suggest an invading nightmarish vision.

Mise-en-Scène Theory. As film has matured as an art, Pudovkin's and Eisenstein's enthusiasm for montage has been tempered by other discoveries, although the principles they explored remain powerful.

Realist film theory gained in importance in the 1940s and 1950s, prompting a new assessment of the effect of montage. The influential film critic André Bazin suggested that Pudovkin's films, based on shots as building blocks, never really showed events but only referred to them. Bazin pointed out that a more powerful, because more realistic, effect may be achieved by presenting subjects in a single shot, rather than in the separate shots of a montage sequence. If, for example, a child is threatened by a lion, we have a much stronger visceral reaction if both child and lion are in the same shot and thus clearly in proximity than if we see each in a separate shot.

Since montage and mise-en-scène are stylistic tendencies rather than strict formulas, we often find that within the same film a filmmaker makes use of one or the other for specific effect. For example, in *Scenes from a Marriage,* Ingmar Bergman tends to show his two principal players in separate shots (montage) when he wishes to emphasize their antagonism toward each other, and in a single shot (mise-en-scène) when they are having a moment of reconciliation.

7

The Script

A script is one of the filmmaker's tools. He uses it during preproduction to prepare a film for shooting and then as a guide and reference during the shooting and editing processes.

A screenplay differs in several ways from a play written for the theater. We can read a play for its own literary merit, and may also use it as a guide for realizing many different kinds of productions. The filmscript can only suggest the sounds and images that it will bring to life, and has relatively little intrinsic interest. It is intended for only one production and is superseded and made obsolete by the actual production of the film.

A play's meaning is conveyed primarily through language—dialogue or monologue—whereas a film's meaning is conveyed through a variety of means: the visual effects, the sounds, the rhythm and pace of editing, the movement, the imagery, etc. The filmscript provides the basic structure for the weaving together of these elements.

FILMMAKING: FROM CONCEPT TO SCREEN

There are many ways of scripting a film and many ways of bringing a script to life on the screen. The filmmaker may scrupulously follow the script. On the other hand, a script may be revised drastically during shooting and editing, and a finished film may bear little resemblance to its script. In fact, many films have been produced without any script.

Films Without Scripts. Some filmmakers work essentially without scripts, other than a few personal notes and guidelines. They prefer to build the structure of a film in the shooting and the editing. This approach requires a strong vision and sense of structure on the

part of the filmmaker, or a gift for improvisation, or a subject with its own intrinsic visual or narrative structure.

FICTION FILMS. Many of the silent American comedies were based on a guiding concept or gag and then were improvised in the shooting by both the actors and the director. (On the other hand, the gags could be complicated and studios like Mack Sennett's employed a staff of writers to think them up.) More recently, directors—including John Cassavetes in *Husbands* and Jean-Luc Godard in *Pierrot le fou*—have improvised films without scripts. "I just write out the strong moments of the film," Godard explains, "and that gives me a kind of *frame* of six or seven points." Cassavetes relied heavily in his early work on the ability of his actors to improvise convincing dialogue based on an understanding of the characters they portrayed.

DOCUMENTARY FILMS. Documentary-film makers have worked without scrips as often as not. Some work through an accumulation of impressions and images. In making his short visual poems *The Bridge* and *Rain,* Joris Ivens spent many months filming short bits of footage at different times of the day and from different perspectives. He would develop and inspect the footage, then continue to seek out further variations on his themes. Each day's footage generated new ideas for the film, which was continually modified and augmented over succeeding months.

Other documentary-film makers have followed the progress of a naturally developing course of events or group of events. In making *Nanook of the North* (1922), Robert Flaherty simply filmed the daily activities of his Eskimo friend Nanook and pieced the shots together into a comprehensive image of life in the Arctic. Flaherty got Nanook's help in re-creating certain events, such as a walrus hunt, which were either typical or dramatic. He would then film whatever happened (the walruses were not amenable to much direction).

Beginning in the 1950s, a wave of *cinéma vérité* and *direct cinema* documentary-film makers have worked without scripts, either creating a human drama through direct confrontation or seeking out subjects that are charged with potential dramatic conflict.

Most of these films are edited in chronological order (or close to it). The film's structure derives from the process or schedule of filming itself or from the inherent narrative structure of the events

filmed. Jean Rouch, D. A. Pennebaker, Albert and David Maysles, Barbara Kopple, and Richard Leacock have all made films in this manner.

EXPERIMENTAL FILMS. Many experimentalists also work without scripts, either improvising their shooting in direct relation to the subject or combining images in the editing process to give structure to a film. Stan Brakhage, Bruce Baillie, and Andy Warhol have made films in this way. Some experimentalists structure their films around such a clear concept that no script is necessary. Andy Warhol's *Empire* was such a film: it simply presented a view of the Empire State Building from a single, fixed camera position as day turned into night over an eight-hour period.

The Scriptwriters. Some filmmakers write their own scripts as a guide for themselves and their collaborators. Many directors who have established unique styles—Jean Renoir and Orson Welles

Song lyric as script in D. A. Pennebaker's cinéma vérité feature *Don't Look Back* (1966). The camera is fixed, and Bob Dylan peels off cue cards for the audience as his "Subterranean Homesick Blues" plays on the sound track. The cue cards don't always match the lyrics. That's Allen Ginsberg poking about on the sidelines.

among others—have begun by writing their own scripts. Others, including François Truffaut, Akira Kurosawa, and Michelangelo Antonioni, prefer to cowrite their scripts, working closely with a collaborator.

Still other directors, including John Ford and Francis Ford Coppola, choose to work from scripts by professional *screenwriters*. A director or producer may use a script that has been written or may commission a script to be based on a *literary property,* such as a novel or a play. For example, the script for Francis Coppola's *God-father* was commissioned to be written by Mario Puzo, the author of the book on which the film was based. Usually, however, a script based on a literary property is written not by the original author but by a professional screenwriter. Some screenwriters work strictly on films; others are novelists or playwrights who occasionally write screenplays on commission. Novelists William Faulkner and F. Scott Fitzgerald both wrote scripts for Hollywood.

Scripts are often written by several collaborators. One writer may specialize in narrative continuity and action, another in dialogue. First drafts of scripts are often rewritten at least once and sometimes by a succession of scriptwriters. It is not uncommon to see two or three names listed in the credits of a film for the script. In fact, it is almost an axiom of Hollywood production that scripts are rarely produced as first written.

The process of script revision can continue even into editing stages. Films are sometimes shot with two or more possible endings, of which one is picked late in the editing process. Tony Richardson's *Tom Jones* (1963) was originally shot as a serious realization of Fielding's novel—only after the "serious" footage was found to be a disaster was the story edited as a comedy. In many documentary films, the script for a narration or voice-over is not written until the final stages of editing.

ELEMENTS OF THE SCRIPT

Most narrative and documentary scripts indicate the major content elements of a film: the action, the important imagery, and the sound. They do not usually detail the formal structure of the film: montage, mise-en-scène, edit points, rhythms, and camera angles. Those details are worked out during the production process.

Occasionally a script will indicate a specific technique, such as a fade-out, a close-up, or a reverse angle, but only if the device is essential to the flow and tone of the action.

Nevertheless, all scripts are written as much as possible in visual terms, and the meaning is clearly conveyed by the action and dialogue. It does not make sense in a filmscript to write continuous interior monologues, omniscient editorial comments, or lengthy descriptions of a character's thoughts and emotions, since these elements will not appear on the screen or on the sound track. The screenwriter must be careful to show thoughts and interior feelings through sounds, visual imagery, and external action. (An internal monologue, however, may be recorded as a voice-over—one of the few ways of presenting thoughts in film.)

Script Content. There are several important elements that occur in scripts for both documentary and fiction films. Of course, some of these elements, such as narration and voice-overs, do not appear in every film.

LOCATIONS. A script indicates each new location, whether it is *interior* or *exterior,* with as much description as is relevant. Some locations are described in great detail to convey the atmosphere and character of a place; others may be simply indicated as "Exterior, City Street." Props and other elements within the scene may be described, if relevant.

CHARACTERS. Important characters are described briefly when introduced; others may simply be indicated as: AN OLD MAN. The writer may specify age, appearance, manner of speaking and moving, dress, and the like. In fictional scripts, the characters are often introduced by name; in documentary scripts, they are sometimes simply A FARMER or A HOUSEWIFE.

ACTION. If people are the subject, their activities and interactions are described. (The same goes for nonhuman actors, such as animals, robots, and cartoon figures.) If mechanical or natural processes are the subject, they, too, are described in detail. The pacing or tone of the action may also be indicated: "She advanced with a strong, firm tread," or "He nervously twisted his hands."

IMAGERY. Some sections of a film may be carried by imagery alone, without specific action or development. In any case, important imagery is indicated in the script, either independently or embedded in the descriptions of locations and characters. The script-

writer may indicate a montage sequence by theme or by principal imagery.

DIALOGUE. Dialogue is written out as in a play, with the name of the character speaking followed by the lines of dialogue. Special instructions may be given as to tone of voice and manner of delivery—GEORGE (hesitantly): "I thought you knew about what happened last night."

NARRATION AND VOICE-OVER. These are written out fully, like the dialogue, and introduced simply as: NARRATION or CATHY'S VOICE. Most scriptwriters employ narration or voice-over only for information that cannot be supplied directly in action or dialogue. Often a narration or voice-over is a means of emphasizing a point of view, whether an objective one or that of a character in the film.

SUPPORTIVE ELEMENTS. Sounds, musical interludes, and qualities of lighting and color may be indicated in the script. Title frames and subtitles are indicated as needed.

EDITING AND CAMERA INSTRUCTIONS. These are provided very sparingly in most scripts and usually only as suggestions, as aids in visualizing the action. The instruction FADE IN is often used to open a script or a scene; the instruction FADE OUT or CUT TO may be used to close a scene. It is understood that the director or editor will make his own decisions about such instructions.

Certain general instructions may be given in the script to describe the scene in terms of the subject of the shot rather than in terms of what the camera does: "ANGLE ON George."

NEW ANGLE or ANOTHER ANGLE indicates a change to a new shot. WIDER ANGLE or CLOSE SHOT can indicate a specific change. POV indicates a shot from one character's point of view; REVERSE ANGLE indicates a 180° shift in perspective. MOVING SHOT simply suggests that the camera move, without specifying whether it dollies, tracks, or cranes. INSERT refers to a close shot, as of a photograph or the face of a clock, inserted into a scene. Other terms occasionally used in scripts include OVER-THE-SHOULDER SHOT, TWO-SHOT, and THREE-SHOT.

Script Form. The script can take many forms: each is a different way of presenting and relating the content elements discussed above. A number of filmmakers devise their own form of script.

For *Que Viva Mexico,* Sergei Eisenstein filled hundreds of notebook pages with scribbled notes and sketches dealing with the imag-

ery of Mexican peasant life in all its struggles and contradictions. These notebooks served as his only script: a guide to shooting, in both words and pictures, without a specific narrative sequence.

There are, however, several standardized script formats that are used by many writers and filmmakers. Certain formats are used more frequently for theatrical films and others for documentaries. (See the sections on dramatic-script development, p. 181, and documentary script, p. 183, for examples.)

THE DRAMATIC SCRIPT

We can approach the dramatic script both from a technical point of view and in terms of overall concept and content. The early stages of a dramatic script are often quite similar to those of the short story or the play.

Theme and Concept. Every dramatic script has an identifiable central theme. The events, the images, and the plot development all serve to develop and reinforce that theme. Stating the theme of a film answers the question "What is the film about?" Although the plot and development of a film may be quite complicated, we can usually identify the principal theme in a few words.

The theme may be a perception about life, human nature, or social conditions. Charlie Chaplin's *Modern Times* focuses on inhumanity and alienation in the modern industrial world. The theme of Stanley Kubrick's *Dr. Strangelove* is the sheer insanity of war and warlike behavior in the age of nuclear weapons.

The theme of a script can often be expressed in terms of struggle or conflict. In Ingmar Bergman's *Seventh Seal,* the knight is struggling to know whether God exists, and the major conflict is his game with Death.

In Sylvester Stallone's *Rocky,* the struggle is simply for Rocky to prove himself as a man and as a fighter. The conflict is between his own aspirations and other people's expectations or judgments of him. Conflict and struggle are often embodied in opposing characters. In the traditional American western, justice and law are personified in the U.S. marshal; chaos and wickedness in the outlaw.

Dramatic Structure. Many scripts follow a *paradigm,* or standard structure, of theme and plot development. The paradigm resembles a three-act play, and we can thus separate most scripts into

three major divisions, each of which plays a distinct role in the development of the theme. The three acts, or divisions, of a typical screenplay are not identified by name or separated by intermissions; in fact, it is the screenwriter's goal to create a sense of the continuous, seamless unfolding of plot and action. Nevertheless, these divisions accurately describe the dramatic structure of many screenplays.

INTRODUCTION. The first act or major division of the screenplay introduces the principal characters, suggests something about their personalities and relationships, and presents the principal conflict of the film. Near the end of the first act, perhaps twenty to thirty minutes into the film, there occurs a major *plot point*—an event that polarizes the characters or the dramatic situation and sets up the essential conflict that will be played out in the rest of the film.

In the first act of *Seventh Seal,* all the major characters are introduced: the knight and his squire, Death personified, and the traveling carnival troupe. The chess game with Death is introduced in the first scene, but the first plot point does not occur until later. The knight has gone into a church to try to make his confession. Unknowingly, he is speaking to Death, who hides behind a screen. The knight tells of his struggle to discover the truth—to know if God exists—but at the end he lets slip the strategy that he will use to defeat Death in the chess game. At that moment, Death reveals himself, and the knight knows that he has been tricked. This is the first plot point, and it closes the first act. Death's trickery establishes that the chess game is going to be far more dangerous and unequal than the knight had thought.

CONFRONTATION. The second major division of a screenplay is basically a development of the struggle or conflict that has been established at the end of the first act. In *Seventh Seal,* the forces of death, destruction, and faithlessness are represented by the spread of the black plague, by the emerging character of Death, by the greed and vindictiveness of several minor characters, by the band of flagellants who whip themselves to purge their sins, by the cruelty of the priests who encourage this self-scourging, and by the burning at the stake of an ignorant girl who is accused of witchcraft.

The forces of faith and humanity are represented by the steadfastness of the knight, the innocent pleasures and good humor of the juggler and his wife, the protectiveness and sense of justice of the

knight's squire, and the juggler's visions of holiness. The second act plays off the forces of death against the forces of faith and humanity in a series of dramatic incidents involving these characters.

At the end of the second act, there is usually a second plot point, which brings to a head all the confrontation and struggle of the second act and initiates the resolution of the third act.

In *Seventh Seal,* this second major plot point occurs just after the knight has witnessed the execution of the young "witch" and while he is camped with his entourage in a dark forest. He has taken under his protection the juggler and his wife and child, but has just realized that Death has designs on them, too, and that it is dangerous for them to be in his company. Accordingly, he plays clumsily during his regular bout over the chess board and distracts Death so that the others can escape; he himself is checkmated.

RESOLUTION. The third act of a screenplay presents the resolution of the principal struggle and conflict. In *Seventh Seal,* the final plot point marks the end of the struggle for the knight—he has lost his game with Death. At the same time, he has achieved a victory. In sacrificing himself to save the juggler and his small family, he has finally committed an act of faith. Those three, at least, have won a reprieve from death, and the knight has chosen the only truth that he could find in helping them to win it—a truth of humanity, not of divinity. The knight's struggle against Death and his search for truth are resolved by his acceptance of his fate and by his knowledge that the juggler's innocent faith and vision will survive him. He returns at last to his home and to his wife, and waits calmly for his fate.

Dramatic Contours: Tension and Release. Besides the principal division into three major acts, a screenplay may contain a number of smaller dramatic movements. Each one is based on a conflict between characters or a conflict between a character and some event or process, like a storm at sea or a race against time.

We can plot a screenplay as a series of these dramatic movements, these moments of tension and release. However, there is no universal paradigm of tension and release in dramatic conflict; instead, the scriptwriter shapes the contours of emotional tension according to the needs of the plot and the theme. If we were to plot a film's peaks of emotional tension like a graph, we might find that fairly equal peaks of tension are achieved in each act, or that each

act builds to an even higher peak. In the days of silent comedy and serial adventure stories, films were divided into reels, and each reel would build to a peak of dramatic tension. Many contemporary horror films and adventure films are structured in almost the same way. Some films build tension through a series of conflicts or struggles, without significant release at the end of each conflict. Instead, there is a single major release that follows the highest peak of emotional tension.

Character Development. The dramatic contours of a script normally follow the behavior of the characters, and the theme is an abstraction from their behavior and experience. A scriptwriter may begin with a theme in mind and seek the characters who will exemplify the theme. Or he may begin with an idea about one or more principal characters and develop the details of their personalities and behavior until a theme is born.

Characters in a script may be based on real people, or they may be imaginary creations based on the writer's experience of life and human nature. But even if the creation of a character begins as a purely imaginative process, a writer usually finds that the logic of human emotion and experience comes to define and limit that character's behavior. Writers of novels, plays, and screenplays often speak of the moment in the writing process when their characters "take over"—when they begin to dictate to the writer what they are going to do. This is not necessarily a mystical or inspirational moment; it simply means that the reality of a character has become so firmly embedded in the writer's mind that the character's actions begin to follow a logic of their own. In the same way, we can usually predict how a person we know very well will behave in certain situations.

We can describe a principal character of a film in terms of his *goals,* the *obstacles* he faces, and the *actions* he takes to overcome these obstacles. In fact, screenwriters make conscious use of these elements in creating their characters and in building dramatic conflict.

In Paddy Chayefsky's screenplay *Network,* William Holden is a director of a network news show, an old hand in the field. His *goal* is simply to survive and to maintain his personal pride and sense of values in the rough-and-tumble world of corporate television. His *obstacles* are mainly people: a ruthless new corporate executive who

tries to reverse the network's declining ratings; an old friend, the tortured anchor man, who gradually goes crazy on the air; and a beautiful and ruthless young producer who wants to take over the news show and exploit the anchor man's insanity to raise the ratings.

Holden's beliefs involve him in a *struggle* with the other characters in the screenplay, and in several decisive *actions*. He tries to restrain and protect his friend the anchor man. He undertakes to collaborate with the new producer and gets himself fired in the process, but ends up having an affair with her. The affair leads him to a confrontation with his wife and eventually to a struggle with himself as he seeks to make sense of what he is doing. His final *actions* are to walk out on the producer, who he realizes represents the destruction of his values, and to return to his wife.

Each of the other principal characters can be similarly described in terms of goals, obstacles, and actions. It is interesting to note that in the course of the screenplay, William Holden undergoes a deep and wrenching experience of change—a testing of his values and the final realization of his commitment to them. This aspect of *change* and *realization* applies to the principal characters of most screenplays. It is a kind of *internal* drama that parallels the external dramatic action.

The paradigm of goal/obstacle/action is, of course, an extremely simplified way of looking at a character. A character may have several goals and face several obstacles, and these may change in the course of a screenplay. Any character may be as simple or as complex as the writer chooses to make him. In John Ford's *Stagecoach,* the characters are relatively *one-dimensional:* the bumbling old geezer, the warmhearted prostitute, the refined young lady, the sleazy gambler, the brave and earnest young cowboy/outlaw. In Orson Welles's *Citizen Kane,* the central character is mysterious and complex—everyone in the film has a different notion of what Kane was really about and what made him tick.

Adaptations—From Literature and Life. Filmmakers have often looked to literature for source material for their creative efforts. Also, like novelists and playwrights themselves, they have often found inspiration in historical events and in myths and folktales. These kinds of sources require special handling to become viable screenplays.

CONDENSATION. Most novels require severe condensation of

plot and action in order to work on the screen. Hitchcock once pointed out that without this condensation the average novel would take up eight to ten hours of screen time. Events can be telescoped into a shorter time frame, or can be referred to rather than shown; plots can be simplified, and minor characters and subplots can be dropped. Because of the extreme condensation that a novel requires, filmmakers have found that the short story translates more directly into a ninety-minute film than does the novel.

SHIFT OF APPROACH. Usually, the translation to film of a literary work requires a shift toward physical action, visual and spatial effects, and concrete objects and images. Novelists often write extensive passages of interior monologue, describing the thoughts and subjective feelings of the characters. Writers use metaphors freely, linking disparate images to create an idea or mood. These literary devices do not translate easily to film, and the filmmaker must find ways of casting the content of such passages into the filmic devices of action, dialogue, sound, and image. Thoughts and subjective feelings must be made exterior—turned into actions and images. Mood and ideas are evoked by dialogue, or by the more subtle clues of music, lighting, or visual composition. Sometimes, however, a filmmaker may deliberately employ a literary device. Robert Bresson's *Diary of a Country Priest* is based on the novel by Georges Bernanos, which is written in diary form. Bresson maintains the device of the diary by combining shots of the priest writing in his journal with a voice-over of actual passages from the novel.

The stage play presents somewhat different problems. Dialogue dominates the play, and action is limited to a small physical area and to the visual perspective of the theater audience. The major decision to be made in translating a play to film is whether or not to "open up" the play, to set it in a wider physical and spatial context, to add or expand locations. The action of a play can also be expanded in translation to film. Certain larger physical movements, like battles or skirmishes or travel by train or car, can be more effectively realized in film. Similarly, small subtle events or actions, like the movement of hands on a clock or the shuffling and dealing of cards, can be emphasized in film in a way impossible on the stage.

RESEARCH. For both literary and historical sources, the translation to film often requires extensive research into the manners, the technology, and the physical environment of the film's historical

period or social environment. Costumes, tools, furnishings, and artifacts are also carefully researched. This kind of research, often used by the director and the designer, finds its way into the script when it relates directly to the action or the dialogue.

Script Development. Most dramatic scripts proceed through a series of distinct stages on the way to becoming films. Each stage has its own special form.

THE TREATMENT. A treatment, or *outline,* is a short (from ten to forty pages) narrative synopsis of the film subject, incorporating some actual dialogue. The treatment suggests the tone and flavor of the film to be made and often includes a separate list of the principal characters with short descriptions. The treatment is usually the first stage of development of a story idea and is often used by the producer to raise production funds and to interest creative talent in the project. The treatment is an optional stage; many films begin with the screenplay itself.

THE SCREENPLAY. This is the basic script, usually about 120 pages long, which details the continuity of actions and images, for the most part without specifying shots and techniques. Camera angles, fades, dissolves, and cuts are occasionally indicated, but only as an aid to visualization, not as a strict direction. Dialogue is centered on the page and indented. The name of the character in capitals is centered on one line, followed by the dialogue on the next lines. Each new time and location is indicated by a heading in capitals, such as INTERIOR, GEORGE'S ROOM, DAY. Action and description are written in conventional narrative form across the page from margin to margin. The screenplay does not indicate exact edit points, lengths of shots, or mise-en-scène.

The screenplay may be based on a treatment or a literary *property,* or it may be written from scratch. In the absence of a treatment, the producer may use the screenplay itself to raise production funds and to interest creative talent in the project.

SCRIPT BREAKDOWN. Before production is begun, the producer or production manager prepares a detailed scene-by-scene analysis of locations, cast, special props and effects, and special weather conditions. Scenes and even individual shots are grouped together according to these elements, and the script breakdown is used as a basis for preparing a precise budget and production schedule.

THE SHOOTING SCRIPT. The shooting script is prepared by the

director. It includes notation of specific shots and angles, the blocking of the action, and other elements of the mise-en-scène.

The degree of detail of the shooting script is affected by the *shooting ratio* and the shooting style. The shooting ratio is the ratio of film actually shot to film used in the final edited film. For a dramatic film, a ratio of 5:1 or 10:1 is not uncommon. This means that five to ten times as much film was shot as was actually used. For a documentary, the ratio might be 15 or 20 to 1, or even higher. A high shooting ratio, and the shooting of master scenes and cutaways for every scene, requires less technical detail. A lower shooting ratio, and a style in which the editing of shots is determined before shooting, requires a more precise notation of each individual shot and calculation of its effect in relation to other shots.

STORYBOARDS. Storyboards are the equivalent of a script in visual, graphic form. A storyboard, which looks something like a cartoon strip, is a series of individual drawings, or frames, on a larger sheet of paper. Each frame represents a single shot or part of a shot. Captions indicate the action, dialogue, or camera position or movement.

Many directors make a storyboard to accompany the shooting script. The storyboard can be a series of rough sketches that simply suggest the look of sets and costumes, or it may rigorously detail the mise-en-scène and even the editing of sequences. Some films are designed so carefully in the storyboard that the camera has only to realize the detailed sketches and instructions. Television commercials, in particular, are usually strictly determined by the storyboard. Commercial storyboards are often prepared by an advertising agency and handed over to a film company for realization.

REWRITES. The screenplay may be rewritten several times on the way to production. Either the director, the producer, or an important star may call for revisions. Even after production has begun, a major rewrite can still take place.

During the rehearsal and production stages, the director may find that parts have to be rewritten to fit the capabilities and personalities of the principal actors, or an actor may have suggestions and ideas that will improve his part within the whole dramatic context. The writer or the director himself may do the revisions. If new dialogue or action seems necessary, the director will sometimes direct the actors in an improvisation and base the new material on the

results of the improvisation. Finally, the director may design shots or direct actors so as to completely alter the tone of a scene as written—to change it from serious drama to comedy, for example.

THE DOCUMENTARY SCRIPT

Documentary scripts pose a special problem, since the filmmaker is often unable to specify dialogue or the precise content or angle of shots. Some documentaries can be more easily scripted than others, but even the most free-form *cinéma-vérité* or *direct-cinema* film may be produced with the help of the written word.

Preproduction Scripts. Preproduction scripts for documentary films range in detail and formality from notes jotted in a journal to a complete audiovisual script that indicates exact relationships between picture and sound.

THE TREATMENT. Similar in purpose to the treatment for a dramatic film, the documentary treatment ranges in length from one to twenty pages. It presents the subject and theme of the film; mentions major locations, persons, and events; and gives some indication of the style of shooting and editing—whether hand-held, newsreel style or carefully composed and set-up shots. In addition, the treatment often includes some discussion of the intended audience and the means of distribution of the completed film.

THE OUTLINE SCRIPT. This type of script presents the actions and elements of the film. It is written in narrative prose rather than play form, but with indications of lighting, images, sounds, and other filmic elements. The outline script may simply describe an image or sound or may introduce it by a phrase such as "We see . . ." or "We hear. . . ." New scenes and locations are sometimes indicated by a heading, as "Morning Scene" or "Garage Scene." As with a dramatic script, camera angles and edit points are not usually specified.

THE AUDIOVISUAL SCRIPT. Many documentary and sponsored films are scripted in a two-column format, with the visual images noted on the left side of the page and the corresponding sounds or commentary on the right in an audio column. In this format, the relationship between picture and sound can be more or less precisely determined. The two-column script is often used for films that will rely heavily on a narration or commentary, so that specific images

can be linked to specific words of the narration. The visual images indicated might be single shots or montage sequences. Special effects such as fades, dissolves, or freeze frames are also indicated in the visual column.

Postproduction Scripts. For documentary films more often than for dramatic films, much of the script material may be written after the actual shooting.

THE EDITING SCRIPT. If a film has been shot in *cinéma-vérité* or *direct-cinema* style, without a detailed preproduction script, the scriptwriting takes place during the editing process.

The first step is the *logging* of scenes and shots. This results in a detailed written record of all available visual material, to which the editor will refer in constructing the film. At the same time, all important dialogue scenes or interviews, including off-camera dialogue and interviews, are transcribed to paper. It is much easier and quicker for the editor to evaluate and compare the content of spoken material in written form.

The editor or the director then sits down with the log of scenes and the transcription of dialogue and begins to construct out of the available material a shape and structure for the film. A rough outline is prepared, and based on the outline a *rough cut* of the film is made.

At this point, the editing process becomes more or less similar to that of a scripted film, although in revising the rough cut the editor or director may refer to the logs and transcripts.

NARRATION AND COMMENTARY. Although the narration may be written first as a guide to shooting, it may also be written after the shooting as a way of tying together scenes, making transitions, providing additional information, or reinforcing mood. After evaluation of the edited film, the director or editor may write a few lines of narration to solve specific problems, or a writer may be called in to provide a full-fledged commentary. The writer or director determines the basic content of the narration, decides on a tone or style, and writes material to fit specific sections of the partially edited film. Documentary narration ranges in style and tone from simple, didactic explanatory statements, to ironic, tongue-in-cheek commentary, to poetic, evocative language. In fact, some noted documentary narrations have been written by poets, such as W. H. Auden's narration for Basil Wright's *Night Mail* (1937).

SCRIPTING EXPERIMENTAL FILMS

Experimental films may be thought of as films that for one reason or another do not fit into the normal genres of dramatic feature, documentary, short fiction, or the like. One way in which an experimental film may depart from the established genres is in its script, or lack of one.

Dramatic Improvisation. As noted previously, many dramatic or theatrical experimental films have been made without any script at all. Instead of a scripted dialogue and action, the filmmaker may suggest characters or roles and basic plot lines or actions to his actors, and allow them to freely improvise scenes for the camera based on these roles and outlines.

The filmmaker may give the actors a great deal of freedom in creating their own roles, or may choose to work with performers who have developed their own theatrical roles independently of the film being produced. Jack Smith, in *Flaming Creatures,* and Andy Warhol, in *Chelsea Girls* and many other films, have worked with actors in this way. In their films, the dramatic and narrative interest centers on the confrontation and interaction of players rather than on dramatic structure or plot development.

Technical Improvisation. Experimental filmmakers who do not work with actors or in a theatrical mode may also work without a script, basing their films on improvisation in a particular area such as photography, editing, or special effects.

Stan Brakhage is a filmmaker who has relied heavily on improvisational photography and editing. In his films, the camera is often used to create nearly abstract movements of light, color, and texture, and his editing creates rhythms of images and of pure color and texture without reference to a predetermined script.

Other filmmakers have based their improvisations on special technical processes. Jordan Belson built a machine that creates glowing, swirling clouds of light and color. His films are essentially controlled improvisations on this instrument.

Many experimental filmmakers work with video synthesizers, computers, optical printers, and contact printers as instruments for improvising visual patterns and movement.

Design as Script. Some filmmakers who work in an essentially

visual, painterly mode generate their designs on paper before incorporating them into a film. In effect, the work on paper is a visual script, which is turned into a film through an animation process.

As early as the 1920s, Hans Richter and Viking Eggeling were making films in this way. They actually began by creating long scroll-like works, intended to be unrolled and viewed as a progression of visual design elements. However, they soon turned to film as a means of creating a visual work that would progress or develop in time.

Scripted Experimental Films. It is in this category that the term "experimental" really becomes awkward, since many experimental films are as carefully scripted and planned as dramatic features. Some more or less experimental films that have been based on carefully prepared scripts and scenarios include Jean Cocteau's *Blood of a Poet* (1930), Gregory Markopoulos's *Illiac Passion* (1967), and Jean-Marie Straub's *Eyes do not wish to close at all times, or, Perhaps one day Rome will permit herself to choose in her turn* (1969).

Unique Scripts. In certain *structural* films, the script may take the form of elaborate notes and formulas that indicate the system or process by which the film is composed. Many of these "scripts" greatly resemble the notation of musical scores. Hollis Frampton's *Zorn's Llemma* (1970) is based on a complicated architecture of conceptual relationships between images and systematic processes for replacing one image with another. The film was carefully planned and organized on paper, although the notes and formulas bear little resemblance to any of the ordinary script formats. Jacques Carty's *Point de Fuite* (*Vanishing Point*) (1980) is a series of musically composed images taken of and through a window, and was also based on a complicated set of geometric and numerical notations. For his "flicker" films, Paul Sharits prepares an elaborate, detailed visual design that indicates the color and image content of each individual frame.

Politically and Socially Influenced Scripting. Some filmmakers have attempted to develop scripts in a way that reflects social or political values. The most significant approach in this area has been the involvement in the scriptwriting process of a film's subject. *Blow for Blow,* a dramatic film about a successful wildcat strike by women garment workers in France, was produced by a women's film-

making collective in collaboration with the factory workers, who not only acted in the film but also participated in writing the script, and voted on each scene after videotaping it.

In another field, several anthropological filmmakers have involved subjects of their films in the process of production. In one of the first such experiments, Sol Worth set up a production workshop on a Navaho reservation, taught several Indians the basic techniques of shooting and editing, and helped them to write their own scripts and produce their own films. These films were then distributed through normal academic channels as anthropological resource material.

8

Producing and Directing Films

Some filmmakers prefer to work alone, but most films are produced through a team effort. Theater and symphonic music also require the coordinated efforts of a group of artists, and such works are usually carefully controlled throughout by one or two people—the playwright and director in theater, and the composer and conductor in symphonic music.

In many film productions, the director serves more of a coordinating than a controlling function—he is at the center of things rather than at the top. The producer, the cameraperson, the editor, and others may all have a great deal of autonomy in contributing to the final look of a film.

THE PEOPLE WHO MAKE FILMS

Although a film may be made either by one or two filmmakers or by a vast organization of many technicians and creative people, we have come to think of the director as the one who has the final creative control and makes the crucial creative decisions for a production. This is true for some films and not true for others. It is sometimes the scriptwriter who dominates a production, sometimes the producer, sometimes the actors. It is true that the director has the *potential* for playing this role by coordinating all the creative and technical functions that go into the making of a film. Often, however, the director plays a more limited role, concentrating on certain creative or technical areas and leaving many decisions to others.

To understand what a director does, or might do, we need to know something about each of the functions that the filmmaking team

might perform. On a large, well-funded feature film, each function, from the fund raising to the sound editing, is usually carried out by a specialist. Of course, not every film calls for all the functions that we will describe: To suggest one exception, most documentary productions do not require a wardrobe supervisor. For financial or other reasons, certain functions may be eliminated from a given production. It is also possible for several functions to be performed by the same person: For example, many documentarians and independent filmmakers like to photograph, direct, and edit their own films.

The Producer's Unit. The producer's unit deals primarily with the financial and business aspects of making a film, but it is not necessarily limited to these areas.

EXECUTIVE PRODUCER. The executive producer secures the necessary funds to make a film, manages cash flow during the production, and makes arrangements for distribution and sale of the completed film.

The executive producer may be the person who actually initiates a film production, or he may join a production after some preparation has already been made. The major Hollywood studios will sometimes assign an executive producer to a film that is being produced or directed by relatively inexperienced filmmakers.

The roles of the executive producer and of the *line producer,* who manages the day-to-day production of a film, are often performed by the same person, called simply the *producer.*

PRODUCER (LINE PRODUCER). This is the person who is in charge of the ongoing organizational and financial aspects of the whole production, from writing to editing. The responsibilities and functions of a producer are essentially the same for both theatrical and documentary films and for television programs and series.

The producer supervises the purchasing of goods and services, the hiring of personnel, the accounting, and the cash flow. He may also be involved in many creative decisions about the writing, the casting, the shooting, and the editing; or he may stand back and let the director and other creative people make those decisions.

The producer is often the person who initiates a production. He may buy a *property* (that is, the rights to make a film of a book or other story) and then hire a writer to make a treatment or a script. He might also buy an original treatment or script and put together a *package,* consisting of script, a director, and one or more actors or

stars, which he then tries to sell to individuals or corporations as a financial investment. The producer is thus often instrumental in deciding who will direct a film and who will play the principal roles. In the history of the Hollywood industry, many producers have also maintained creative control over other aspects of the production.

On the other hand, a director with a proven track record may write or find a script he wishes to direct and take it to a producer in order to get the financial backing to make the film. Depending on the kind of agreement the director makes with the producer, either of the two may have final creative control over the film. The right to *final cut* is crucial to this control. Many a director has supervised the editing of a film according to his wishes, only to have the film completely reedited and transformed because the producer has retained the right of final cut.

PRODUCTION MANAGER. An essential member of the producer's unit, the production manager joins a production at the point when actual preparation for shooting begins. He is responsible for conducting the day-to-day business and organizational operations of a film. He arranges for purchasing of supplies and services, for transportation of equipment and people, and for all necessary facilities at the shooting locations. He helps plan the overall production schedule and sees that all necessary daily arrangements are made to keep the production on schedule. He may also assist in drawing up a detailed budget for the production.

UNIT MANAGER. The unit manager works on location and is directly responsible for housing, transportation, meals, payroll, and supplies.

The Director's Unit. The director is first of all in charge of the day-to-day progress of shooting on the set or location. He creates the mise-en-scène of a film by coordinating the activities of the technical crew with the performance of the actors of a fiction film, or the subjects of a documentary.

In some cases, the director's role is limited to these activities. This is particularly true of television production and for films in which the producer takes the dominant creative role. In other instances, the director's influence and control extend to every aspect of a production, so that he becomes the principal creator or "author" of a film.

DIRECTOR OF DRAMATIC FILMS. The director's work usually begins with making a shooting script or a set of storyboards as a guide to how he will set up specific shots. He may hold rehearsals with the actors before the shooting period begins or may simply rehearse shots briefly on the set while the technical crew is setting up or standing by. In either case, he works with the actors in the way that a director works in the theater to develop and guide their performances in keeping with the theme and the dramatic contours of the script.

Like a stage director, he also determines the *blocking* of the action—that is, he will indicate specific actions that the players are to perform and will determine the overall timing and pacing of their actions and their movements in relation to each other and to elements of the set or location.

On the stage, blocking is determined in relation to the audience's point of view. In film production, blocking is created for the camera and in coordination with the camera's positions and movements. The director will ask actors to look in specific directions and to move to certain positions or *marks* so as to appear correctly within the frame.

The director also works closely with the *director of cinematography* and with other technical personnel. In consultation with the cinematographer, he will establish camera positions and camera movements and coordinate the movements of the actors with the actual photography and sound recording.

In addition, he consults with the technical crew in order to establish all other visual and sound effects. The lighting, the camera positions, and the sound recording are choreographed and adjusted until the desired effect is achieved. The director may ask for a specific quality of lighting to create a certain mood, or for a specific lens or shift of focus to create a desired feeling of space. He also approves the choice and placement of props and other set elements.

After preparing the actors and supervising the preparation of the technical crew, the director determines when all the elements are ready for a shot to be taken. He gives precise instructions for the execution of the shot and cues the actors and crew for a *take*.

The director evaluates the performance of the crew and the actors while the shot is being executed and decides whether or not a second

take should be made. He will sometimes ask for many takes of a single shot in order to achieve precise nuances of technical and dramatic performance.

If some of the takes have obvious technical or dramatic problems, the director will indicate that only certain takes are to be work-printed and made available for the editing.

DIRECTOR OF DOCUMENTARY FILMS. Although most documentary films do not employ actors as such, the director performs essentially the same functions on a documentary film as on a dramatic feature. He coordinates the work of the technical crew with the activities of the film's subjects and determines the mise-en-scène to a greater or lesser extent, depending on the constraints of the shooting process. He directs the crew to the chosen locations and within each location may suggest camera positions and even specific shots. Many documentary directors do their own camerawork; others work with one or more camerapersons and may allow the cameraperson a great deal of freedom in choosing and framing shots.

In working with the subjects of the film, the documentary director may assume one of several different roles. He may collaborate closely with the subjects, discussing approaches to the filming process; he may adapt the filming process to ideas and wishes of the subjects; or he may suggest activities for the subjects to perform and locations to shoot in. The latter approach tends toward the active creation or re-creation of reality for the film.

Robert Flaherty worked with his Eskimo subjects in this way when making *Nanook of the North*. He and Nanook would each suggest possible scenes for the film and would then work out together the best way for the scenes to be shot. It was Nanook who suggested a walrus-hunting scene and who organized a group of Eskimos for the hunt. In a scene of an igloo interior, Nanook cooperated with the filmmaking process by cutting away half the igloo so that Flaherty would have enough light to film by. Nanook and his family then enacted a scene of undressing and preparing for bed while exposed to the freezing open air.

The documentary director may, on the other hand, approach his subjects as a more passive observer. He will communicate with them to the extent of learning as much as he can about their activities, but will then work as unobtrusively as possible in the subjects' presence and insofar as possible will not attempt to influence their activities.

The effect of this approach is that the subjects often appear to forget the presence of the camera and crew and begin to allow extremely natural and candid behavior to be recorded. In the United States, filmmakers Albert and David Maysles, D. A. Pennebaker, Frederick Wiseman, Richard Leacock, and many others have worked in this way.

Documentary directors are often closely involved in the editing process. In fact, editing is so crucial to the shape and message of a documentary film, especially an unscripted film, that the editor is sometimes credited as a codirector of the film.

DIRECTOR AS FILMMAKER. Although the director's role is sometimes limited to working out the mise-en-scène and supervising the shooting process, he is often involved in other aspects of a production. Sometimes his influence is so pervasive that the film strongly reflects his personal vision, even though many other artists and craftspeople have contributed.

A director's vision and influence may be so strong and consistent that we can recognize basic stylistic or thematic similarities throughout his work. These similarities are reinforced if the director chooses to work with the same group of actors, as does Ingmar Bergman, or with the same writer, as does Woody Allen. Even within the constraints of the Hollywood studio system, under the watchful eyes of powerful producers and working within the conventional forms like the thriller and the western, such directors as Alfred Hitchcock, John Ford, Howard Hawks, Nicholas Ray, Frank Capra, and Samuel Fuller were often able to impose their own stylistic and thematic imprint on their work.

To influence the whole production, the director may either work closely with other members of the production team or perform certain functions himself. He may be involved in the financing of a production or may even produce the film. He may write the script, collaborate with a writer, or require revisions of a script that he is to direct. He may strongly influence the casting process and make final decisions on casting. He will work closely with the art director and make final decisions regarding the physical appearance of sets, costumes, and locations.

With the help of camera and lighting assistants, some directors perform their own photography. The director as filmmaker will take charge of the editing. He may work side by side with an editor or

allow the editor a degree of creative freedom while himself making the final creative decisions. The director may also collaborate with the composer of film music or even write the music himself.

OTHER MEMBERS OF THE UNIT. The *assistant director* performs numerous tasks that do not require the director's personal supervision. These can include the scheduling of shots, supervision of crews, conducting walk-throughs of the action, and arranging to fill the personal requirements and requests of the actors. The assistant director is something of a traffic cop, coordinating the work of the various crew members and actors.

The *casting director* arranges casting calls and interviews with potential players and keeps files of auditions, interviews, and screen tests.

The *location scout* researches and explores possible shooting locations, evaluates their feasibility, takes photographs for a location file, and arranges permissions.

The *script clerk,* or *continuity person,* works on location during shooting and sees that all props, lighting, and positions of actors and set elements are consistent from one shot to another for purposes of editing. The script clerk must make sure that details match between shots that may be taken hours, days, or weeks apart. He also keeps exact records of camera and sound takes for editing purposes.

An *acting coach* (or coaches) may be hired to assist with special performance problems. For example, a performer may be called upon to sing or dance in a role without having much experience in these areas. A singing or dancing coach would instruct him in the basic techniques necessary for the role. For help with a specific problem, an actor may independently consult an acting coach, who may or may not appear on the set or become an official member of the production team.

The Design Unit. Members of the design unit work closely with the director in the planning of a film, including the design, construction, and preparation of sets, the modification of actual locations, the design of props, costumes, and sometimes even lighting.

Documentary-film makers, of course, usually work without a design unit, but designers assist in the production of most dramatic films and those films that make use of sets or attempt to re-create reality. Some design artists contribute to the conception and planning of a film; others assist in the execution of plans and sketches.

ART DIRECTOR/PRODUCTION DESIGNER. With the director, the
art director works out an overall design concept and treatment of
the film's theme. A given theme might be treated as realistic, as
fantasy, as a monumental epic, as an expressionistic work, or in
many other ways.

The designer then begins to work with the director on the mise-
en-scène and shot breakdown, and his plans and compositions be-
come part of the actual shooting script. The designer tries to estab-
lish the symbolic meaning and emotional tone of each location. He
uses costuming and other elements to add meaning to individual
characters and locations and to specific dramatic moments.

Some of the basic elements the designer works with include tones
and contrasts of light and dark, color and texture, sharpness or soft-
ness of focus, movement of the camera within the frame, spatial
perspective and depth, the quality of light and shadow, and the
apparent sources of light.

The designer may plan a composition in depth as a series of planes
of distance from foreground to background. He will compose with
diagonal lines, horizontals, or verticals according to the desired emo-
tional tone of a scene or location. He may also work with angles of
vision by designing several levels of height within a set and by sug-
gesting specific high or low camera angles.

Finally, the designer considers the combined interlocking effect of
all design elements, including costumes, props, and sets or locations.

OTHER MEMBERS OF THE UNIT. The *art department* prepares
layouts, floor plans, and drawings and three-dimensional models of
proposed sets and locations. Sketches and paintings may be executed
to suggest the tone and feeling of major scenes and locations. A
sketch artist or *draftsman* may work with the director to prepare a
storyboard or series of continuity sketches for the entire film.

The *costume designer* considers characterization, the dramatic
context of scenes, and the set or other environment in creating a
costume plan for the entire film.

Once the basic design elements have been chosen, the *set dresser*
researches props and materials and collaborates with the art direc-
tor in arranging them within the set or location.

The *construction manager* and *carpenters* may physically build
the set or may radically modify an existing location to fit the design
treatment. The *construction crew* may add facades to existing build-

ings or even build new structures on existing locations. *Gardeners* may landscape the grounds. *Scenic artists* paint backdrops and other large areas within the set.

Stagehands and *riggers* are responsible for setting up, moving, and dismantling set elements during the shooting. The *property department* keeps an inventory of properties for the production and acquires or constructs properties as needed.

Makeup and wardrobe personnel work closely with the performers and may respond to their suggestions and requests as well as to the director's or art director's instructions.

The Production Staff. The production staff includes all the technicians, craftsmen, and assistants who perform the actual lighting, photography, and sound recording of a film. This staff can be quite large for a feature film or may comprise just one or two people for a documentary or animated short.

CINEMATOGRAPHY FOR DRAMATIC FEATURES AND SHORTS. The *director of cinematography* (or *cinematographer*) is in charge of the whole process of photography, including lighting and liaison with the film laboratory as well as the actual execution of shots.

He works closely with the director, either to execute the director's wishes or in full collaboration with him. For a given film, the director and cinematographer usually work out together an overall photographic style or approach. The cinematography should reinforce the basic design concept and treatment, whether it be realism or fantasy. Some cinematographers tend to specialize in a particular style or approach; others become skilled at adapting their techniques to a variety of different design concepts and types of films.

In working out his approach to a film, the cinematographer chooses a film stock for its qualities of contrast and color tone. He makes decisions about the optimum exposure and often performs extensive test photography in order to achieve a precise effect. He may, for example, be looking for soft pastel tones, for a grainy effect, or for vivid, vibrant colors.

The cinematographer plans the lighting to reinforce the effect of the film stock and processing. He may work for brilliant, *high-key* lighting throughout a film or for a *low-key* contrast effect. He may prefer to work with luminaires and elaborate lighting equipment or to use natural available light as much as possible. Of course, he may vary lighting in individual scenes to reinforce the dramatic moment.

The cinematographer may also choose to work with a given *f-stop* throughout a scene or a film in order to achieve a desired depth of field (shallow or deep) in his compositions. This means that he will need a given light level, measured in *footcandles,* on every set and location. He transmits his lighting requirements to the *gaffer,* who is in charge of all lighting circuits and equipment. The gaffer directs his assistant, called the *best boy,* and his crew of *electricians* in the actual setting up, powering, and adjusting of lighting equipment.

The cinematographer also works directly with the *camera crew,* which handles the positioning and operation of the camera or cameras. On many productions, the cinematographer will direct the placement of the camera and the choice of lenses but will have a *camera operator* perform the actual shooting. The cinematographer may also be assisted by a *focus-puller,* who will change the focus of the lens during a shot, and by a *camera assistant,* who will load and change *magazines* and keep records of shots and camera rolls.

Another crew member who works closely with the camera crew is the *grip,* a general handyman who can move or adjust sets, repair props, perform stagehand work, prepare special camera mounts (such as a camera mount on the hood or door of an automobile), and pull a dolly for a moving shot.

A large production may employ a smaller *second unit.* This camera crew may work simultaneously with the first unit for a large action scene like a battle scene, or may perform additional location photography that is peripheral to the main action. The second unit may also work at a separate location.

DOCUMENTARY CINEMATOGRAPHY. The camera crew for a documentary film is usually much smaller in number than the crew of a dramatic feature or commercial short. A basic crew might consist of a *cameraperson,* who actually operates the camera; a *camera assistant,* who loads magazines and keeps records; and a single *gaffer,* who manages the lighting. Many documentary films are shot by a single cameraperson, using available light, without an assistant. On the other hand, a large or complex event may require several camerapersons, shooting simultaneously in the same or different locations.

The technique of documentary cinematography may resemble that of a dramatic feature, with carefully planned and set-up shots and prepared lighting, or it may be quite different. In the *direct-cinema* or *cinéma-vérité* style, the cameraperson works with a port-

able, hand-held camera and engages in a kind of spontaneous, improvised response to the subject, usually shooting long camera takes in real time. This technique requires great skill on the part of the cameraperson, who realizes that every one of his movements and adjustments—including his mistakes, his shaky movements, his finding of focus—may appear on the screen if the filmed moment itself is crucial to the story. The cameraperson strives for a fluidity of response that will minimize such problems and a sensitivity to the dramatic elements of the image and the action that will overshadow unavoidable flaws. In this kind of shooting, the mobility of the camera is essential, and the cameraperson must be prepared to walk with the subject, to move in and out of rooms, to climb into a car or a bus while still shooting.

THE SOUND CREW. The sound crew for a dramatic feature might consist of a *boom operator,* who wields the microphone boom; a *mixer,* who mixes and controls the levels of several microphone inputs; and a *recordist,* who controls the level of the mixed signal as it is fed into the recorder. The functions of mixer and recordist are often performed by the same person.

A sound crew might also include a *general assistant,* who maintains the equipment and accessories and assists in setting up microphones. Many films are shot with a sound crew of only one or two people. For documentaries, in particular, the "sound crew" is usually a single person who operates the recorder and positions the microphone at the same time. On the other hand, special circumstances, such as a musical performance, may require more elaborate recording equipment and a large sound crew.

The Animation Team. Filmmakers can employ a great variety of techniques to produce animated films or sequences. Many animated films are produced by a single individual who performs all the necessary design and technical functions. These individually produced animated films are usually quite short, since the work is laborious. It may require many hours of production to result in a few seconds' worth of actual film. Because of this fact, large studios have developed a complex production system, involving much division of labor, in order to produce longer films such as animated features or television series. This system is based on the technique of *cel animation,* discussed in chapter 4.

The distinction between design and production functions becomes

somewhat blurred in the animation process, since the design staff physically produces all the images of the film. The production staff—including sound technicians, editors, and camera operators—is engaged in combining and giving motion, sound, and continuity to the images that the design staff has created.

DIRECTING ANIMATED FILMS. The *director* of an animated film coordinates all the activities of the production team. There is usually no live photography to be shot, so he does not direct a set or location. Nevertheless, he works closely with all the writers, artists, technicians, actors (for characters' voices), musicians, and editors whose skills go toward the creation of each animated sequence. Like the director of a live-action film, he is responsible for making the final creative decisions.

He works with a *storyboard artist* to break down the script into component scenes and sequences. At the same time, other artists are working out detailed drawings of the characters and settings of the film.

DRAWING FOR ANIMATED FILMS. The *character artist* interprets the script to create individual characters of distinct personality and behavior. For each character, he makes several *model sheets* on which he sketches the character from many points of view, suggesting different expressions and physical stances and indicating the physical size of the character relative to other characters.

The *layout artist* creates the imaginary space in which the characters are to move. In numerous sketches and realizations, he indicates all the elements of the environment, including the landscapes, vegetation, buildings, and fixed props. He plans the physical arrangement of these elements within the imaginary space and plots out in rough form the characters' paths of movement within these spaces.

He works with color values and light and may create apparent sources of light within the settings or suggest contrasts of light values between the characters and the backgrounds.

The layout artist also works out the effect of scene-to-scene transitions and designs camera movements such as pans or zooms. In each scene and sequence, he strives to create a mood or atmosphere for the setting that will reinforce the meaning of the script.

RECORDING FOR ANIMATED FILMS. The *sound editor* of an animated film sometimes completes his work before the visual elements

are given final form. The complete sound track, including music, dialogue, and effects, may be recorded and mixed before any sequences are photographed.

After the sound is mixed, the sound editor plots on paper an exact visual record of every element in the sound track. Sound elements are recorded on a *bar sheet* in spaces that correspond to single frames of sound track. The editor records on a separate line each major element, whether effect, music, or dialogue. These markings can then be used to determine the precise timing of movements of characters, including lip movements.

COMPLETING THE DESIGN. The *background artist* colors in and finishes the sketches of settings and environments made by the layout artist.

The *animator* begins to place the characters in each scene, referring to the script and storyboard and to the spatial indications of the layout artist. He plots the key points of movement and position of each character within the setting.

The *in-betweener* refers to these key positions or points of movement and fills in all the steps between them by making a series of images of the character in motion. He creates the effect of moving limbs, clothing, facial expressions, trees blown by the wind, etc. These drawings are made on paper.

The *inker* transfers the character drawings to transparent cels by tracing the outlines. The *opaquer,* or *colorist,* fills in these outlines and adds details.

The *checker* examines all the cels and the background painting(s) that go into each scene. If several characters are in the frame at the same time, each character may be drawn on a separate cel so that his movements can be produced independently. Sometimes parts of a single figure, such as the body and wheels of a train, may be painted on separate cels. The checker lays these cels on top of one another and makes sure that they are *registered* properly: that they appear in the correct portion of the frame and that the movement of each character is continuous.

CAMERAWORK FOR ANIMATED FILMS. The *camera operator* works with the *animation stand,* and refers to an *exposure sheet,* which provides precise instructions for the framing and cel elements of each frame of a scene. He changes and moves individual cels on the animation stand according to the instructions of the exposure

sheet. (See chapter 4, pp. 73–76, for further discussion of animation techniques.)

LIVE-ACTION PROCESSING. A *live-action crew* may contribute to an animated production. A scene may combine live action and animated elements, or the director may use live action as a guide to the creation of complex animated movements. In the *rotoscope* technique, live-action footage is projected onto a translucent plate so that tracings can be made of characters or backgrounds. For *Lord of the Rings,* director Ralph Bakshi photographed extensive live footage of battle scenes, which were then transformed into animation to achieve a greater realism of movement.

VIDEO PROCESSING. As noted in chapter 4, recent developments in computers and electronic video synthesizers make it possible to transform and modify the shapes and colors of any visual image and to combine images in unusual ways. This kind of processing (which was used extensively in Ralph Bakshi's *Wizards*) is performed in a video studio by specialists.

The Editing Staff. The editing staff of a film may range in size from one person to more than a score. The *editor* is responsible for supervising the entire editing process and for making the final creative decisions about the structure and shape of the film, or for seeing to it that the director's or producer's suggestions or instructions are carried out.

The editor may work with one or more *assistant* or *apprentice editors,* who perform much of the routine work of organizing material, record-keeping, *syncing rushes,* keeping track of *outs* and *trims,* and *reconstituting* the work print. The assistant editor may be allowed to construct short sequences of a film, subject to the editor's approval.

Sound editors and *music editors* are specialized craftspeople who are recruited to put together sound effects and musical sequences after the main structure of visual image and dialogue has been determined. Sound and music editing is painstaking, detailed work that may require as much time as does the principal image and dialogue editing.

STYLES OF DIRECTING

The filmmaker/director makes many decisions that affect the final shape and appearance of a film, either independently or in collabo-

ration with other members of a production team. These decisions may in time add up to an indentifiable directorial style. In the history of film, we can identify a number of distinct directorial styles and approaches that have been used by filmmakers of widely varying cultures and circumstances.

The Director's Choices. Some of the same *kinds* of decisions need to be made for almost every film, whether it be dramatic fiction, documentary, experimental, or animated.

THEME AND STORY. Like the director of a stage play, the film director must examine the script closely, if he has not himself written it, to determine which themes he will try to bring out. Like a stage play, a film script may suggest several possible themes. To realize a script, the director must also develop a strong and clear concept of each of the major roles and how they are to be played. These concepts will strongly affect the story and theme.

For many documentary films, the director's concept of theme and story may be stronger even than the writer's, especially when the writer is brought in after the shooting process to construct a narration. It is a misconception that documentary-film makers simply shoot what they find. Even cinéma-vérité films rely heavily on the director's concept of theme and story.

IMAGES AND MOVEMENT. The director's choice of images, camera movements, and *pacing* of shots and action can strongly influence the effect of theme and story. Although a script may indicate the principal images and some possible approaches to photography or editing, it is the director's responsibility to create the nuances and visual details of every moment of a film. Different directors would be likely to realize the same script in quite different ways of creating shots and blocking and pacing the action.

Directors like Sergei Einsenstein have worked primarily through the montage technique of breaking down the action into sequences of shots. Others, including Jean Renoir and Michelangelo Antonioni, prefer the mise-en-scène technique of longer shots with carefully choreographed action and camera movement. Directors of the American silent comedies worked toward a rapid, almost frenzied pace of action or cutting. Other filmmakers—such as Marguerite Duras in *India Song*, Stanley Kubrick in *Barry Lyndon*, and Alain Resnais in *Last Year at Marienbad*—have worked in a much slower pace, both within and between shots, evoking stately and meditative or constrained and claustrophobic effects.

In documentary films, we can easily observe the effect of the director's decisions concerning image and movement. In *Louisiana Story*, Robert Flaherty photographed and paced the visual imagery as carefully as would any director of dramatic fiction. In the direct-cinema or cinéma-vérité style, however, filmmakers like the Maysles brothers, D. A. Pennebaker, and Richard Leacock follow the action with a casual fluidity of hand-held-camera work that often eschews the steady, carefully composed shot in favor of a kind of exuberance and involvement with the subject and the energy of the moment.

DIALOGUE AND SOUND. A director may use sound and dialogue to reinforce realism and to "fill out" the visual images, or he may use the aural elements more creatively and consciously, creating a

Federico Fellini's romantic theatricality in *La Dolce Vita* (1959). The pools of light, the design, the relationships, and the gestures suggest the grand opera. Note the shallow focus that blurs but does not obscure the figure of Marcello Mastroianni in the background. His gesture and Anita Ekberg's incarnation of sensuality and innocence are pure Fellini.

complex sound track that can support, interact with, or even domi-
nate the image. In composing the complex sound track, he may lean
more toward expressionistic or toward realistic effects.

The script may suggest approaches to the sound track, but it is
often the director/filmmaker who makes the crucial decisions about
tone and emphasis on a scene-to-scene basis. Dialogue or voice-over
may be added to scenes by means other than simple lip synchroniza-
tion. Music and musiclike sounds or effects can add a depth and
richness to a film in a way that cannot be precisely notated in the
script. In mixing the sound for a scene, the director may choose to
emphasize the dialogue, the sound effects, or the music, and he may
shift the emphasis during the course of the scene.

ACTORS AND SUBJECTS. A director's way of working with the
actors or other subjects of a film is truly his responsibility and is a
key element of his style. Filmmakers have approached this responsi-
bility in quite different ways. At one extreme are directors like Al-
fred Hitchcock and Robert Bresson, who think of their actors as
essentially elements in a visual design or as vehicles of the spoken
text. At the other extreme, directors like Robert Altman and John
Cassavetes work in close collaboration with their actors, allowing
them a great deal of creative freedom and input in shaping their own
performances.

Even in documentary filmmaking, the director's approach to his
subjects can produce quite different results. In many documentary
productions, the director really *directs* the subjects a great deal,
setting up shots and actions for the camera. Other documentarians,
especially in the *direct-cinema*, or *cinéma-vérité*, style, tend to keep
to the background and act as neutral observers, simply recording
their subjects without much direct interaction. Even in the cinéma-
vérité mode, however, the filmmaker/director may choose to step
into the action to provoke a response. He may also suggest scenes
that would give a new turn to the subjects' lives. This kind of in-
volvement might be as simple as asking a sensitive question in an
interview, or as elaborate as arranging a meeting between family
members who have not seen each other for years.

MOTIFS AND OTHER CODES OF MEANING. The director can
strongly affect the emotional implications and the *subtext* of the
basic theme and story through a variety of codes of meaning, includ-
ing symbol and motif, point of view, realism, expressionism, and

references to the film medium itself. We can often recognize a direc-
tor's characteristic style in his use of these codes of meaning. (For
example, Fellini's expressionism, Godard's self-referential cinema.)

Directing Fiction. Directors of fiction film may wish to amuse
and entertain, to present a true-to-life or historical drama, to adapt
a literary work to film, to express their own feelings and ideas about
life or human nature, or to undertake a process of investigation and
discovery.

SHARED APPROACHES. In different parts of the world and in
different historical periods, there have been groups of filmmakers
who have worked in similar ways or for similar purposes. Their
common interests, shared values, and interest in each other's work
often result in an overlapping or sharing of technique and approach-
es. In retrospect, we see stylistic similarities in their work.

For example, in the Soviet Union, after the 1917 revolution, a
group of directors including Eisenstein, Pudovkin, and Dovzhenko,

Soldiers rescuing a surfboard in *Apocalypse Now* (1979), Francis Coppola's vision of
the Vietnam War. His basically realist style in this film is heightened by such surreal
moments, which are all the more compelling in that they have the ring of truth.

turned to film as the most effective medium for expressing the humanistic and intellectual ideals of their time and place. Their films exhibit many individual differences but also a number of stylistic similarities, including a reliance on montage and a thematic involvement with the lives and struggles of the working class.

In the United States in the 1920s, the general mood was quite different and many filmmakers worked in the genres of comedy and other forms of entertainment. Although no one would mistake a Chaplin film for one directed by Keaton, we recognize stylistic similarities between their works, including the madcap chase and the theme of the ordinary fellow caught up in a series of improbable events.

Sometimes we can observe stylistic affinities that seem to cross geographic and temporal boundaries. In Japan, Teinosuke Kinusaga's *Pages of Madness* (1926) was a tour de force of montage technique, going beyond even Eisenstein and Pudovkin, and at the same time it evoked the fearful imagery and mysterious processes of the unconscious mind as powerfully as did any of the 1920s German expressionist films. Similarly, we can view Maya Deren's 1943 American film *Meshes in the Afternoon* as a work in the tradition of the French surrealist and dadaist films of the Twenties.

INDIVIDUAL STYLES. We can most easily identify individual directorial styles by their relationship to film technique, to the means of production, or to certain themes or codes of meaning.

Federico Fellini, for example, takes a special interest in the casting process, interviewing hundreds of people, both actors and nonactors, to find exactly the kinds of faces and appearances he is looking for. Alfred Hitchcock focused on the planning of shots—working out the mise-en-scène in such rigorous detail that the director of cinematography would have little to do but execute Hitchcock's written instructions. Ingmar Bergman concerns himself especially with acting and has frequently worked with the same small group of players, who have appeared in many of his films. He tries to build an atmosphere of concentration, intimacy, and emotional intensity on the set or location.

Some groups of filmmakers, such as the Italian neorealists and the *cinéastes* of the French New Wave, have made a virtue of the necessity for a low budget by working with small crews and with a minimum of technical encumbrances. They would often resort to

hand-held camera shooting or to the use of available natural light-
ing. The result is an immediacy and freedom of style and a sense of
almost documentary realism. Other filmmakers, such as Cecil B. De
Mille, Stanley Kubrick, and Francis Ford Coppola, have chosen to
work on a grand scale, with massive production facilities, elaborate
sets, big crews, "casts of thousands," and the most sophisticated
technical support systems available. Such films often appear grandi-
ose, even operatic in style.

One of the most interesting aspects of a director's individual style
may be his preoccupation with similar or recurring themes. Some
directors have specialized in certain *genres*, or typical stories, such
as suspense, comedy, or the western, and have worked with similar
themes within their chosen genre. Chaplin, for example, often
worked with the theme of the innocent chump who is caught up
willy-nilly in a series of hazardous adventures. Hitchcock, working
in the genre of suspense, frequently based his stories on the theme of
"the wrong man" (the title of one of his films)—an innocent person
caught up in dangerous events or mistakenly accused of a crime.

Even outside the limits of the genre film, directors have often
chosen to work with similar themes in different films. In many of his
films (e.g., *8½, Juliet of the Spirits, Satyricon, Casanova*), Federico
Fellini has focused on the overlapping of theater and dreams with
ordinary life. His characters seem to live in a world of heightened
theatricality, which is perhaps a dreamworld of their own. Ingmar
Bergman has often dealt with themes of the confrontation with
death, the search for God or for meaning, the struggle to love, the
experience of madness. In many of his films, Luis Buñuel has por-
trayed the absurdity and cruelty of social and religious institutions
in both realistic and surrealistic ways.

PSYCHOLOGY OF DIRECTION. Consciously or unconsciously, di-
rectors of feature films usually develop a consistent individual ap-
proach to the coordination of the crew, the actors, and other creative
contributors. They tend to play a specific psychological role in the
production process, one that is often reflected in the style or content
of their films.

Alfred Hitchcock was known for the cold precision with which he
organized a production. Eric von Stroheim and Otto Preminger
played the roles of strict disciplinarians, while Jean Renoir and
François Truffaut have preferred to work in a more gentle and se-

ductive spirit. Fred Zinnemann and David Lean have relied on their
air of competence and personal charm to inspire support.

A number of directors, including Ingmar Bergman, Elia Kazan,
and Francis Ford Coppola, have taken an intimate, almost psycho-
analytic approach to their work with actors. Others, such as Orson
Welles and Federico Fellini, have relied on their personal mystique
as artists to command the involvement of crew and players. Some
directors, notably Robert Altman, have directed films in an open,
almost communal style, shaping the group dynamics of the produc-
tion team and players and allowing considerable creative input from
both groups.

Directing Documentary Films. A number of different goals have
motivated the documentary-film maker and affected his directorial
style. He may wish to entertain or amuse, to present a true story
from history or the present day, or to explore certain ideas about life
and human nature through the medium of real-life events. He may
be attracted by the visual beauty or human fascination of a subject
and wish to communicate this vision. He may also wish to explore a
subject, to discover something about a place or group of people by
making the film as a kind of *reportage,* or journalistic report. He
may feel passionately about a subject or an issue and make a film in
order to convey information or ideas in a vivid and effective way.

In addition to the filmmaker's motivations, a number of stylistic
tendencies have informed the history of documentary film. Al-
though the documentary-film maker will often combine several ap-
proaches in a single film, we can identify more or less pure examples
of each.

THE POETIC DOCUMENTARY. Poetry is, of course, a literary
form, but we can identify a strain of documentary filmmaking that
emphasizes and exploits the rhythms, compositions, and symbolic
implications of images and sounds in a way similar to a poet's work-
ing with words.

An example of the poetic documentary is Joris Ivens's *The Bridge*
(1928), for which the filmmaker recorded hundreds of shots of dif-
ferent aspects of a drawbridge over the Maas River in Rotterdam.
Ivens filmed the motions of the bridge in long shot and close-up,
from many different angles, and he also photographed the move-
ments of trains passing over the bridge and ships beneath it. From
this footage, he edited a short film that is a kind of visual music,

based on the rhythms of movements within the shots, the various directions of movement, and the contrasting tones of light and dark.

In *Berlin—Symphony of a City* (1927), Walter Ruttmann took on a larger subject. This half-hour film is a poetic vision of the German capital. Beginning with images of a train rushing toward Berlin in early morning, the film progresses throughout a typical day in the city, exploiting the rhythms and images of people at work in offices and factories, crowds on the streets, motorcars and trolleys. In *N.Y., N.Y.* (1958), Francis Thompson created a poetic vision of a city in quite a different way. He used special lenses and mirrors to turn buildings, people, and cars into colorful abstract shapes, which flow and change before our eyes. In Hilary Harris's *Organism* (1976), another vision of New York City, activity is speeded up through *time-lapse photography* to create the effect of people and vehicles streaming through the streets like corpuscles in an artery of the body.

THE CLASSICAL DOCUMENTARY. The "classical" documentary focuses on people as personalities and characters and on events as dramatic or illustrative episodes. Robert Flaherty, John Grierson, Pare Lorentz, Sidney Meyers, and other filmmakers have worked in this style.

The director may actually script the documentary, determining principal characters and conflicts. He will compose and set up shots for the camera much as would be done for a fiction film. In fact, the classical documentary often resembles a fiction film in appearance. However, the crew will usually be much smaller than the crew for a fiction film and will work primarily on location with available light or simple lighting setups. The tripod is often used. A narration may explain events that are not made clear by the dialogue or may replace dialogue entirely.

CINÉMA VÉRITÉ (DIRECT CINEMA). *Cinéma vérité* (translated literally, the French term means "film truth"), or *direct cinema,* usually looks very different from the ordinary fiction film. Like the classical documentary, cinéma-vérité may present characters, personalities, informative material, dramatic events, and stories. But the cinéma-vérité filmmaker employs a different technique, relying on special lightweight cameras and portable sync-sound recorders that were developed in the 1950s. Both cameras and recorders may be easily hand-held, and the extremely mobile crew can move about

in a location and between locations with no need for extensive setup time. The crew may be as small as one or two people and can thus unobtrusively film within locations where a larger crew would disrupt the events being filmed. Since available lighting is often used, the film stock may be *pushed* in the processing so as to record an image under low-light conditions. (This often results in a grainy, contrasty image.)

Although we may associate cinéma vérité with shaky, out-of-focus, grainy images and a noisy sound track, these are in fact the effects of difficult filming conditions. Often the film's content is so compelling that we readily accept this roughness of technique. In addition, the mobility and smallness of the crew make possible an intimacy with the subjects, a flexibility of story line, and a sensitivity to fleeting nuances of action and expression that would be lost to a larger (and therefore slower and clumsier) crew. Under the proper conditions of lighting and action, of course, the cinéma-vérité image can look as clean and steady as any fiction film or classical documentary.

Cinéma vérité films often employ only minimal narration. The story is developed instead through action and dialogue.

JOURNALISTIC DOCUMENTARY. The journalistic documentary employs certain conventions, such as the use of a moderator or an on-camera journalist and extensive reliance on the interview format. In these films, the verbal and informational content often takes precedence over visual and aural creativity.

Whether hand-held or tripod-mounted, the camera usually frames a medium close-up of the interviewed subject, creating the image that filmmakers call a *talking head*. Journalistic documentaries often unfold as an alternating series of interviews, action sequences, or illustrative montage sequences with voice-over. These films usually rely on a narration or the on-camera statements of the interviewer or journalist to provide background information and to develop the story line.

The director may work within strict guidelines of time and format, as in the television series *60 Minutes,* a magazine-format program first produced by CBS in 1968. The standard *60 Minutes* segment is about fifteen minutes long, often based on a public controversy, or a crime of fraud, and consists of opposing or contradictory statements elicited by the investigating television journalist. The conclusions of

the journalist are indirectly but strongly stated by the line of questioning. The director may also work in a more searching, open-ended manner, as did Marcel Ophuls in making *Memories of Justice*. This is a four-and-a-half hour film about the Nuremberg war-crime trials after World War II. Through interviews with Nazis accused of crimes, survivors of concentration camps, administrators of the trials, and many others, the film confronts ideas and issues in an extremely complex, subtle, and forceful manner.

COMBINING THE STYLES. The documentary director may choose to combine several styles in a single film. One of the earliest examples of this eclecticism was Dziga Vertov's *Man with a Movie Camera* (1929), which combined the visual, poetic style with the classical documentary images of characters enacting their daily lives in factories, on the streets, and at the beach. There is even a hint of the journalistic style in that the central character is a cameraman who travels about Moscow recording the images that we see in the film. The film shifts back and forth between rapid montage sequences of machinery, streetcars, carriages, automobiles, and slower, mise-en-scène vignettes of individual lives and personalities.

Canadian filmmaker Michael Rubbo combines the cinéma-vérité and journalistic styles by inserting himself as a character within his own films—as the filmmaker who is trying to come to grips with his subject.

Combining Fiction and Documentary Styles. Jean-Luc Godard has suggested that fiction and documentary film are processes that lead to the same result—that is, the pursuit of the fiction film can lead to a documentary realism, and the pursuit of documentary realism can lead to a fictionlike drama. In fiction, we can see this when a film is built so closely around a star's personality that it becomes in some sense a documentary of the star's characteristic behavior, if not also of events in his life. Many of Andy Warhol's films, featuring his own "superstars," were essentially documentaries, structured by a loose fictional script, about a group of creative and theatrical people. Judy Garland's role in *A Star Is Born* closely mirrored her own personal history.

Documentary-film makers have often staged scenes with actors and sets, or even written fictional scenes to convey the "truth" about their subjects. The *March of Time* newsreels produced in the 1930s by Time, Inc., were notorious examples, but even Robert Flaherty,

in *Louisiana Story* (1948), would construct a dramatic "fictionalized" account of the life of the Cajun boy and his family and their interaction with the oil-rig workers. This impulse to reconstruct events is as old as documentary itself; many of the first documentaries were reconstructions of famous battles and military conflicts. Sometimes, too, documentary seems to go beyond its individual subjects toward a more nearly universal, abstract reality. In Albert and David Maysles' *Salesman,* the cinematic truth about the lives of a group of traveling Bible salesmen rivals any fictionalized account in strangeness and pathos.

Directing Experimental and Independent Films. We generally use the categories of fiction film and documentary (or nonfiction) film as a convenient way of organizing the rich profusion of film styles and techniques into two broadly defined categories. It is important to keep in mind, however, that these categories are often assigned after the fact and that a filmmaker may choose to work in an area that does not conveniently fit into either camp or fits into both at once.

This is especially true of directors who consciously try to work in the area between art and life, between fiction and reality. It is also true of many filmmakers and directors who have chosen to work with a special technical or perceptual process in order to realize a highly individual vision in their films.

No catalog of directorial styles can be all-inclusive, particularly when we come to those filmmakers who are working at the frontiers of the usual modes of filmmaking. At best, we can identify some of the more interesting tendencies and experiments.

POETIC OR VISIONARY STYLE. Some filmmakers tend to abandon realism, at least in the sense of a realistic representation of ordinary life and experience. Instead, they employ the expressive power of film to create a more intense, transcendent reality of the spirit, the imagination, or the unconscious mind—a magical, mysterious, or extra-ordinary reality.

Visionary filmmakers may choose to work with the complex production techniques of feature filmmaking or with simpler means. To make such films as *Blood of a Poet, Orpheus,* and *Beauty and the Beast,* writer, poet, and filmmaker Jean Cocteau worked within the structure of the French feature-film industry and employed a large crew of actors and technicians. American experimental filmmaker

Stan Brakhage, on the other hand, prefers a more independent method, using the simplest of technology—a hand-held windup camera—and working exclusively with silent film.

Many visionary films are based on special techniques. Jordan Belson produces his meditative, glowing colors and shifting abstract forms with special equipment whose exact design is a closely guarded secret. Other visionary films work through the juxtaposition of images that are striking, shocking, or suggestive in a more than simply visual sense. In *Blood of a Poet*, Cocteau draws on paper a mouth that suddenly attaches itself to his palm and begins to speak. He then transfers the mouth, still speaking, to a marble statue and falls through a mirror into a world where a strange magnetism draws his body to the walls of a hotel corridor, where another statue comes to life. Luis Buñuel's and Salvador Dali's *Un Chien Anadalou* (*The Andalusian Dog*) is filled with strange and shocking images:

An oddly disturbing image from Luis Buñuel's and Salvador Dali's *Un Chien Andalou* (1928). The bird's-eye view from a balcony turns the passers-by into dehumanized lumps with hats. They form a ritualistic circle, almost the image of an eye. The object being poked at in the center is a hand.

As a cloud passes over the moon, the moon turns into a woman's eyeball being sliced by a razor; a man discovers a wound in his palm from which a colony of ants begins to emerge, etc.

The mainstream directors who perhaps come closest to the purely visionary style are Federico Fellini and Luis Buñuel: both include visionary poetic imagery and magical transformations throughout much of their work. Other filmmakers, including Alain Resnais in *Last Year at Marienbad,* have experimented with this approach. Many science-fiction films and futuristic films, and even horror films, might be considered visionary in approach. So might some of the more surrealistic comedies, such as those by Buster Keaton and Woody Allen.

PERSONALISM. Although many experimental filmmakers work in an objective or even abstract style, others emphasize a strong current of individualism and a concern with personal experience throughout their work. Experimental filmmakers often use themselves, their own families, and their friends as subjects and their own homes or surroundings as locations. Others create such highly personal visions that we cannot ignore the personality and psychology of the filmmaker as a major component of the work.

Because this emphasis on a personal vision can be provocative and upsetting to the unsophisticated or uninterested viewer, experimentalists have been accused by some of such faults as infantilism, self-indulgence, immorality, depravity, and the desire to hoodwink their audience. Other filmgoers enjoy the intensity of feeling, the originality of sensation, and individualistic point of view of these works as a refreshing alternative to the pervasive sameness of mass culture and middle-class society.

Many experimentalists work with silent footage to which effects or other sounds may be added later. Others create a personal vision by working with actors who are themselves unusual or creative people. Filmmakers Jack Smith and Andy Warhol, and more recently directors of Punk and New Wave films (discussed in chapter 9), have relied heavily on the screen presence of theatrical, original, and flamboyant personalities, including transvestites, underground superstars, poets, rock singers, and the like. Such films often involve extensive improvisation, and the performances and personalities may tend to overshadow such elements as narrative plot, fictional characterization, or location. This approach is, in fact, not very dis-

similar from the Hollywood star system that sometimes fits established film performers into convenient "vehicles" of narrative and action.

FILM AND MODERN ART. Some filmmakers feel themselves more closely involved with the modes of twentieth-century fine art—including painting, sculpture, music, and conceptual and performance art—than with the mainstream of film history. These filmmakers work with a variety of styles and techniques that often bear little resemblance to the usual film forms of theatrical fiction, documentary, and animation. Even more than the poets and visionaries of film, they often strike off into uncharted territory.

Despite differences in style and technique, filmmakers who view themselves as modern artists share several areas of exploration.

1. One important area of exploration is perception itself, both visual and aural. *Flicker films*, in which frames of color or black and white alternate at extremely rapid frequencies, are one example of this sort of exploration. Some filmmakers have found that different rates of flicker have different emotional effects. Others have experimented with the perception of images that are flashed on the screen for very brief intervals, even as short as a single frame, or one twenty-fourth of a second.

2. A second important area is the study of the meaning and even the *ontology* of the image. ("Ontology" is a philosophic term for the study of being and its principal categories.) In watching most films, we simply accept the image as a representation of reality or imagination and let it go at that. In watching some films, however, we are asked to question what the image really is, how it can represent something, and what kinds of things the same image can represent.

Tom, Tom the Piper's Son by Ken Jacobs raises such questions. This feature-length film is a visual analysis of an obscure black-and-white short of the same name that dates from the early twentieth century and that has been extended and transformed through the techniques of optical printing and rephotography. In Jacobs's film, the original story is obscured and made mysterious; background figures are enlarged in importance; small details are presented in extreme close-up; actions are repeated and extended or speeded up; and the image itself becomes so contrasty and grainy that it verges on abstraction.

The effect is an almost academic study of the *being* of an image—

of how an image can have meaning or significance when linked to other images, and of the borderline between abstract shapes and those shapes that we perceive as representational images.

3. A third area of exploration is *performance* and the *audience/ artist relationship*. Some film artists have emphasized the audience's experience of watching a film; others the filmmaker's experience of performing and presenting subjective thoughts and feelings; still others have explored the area in between.

Some of Andy Warhol's early films, such as *Empire* (the eight-hour static shot of the Empire State Building), were deliberate attempts to call into question the normal experience of watching a film, in which an audience watches passively, allowing the filmmaker to do all the entertaining and all the structuring of the experience. Warhol expected his audience to view the film as something like a painting: to come and go in the theater as they wished; to talk or otherwise amuse themselves while the film played; and, if they simply sat and watched, to provide their own associations, structure, and meaning for the experience.

The artist Alan Sondheim, on the other hand, has made several videotapes that explore his own personal life and private obsessions with such intensity and directness that members of the audience may feel embarrassed or annoyed. The focus in this instance is on the subjectivity of the performer/filmmaker, an emphasis that calls into question the normal audience/performer relationship as much as does Warhol's cold, objective distance.

We can observe still another way of working with the performer/ audience situation in George Landow's *Remedial Reading Comprehension*. Here the filmmaker mixes the images and styles of educational and promotional films with direct address to the audience, such as the subtitled statement "This is a film about you, not about its maker." The educational film references lead us to expect one kind of experience, but we are continually surprised by the sudden shifts and ironies of sound and image. As a result, a very complicated experience of the relationship of audience to filmmaker begins to emerge.

4. A fourth major area of exploration is that of the *structure* of the filmmaking process and of the film-watching experience itself. Just as modern painting and music began to take a fresh look at the basic structures and available materials and to explore such ele-

ments as the means of applying paint to a surface or of producing a sound, film has begun to explore its own methods.

This approach may combine several of the previously mentioned concerns: audiovisual perception, the study of the meaning and ontology of image and sound, and the relationship of filmmaker or performer to the audience.

Paul Sharits's *Color Sound Frames* is an example of the structural approach. In this work, a flicker film has been photographed on an optical printer in such a way that on the screen we seem to see a strip of film moving through the projector at varying rates, backward and forward, and are able to observe frame lines, sprocket holes, and the color differences between frames as they slide past the gate. It is as if we were watching a camera pan rapidly back and forth along a strip of film. The sound track is the sound that a projector makes when perforated film is run through it—a sort of popping or buzzing that changes in frequency and loudness in relation to the apparent speed of movement on the screen. The film combines elements of perceptual concern and of the ontology or essential being of the image, by exploring the shape and effect of a filmstrip moving past a camera.

Michael Snow's *Wavelength* is concerned with audience expectations, and it also explores some basic structures of the film process. The film is structured as a forty-five-minute continuous zoom from a wide shot of a loft space to a tight close-up of a photograph on the far wall. During the course of the zoom, we see the film shift between various color tints, between negative and positive, and from day to night. Apparently random events, including the discovery of a dead body, also take place in the loft. Partway through the film, a pure musical tone begins, and it rises in pitch as the zoom continues forward.

Watching this film, we are made aware of the structure of filmic space, of the perceptual manipulations of film technique and narrative fiction, and of the conditions of audience expectation, which is controlled by the inexorable process of the zoom and by the rising pitch of the sound track.

At the end of the film, the zoom moves into the photograph—an image of waves in the open sea. There is a suggested equivalence between the filmic reality of the three-dimensional loft space, which we perceive in time, and the photographic reality of the still photo-

graph on the wall, which represents three-dimensional space in a static, atemporal way. The film's own shape has thus been doubly defined: as an image of motion in three-dimensional space and as a flat image that *represents* three-dimensional space.

DIRECTING AND THE RELATIONSHIPS OF PRODUCTION AND CONSUMPTION

The various relationships between producer, distributor, and consumer in any production system—whether the product be shoes, energy, or motion pictures—have an important bearing on the process of production and on the final product.

In the case of an art like film, we can examine these relationships in four principal areas: the social or political, the economic, the psychological, and the technical or formal. The director's work is deeply involved in each of these areas.

Political and Social Relationships. The political and social environment generally has a great influence over how a director works—either directly, by arousing his support or opposition, or indirectly, by affecting the degree of ease with which certain subjects can be dealt with and with which certain kinds of films can be distributed and made available to audiences.

THE POLITICAL INFLUENCE. Many directors have turned to film as a means of making a political statement or of furthering political activity. During the 1920s, Sergei Eisenstein worked consciously and actively to promote the cause of the international socialist revolution that he believed had begun in his native Russia. A decade earlier, in the United States, D. W. Griffith had been employing his considerable talents in the service of political ideas that reflected the diversity and contradictions of his own capitalistic (and racist) society. His *Birth of a Nation* (1915) was a monumental and skillfully crafted epic that denigrated blacks, promoted the idea of white supremacy, and presented the Ku Klux Klan in a romantic and heroic light. It was a great popular success. His *Intolerance* (1916), on an even grander scale, treated four different stories of intolerance, juxtaposed to convey outrage at human injustice and compassion for its victims, a concern that we now find at odds with the racist viewpoint of *Birth of a Nation.*

Perhaps even more than fiction, documentary films have been used for political effect. In wartime, governments have produced them for propaganda purposes. During World War II, the propaganda battle was waged on the Nazi side by such films as Leni Riefenstahl's *Triumph of the Will* (filmed in 1933) and on the Allied side by films like Frank Capra's *Why We Fight* series.

Because of its vivid reality and relative simplicity of production, documentary film has frequently been used to provoke thought or political action, to expose injustice, and to oppose prevailing political powers. Joris Ivens, for example, has worked in many countries throughout the world, seeking in his films to expose injustice and oppression and to promote the cause of solidarity and cooperation among working people. For *The Spanish Earth,* made in 1937, he enlisted the support of a group of American writers—including Archibald MacLeish, Dorothy Parker, and Lillian Hellman—to finance this film about the struggle of the Spanish Republicans against the Fascist forces during the Spanish Civil War. Ernest Hemingway became a collaborator and writer for the film, which was shot in Spain during actual fighting and bombardment. More recently, filmmakers have turned to the documentary for assistance in a number of political causes, from resistance to oppression in Latin America to the struggles for equal justice for minorities such as blacks, native Americans, and the disabled.

Even films that have no overt political content are influenced in their production and distribution by the political environment. In the United States, for example, it is perhaps easier to produce and distribute films that *avoid* political issues or that indirectly support the capitalist system through portrayal of the pleasures of a consumer-oriented economy.

THE SOCIAL INFLUENCE. A nation's social structure also has considerable influence over the ways that films are produced. For example, the system of training for the film profession and the paths of entry into the field vary from one culture to another. In most European countries, film training is provided through a few central, state-supported schools, which are highly selective, closely linked to the nation's film profession, and highly regarded by professionals.

The apprentice system also is widely used in Europe. In fact, the whole system of training and entry into the film profession resem-

bles some of the older traditions of training in the fine arts, including music and painting. Many European films reflect this artistically oriented approach to film training.

In the United States, there are a few schools, primarily in California and New York City, that have close links to the film industry. Entry into the profession, however, is achieved more often through personal enterprise or personal connections than through any organized system of training and apprenticeship. In fact, only recently have film-industry professionals really begun to take film schools seriously. Partly because of this situation, American films have generally displayed a highly commercial, technically advanced orientation. Glamour, money, and spectacle are more natural to the marketplace than to the artist's studio.

However, even though it has usually had little connection with the mainstream film industry, film training in the United States is relatively widespread. This unselective, widely available film training has clearly contributed to the development of the independent film movement. This movement is composed of a great variety of individuals, many of whom work only part-time in film and support themselves in related professions, who have found ways of producing both short and feature-length films outside the Hollywood system. These films often display a more individual or original point of view than do industry-produced films.

Economic Environment. The economic environment strongly affects the production, distribution, and consumption of films, and therefore it affects the way in which directors work.

Production and Distribution. Film stock itself is expensive, as are the services necessary to process and print it and the equipment used in shooting and editing. Although certain kinds of films can be made at relatively little cost, money is always an important factor in the planning of a film production. The kinds of sets, locations, and special effects, the number of crew members and performers, and the amount of footage that can be shot are all determined to some extent by the available funds. From as early as script and casting stages, directors and producers make aesthetically significant decisions that are based soley on budgetary considerations.

We can often identify the "look" of a film as being low-budget or high-budget by such elements as lighting, graininess of film stock, etc. This, however, is not to say that high-budget films are aestheti-

cally more valid. We might compare the size of a film budget to other sorts of artistic constraints that an artist chooses to work within, such as the choice of black-and-white or color film or the decision to shoot only on location.

There are, of course, a number of expenses involved in high-budget films that may have little connection with what we see on the screen or how we are affected by the film. These might include salaries of actors, producers, or crew members, and studio overhead costs.

High budgets can have another kind of effect on films, in that they often mean an increased participation in the creative process by producers, studio executives, or other investors. It is rare for the director of an extremely high-budget film to maintain complete artistic control over the film. The producers of a high-budget film may be primarily concerned with its commercial potential and may add or remove elements to try to make it more appealing to a wider audience. In order to maintain artistic control as well as a certain simplicity and ease in the shooting process, a director such as Alain Tanner (who has worked primarily in Switzerland) prefers to work with smaller budgets than might be available to him.

The large budgets that have been available for Hollywood productions have, however, permitted the development of extremely sophisticated technical processes, with the result that American films have become in some ways the technical standard against which the international film industry has measured itself. Hollywood budgets have also tended to attract film artists—including actors, directors, and technicians—from all over the world. Some of the biggest names in Hollywood history—including Garbo, Valentino, and Lubitsch—were immigrants, and this phenomenon has continued to the present day with such artists as Hitchcock and Polanski and, even more recently, Wim Wenders and Costa-Gavras.

The economics of film production and of distribution have always been closely linked in American film history. Up to the 1940s, the major Hollywood film companies produced films and distributed them to the theaters, which they also owned. Although they were forced by government antitrust suits to divest themselves of their theater holdings, the production and distribution facilities remained in the same hands, controlled for the most part by a small number of companies, the "majors."

The effect of this linkage has been that the decisions as to what films are to be produced and what films are to be distributed have been made by the same people. This has made the whole process simpler and more efficient than would otherwise have been possible, but it has also had a limiting effect on the kinds of films that could be made. The concern with commercial success and the resulting involvement of the studio executives in the creative process have, without question, had a significant influence on American film history, tending to make the directing of major films a collaborative effort in which the producer rather than the director has final creative control.

Only gradually have independent producers begun to finance and develop projects, but their freedom is still somewhat limited. Since the major film companies maintain a virtual monopoly over the distribution and marketing of feature-length films in the United States, they can still bring a great deal of pressure to bear on the independent producer or director.

A major company may even choose not to distribute a film that it has produced if it feels that the cost of marketing and distribution will incur a loss greater than the cost of production itself. Such a film is said to be placed "on the shelf," and the director and actors will probably never see it screened in a theater.

In many European countries the system of film production and distribution differs to some extent from the American model. The distribution industry often relies heavily on American films to generate revenues, but there may also be a government-enforced quota system to ensure that a certain percentage of films distributed within a country are produced within that country. This requirement often creates opportunities for aspiring directors by creating a demand for locally produced films beyond the demand of the marketplace. Some governments also assist in the financing of films made within their borders by assessing a special tax on ticket sales and advancing loans from this fund to their own producers.

EXHIBITION. There are basically two types of film exhibitors: those that depend on the sale of tickets for their continued existence and those that are subsidized wholly or in part by other sources of funds.

In the United States, the first type is called the *theatrical* circuit and the second type the *nontheatrical* circuit even though the same

fiction films may be shown in both circuits. The nontheatrical circuit relies primarily, but not exclusively, on the screening of 16mm prints.

The costs of theatrical exhibition include not only the overhead and profit margin of the theaters but also the costs of advertising and marketing the film. In the United States, the expense of making and distributing films for the theatrical market is sustained entirely by private investment and return on that investment This means that the director must take into account the ideas of the producer and distributor concerning the kind of film he can make and the subjects he may deal with. In Europe and some other parts of the world, the production of films for the theatrical market may be partially or wholly subsidized by the government or other public agency. This support can allow the director somewhat more freedom in style and subject matter.

Nontheatrical distribution is usually directed toward a specific audience, such as college or university students, or even elementary-school students. Museums, cultural centers, libraries, political organizations, and other community groups may also screen films on a nonprofit basis. Some of these are films sponsored by government or industry to sell a point of view, but others are independently produced. Many filmmakers produce exclusively for this kind of exhibition, making films that are consciously intended for small, specialized audiences that may be interested in a specific subject or in the art of film for its own sake.

Nontheatrical exhibition sometimes allows a film director the freedom to work in a personal, subject-oriented, or experimental way. However, it usually imposes constraints in the budgeting of his films, since there is little financial support available for such productions unless they present a government or industry message.

Psychology. There are two important psychological aspects to the filmmaker's work: his own involvement in the creation of a work, and the audience's response to it.

THE PSYCHOLOGY OF THE FILMMAKER. This has been a rich and sustained (although perhaps overworked) resource for critical investigation of films and filmmakers, with critics often approaching a filmmaker's work somewhat as a psychoanalyst would approach a patient's self-revelations.

The attitudes and personal values of the artist may be revealed in

any work of art, and not least in film. If we look at five or ten works by the same filmmaker, we can often observe consistent attitudes toward such things as violence, emotion, sexuality, and human relationships. The films may also reveal personal obsessions, such as Sam Peckinpah's with physical violence, Alfred Hitchcock's with the plight of an innocent person unjustly accused, Jean-Luc Godard's with the role of the prostitute in society.

Sometimes the filmmaker deals directly and self-consciously with his own values and psychological concerns. Federico Fellini's *8½* is a kind of filmic self-analysis, centered on the figure of a film director who is haunted by visions and fantasies, tormented by the inability to begin work on his next film, and who enters a sanatorium to try to regain his equilibrium. An emotional need to make films is itself part of many filmmakers' psychology. Jean-Luc Godard, the master of self-conscious filmmaking, has said that "films are easier than life.... I don't see so much difference between films and life, I would say that films help me to live, like remedies, or elixirs—that is how the public uses them, too."

A film may reflect not only the film artist's personal vision but also some of the group fantasies, emotional attitudes, aspirations, and myths of the society in which he works. In the United States, for example, the myth of the cowboy became a powerful influence on many filmmakers and actors—a myth that influenced them even as they helped to create it. In Germany, more frightening myths were being nurtured. In his important book *From Caligari to Hitler* (Princeton University Press, 1947), Siegfried Kracauer examines the history of film in Germany throughout the 1920s and 1930s and finds evidence of a psychological climate of conformity and authoritarianism that prefigures the excesses of Hitler's Third Reich. This is not to say that German directors of the time were necessarily proto-Nazis; they simply could not help reflecting the psychological forces of their epoch.

THE PSYCHOLOGY OF FILM EXPERIENCE. The psychology of film is of interest to filmmakers for very practical as well as for personal reasons. Almost every aspect of film expression has its psychological component—from the perceptual principles that make possible the appearance of moving images, to the illusions of film space and time, to the evocation of emotional responses, and even to the experience of film as a reflection of consciousness itself. The

experience of film is based on two principles of perceptual psychology (discussed in chapter 4): the *phi phenomenon* and *persistence of vision.* The composition of forms within the frame relies on other principles of perceptual psychology and can be analyzed by experiments that record the pattern of eye movements across a visual composition. On the technical level, the psychology of sound perception employed by the filmmaker is basically the same as that used by the musician or composer or recording artist. Filmmakers may employ these components routinely as the means to various ends, or they may work in a self-conscious and experimental way, exploring the limits and possibilities of the film experience.

UNDERSTANDING IMAGES AND SOUNDS. Filmmakers rely on a psychology of associational logic in order to create comprehensible stories and narratives. When we watch a narrative or documentary film, we begin to build up in our minds an understanding of characters, of the progress of time, of various spaces and locations, and of a logic of events. This is an active mental process that enables us to make sense of a story, even if it is presented as a series of separate shots that may shift back and forth between locations and time periods.

This ability is partly a process of logical perception: If we see a character holding a gun in one shot and a close-up of a hand pulling a trigger in the next, we conclude by induction that we are watching a continuous action. It is also partly a learned process: From watching many films, we know that a cut may mean simply a shift of point of view or a shift to a different time or place, and we look for clues to tell us which it is. As audiences become more sophisticated, filmmakers can create more complex associations of images by shifting continuously between different time periods to build up a narrative story.

VARIETIES OF PSYCHOLOGICAL RESPONSE. We can describe our psychological involvement with a film in terms of our subjective response. Some films rely heavily on our emotional involvement, or *identification,* with the characters or experiences presented on the screen. We may feel suspense or anguish or joy, depending on what is happening to the characters, and the dramatic structure of the film can lead us gently or abruptly from one emotional response to the other.

Other films evoke a more distanced, intellectual response to what

is happening on the screen. We become thoughtful observers, considering and analyzing the visual and aural material, comprehending information, comparing and making connections between ideas and experiences.

There are also films that evoke a kind of trance state, a response that is not connected with specific images and circumstances. An abstract film can evoke this feeling, which resembles our response to instrumental music.

Of course, many films evoke all three kinds of psychological response—emotional identification, intellectual response, or a trance state—at different moments.

FILM AS A MIRROR OF THE MIND. One the fascinating potentialities of film is its ability to mirror and represent some special states of the soul, such as dreams, fantasies, recollections, and hallucinations. In fact, some of the earliest writings on film compared the experience of viewing films to the dream state, in which visual images appear and change in a fluid, transformational field. Many critical writers and filmmakers have also drawn comparisons between film and dreams and have even consciously tried to evoke the dream experience in their films. Flashbacks of memory, hallucinations, fantasies, and subjective thought images have also been vividly represented on film.

In recent decades, some filmmakers have attempted a representation of the thought process itself, often through a voice-over combined with other techniques. In Jean-Luc Godard's *A Married Woman* (1964), the woman's voice-over does not speak in coherent sentences but in fragments—words, images, and associations that make up an internal monologue that directly represents her thought process.

The Relationship of Technique and Production. An understanding of film technique must include not only those physical and technical processes that give shape to the finished product but also the formal, aesthetic models that inform the processes.

THE PHYSICAL PROCESS. The style and appearance of films and the director's aesthetic choices have always been closely linked to the available technical processes. Some directors have chosen to work within the technical means available to them, whereas others have felt the need to expand the capabilities of film in order to realize their visions. At the very beginning of film history, Louis

Lumière was content to simply record events with his newly invented camera; while Georges Méliès was impelled to invent techniques and create new forms of cinematic magic for his fantastic stories.

The history of black-and-white and color techniques illustrates a wide range of directorial attitudes toward technical limitations and possibilities. For many years, black-and-white cinematography was the only kind available, and all filmmakers had to learn its range and special qualities. (Even during this time, however, some filmmakers experimented with tinted or laboriously hand-painted prints.) When color cinematography was developed, it was almost universally accepted; and since then, many directors have worked exclusively in color. Others, however, have chosen to work occasionally with the black-and-white palette, which is capable of more subtle shades of light and dark and which evokes the "classic" age of filmmaking.

Sometimes technical advances have made possible entirely new styles of filmmaking, as when the development of lightweight portable cameras and recorders gave impetus to *cinéma vérité* or *direct cinema*. Other technical advances have simply been refinements of existing processes and techniques and have had a more subtle influence on film style. Special-effects techniques, for example, have become vastly more sophisticated over the years. The result has been not a new radical style of filmmaking but a gradual shift toward greater realism in many films and toward astounding spectacle in others.

FORMAL AND AESTHETIC CHOICES. Using the same technology, one filmmaker may create an expressionist film, while another might make a realist work. The difference in technique between the two styles has to do with formal, or aesthetic, choices of how to employ the available technology.

Again, some filmmakers prefer to work within the commonly employed formal and aesthetic techniques of their time and have often created great works of art with simple and ordinary means. Others have ventured to introduce new format approaches, to break new ground, and to explore new territories of style and aesthetics. Both styles have resulted in exciting, important films.

Sometimes an aesthetic approach is imposed by necessity, as when during their austere postwar period the Italian film industry pioneered the gritty, technically simple aesthetic of *neorealism*.

Shooting frequently with nonactors, with war-surplus cameras, and with dubbed sound, these filmmakers founded a new style of immediate emotional effect and almost documentary realism.

On the other hand, a formal technique may be founded on a self-conscious and almost philosophical deliberation about the history and theory of film. The films of Carl Dreyer and Robert Bresson exhibit this sort of thoughtful, idealistic approach. Many filmmakers have attempted to base their formal and aesthetic techniques on political philosophy. These include both experimentalists like Sergei Eisenstein and Jean-Luc Godard and practical revolutionaries like those working in South America during the second half of the twentieth century.

9

Actors and Other Players

Of the films made throughout the world since Edison's and the Lumière's discoveries, it is probably safe to say that the vast majority have featured human beings as subjects. Landscape documentaries and abstract films are still important genres, but the human figure has remained of central importance in film, even though it has disappeared from much of modern painting and photography.

A great part of the magic of film lies in its power to fix and preserve special moments of human experience, kinds of behavior, and particular customs, and to transmit them to audiences that may be far removed from them in space, time, or social circumstance. Film has also the power to capture and magnify nuances of human expression and communication and to convey a level of implied meaning, or *subtext,* beneath the surface text or exchange. We can find both of these qualities in most films that feature human subjects—whether the human subjects are actors or nonactors, whether they are fully aware that they are being filmed or are unconscious of the process, whether they are given special instructions or follow their own habits or instincts, and whether they apply a special technique to their behavior in front of the camera or simply "act naturally."

These different approaches to human subjects affect the making of a film and have a subliminal effect on our response to it, even when we cannot tell exactly which approach was used. In this chapter we will explore some of the things a filmmaker considers in deciding on subjects or actors for a film, and some of the techniques of communication, direction, and performance that filmmakers and players use.

PEOPLE WHO PERFORM IN FILMS

The first performers in film were often those people who were most readily available to the filmmakers. Thomas Edison's assistant and colleague, W. K. L. Dickson, appeared in the first film made at Edison's studios. He appeared on the screen and delivered a simple message about the invention itself (it was a sound film). Louis Lumière found subjects for his first films in a gardener, in a child playing with a cat, and in a crowd of workers leaving the Lumière factory. He deliberately avoided actors and anything else that smacked of the theater. Later, Lumière's cameramen traveled the globe in search of more exotic subjects: kings, czars, and historic or picturesque events. Still, they continued to avoid actors and fictional subjects.

Georges Méliès gave the new art a spin in a different direction. His films were an extension of his previous work in magic shows and the theater, and his performers were truly *acting* in fantastic and fictional settings. In the United States, Edison's peep shows and nickelodeons presented performers who seemed to come right out of the tradition of vaudeville theater, engaging as they did in slapstick routines, exotic dances, and the like.

Each of these approaches has continued to the present day, and we still may find on the screen not only actors but nonactors and performers from other fields.

Professional Actors. Acting is, of course, an ancient profession. Greek tragedy and comedy, the passion plays of medieval Europe, the *noh* plays of the Japanese courts, the riotous and bawdy commedia dell'arte of Rennaissance Italy, the courtly drama of Shakespeare, Molière, and Racine—all have provided opportunities for actors to practice their art. Each of these theatrical traditions is characterized by a distinct style and technique of acting and a distinct relationship between the actor and the audience.

With the invention of motion pictures, new acting techniques were called for. Actors had to learn how to work without the direct response of an audience, how to adjust their expressions and gestures for the intimate framing of the close-up, and how to break down their performances into small bits that would be recorded in separate shots. Many actors became specialists, working only in

films. Others mastered both stage and film techniques and were able to work in both media.

ACTING IN SILENT FILMS. For the first thirty years of motion pictures, actors were confronted with a special problem: Films were silent. In one sense, this could be an advantage: Actors might be chosen for their looks alone, since the quality or refinement of their speaking voices was not important.

For narrative continuity, the silent film was completely dependent on occasional subtitles and on clear action on the screen. Because of this factor, but also because of the melodramatic style of theater acting then in vogue, actors and directors of silent films developed a style of acting peculiar to their time. In this style, gestures and facial expressions were exaggerated and melodramatic. Sometimes this was done for comic effect, but more often it was simply an accepted technique for making emotional responses and relationships between characters perfectly clear. Of course, this exaggeration now appears artificial or unintentionally comical when compared with the contemporary acting styles of the sound film. In modern acting language, this nonverbal exaggeration is called *signifying, signaling,* or *indicating* an emotion, and it is generally considered a defect in an actor's performance. It derives, however, from an ancient acting tradition, found in such theaters as the Japanese *noh* drama and the Italian *commedia dell'arte*. To appreciate silent films, we must simply accept the acting style as one of the conventions of the period.

There were some exceptions to the exaggerated style of silent film acting. The acting in much of Eisenstein's work was somewhat more subtle than in most of Griffith's. Buster Keaton demonstrated that even comedy could be played without signaling emotions, although his deadpan was itself a technique of extreme stylization. One of the most subtle and sensitive performances in silent film was Maria Falconetti's leading role in Carl Dreyer's *Passion of Joan of Arc* (1928). Her restrained and passive demeanor, presented in close-up, allows us to read into her face all the motion and suffering of her plight. Marlene Dietrich and Greta Garbo were also aware of the power of restrained expression.

ACTING IN SOUND FILMS. Many silent-film actors were unable to make the transition to sound films, because of their impossible accents, unappealing voices, or simply because they did not have the

necessary facility and control for the speaking voice. These qualities had always been essential to the stage actor; and with the sound film, the craft of acting for the theater and of acting for film became much more closely related. Whether an actor chooses to work in film or on the stage is now primarily a matter of inclination, circumstance, or economics—and many actors do both. The stage, however, requires a more sustained, consistent performance. It is possible for a filmmaker to draw a convincing performance from a relatively inexperienced or limited actor by judicious cutting and camera placement, and by working separately on small segments of a script.

TYPES OF ROLES. As in the theater, certain film actors have the talent, appearance, and versatility to play many different kinds of roles. Others limit themselves, or are confined by directors and producers, to certain kinds of characters or even certain genres of film. An actor might play only "heavies" or villains or only romantic leads. Or, like John Wayne, he might do much of his work in one genre (in Wayne's case the western). If the audience becomes accustomed to seeing an actor in a certain type of role, the mere casting of the actor may be a clue to the drama. We expect trouble, for example, or romance, the moment such an actor appears on the screen.

Alfred Hitchcock, on the other hand, often experimented with casting an actor against the expected type, as when he cast Cary Grant as a "heavy" in *Suspicion*. The effect in this case was to unsettle our expectations and to increase the feeling of suspense, of wrongness, and that "anything can happen."

Certain actors, called *character actors,* make a career of playing distinctive, specialized roles that have little resemblance to the actor's own personality. Character actors often play older characters or *supporting roles*. Aging former stars sometimes develop a "second career" as character actors.

A *bit player* is an actor who specializes in walk-ons and other small roles, either by choice or because those are the only roles available to him.

Film Stars. There had always been "stars" in the performing arts, renowned performers like the dancer Nijinsky and the actress Sarah Bernhardt. However, the new art of film ushered in a new kind of star. Film stars seemed more intimate and accessible than the stars of the stage and ultimately more glamorous in their wealthy, extravagant life-style. Their screen personalities were more

consistent and the kinds of roles they played were more predictable, reflecting the heroic image and the archetypes of the age. For these reasons, film stars were idolized, fantasized about, and emulated.

CONSISTENT IDENTIFICATION. It is commonly said of film stars that they always play themselves. Even in a costume drama, when the star makes his appearance on the screen, we don't remark to ourselves, "Oh, there's Mark Antony," but instead, "Look, there's Richard Burton, dressed up like a Roman." In effect, the role of the actor as film star is often stronger than his role in a given script.

Our sense that the star plays himself is based not only on his immediately recognizable features but also on his personal mannerisms, his way of talking and moving. Whereas an actor who is strictly an actor tries to suppress his personal mannerisms in order to better convey the character he is playing, the film star allows his own personality and behavior to take over. Thus, in film after film, in no matter what role, we recognize Marlon Brando's mumble, Humphrey Bogart's clipped speech and the way he tugs his ear, Chaplin's shuffle and coy smile, Katharine Hepburn's commanding and cultured tone.

Beyond consistency of personality and mannerisms, film stars are identifiable by the types of roles they tend to play. Chaplin as the little tramp, Doris Day as the wholesome American girl, Marilyn Monroe as the sex goddess, Cary Grant as the debonair but strong and romantic lover—all these roles were consciously planned by either the actor or the producers and were rigorously adhered to. James Stewart, for example, refused to play a role for Alfred Hitchcock as even a suspected murderer, since this would have conflicted with his popular image as a homespun, moral good fellow.

In many cases, these customary roles closely overlapped the actual personalities and lives of the actors who played them, especially with regard to their romantic involvements, to the point where the audience felt that they were watching thinly veiled life histories. In other cases, the roles were clearly distinct from the stars' offscreen lives—the plight of the little tramp bore little resemblance to Chaplin's glamorous existence. Unfortunately, a star's customary role might seem a limitation or even a trap to the actor who played it— both Marilyn Monroe and Judy Garland apparently suffered a great deal from the roles that producers and fans expected them to play.

CULTURE HEROES. In their customary roles, the stars represent-

Stylized acting in silent films. The woman mourns the dead, while strange and terri-
fying thoughts occur to the young hero, in Robert Wiene's *The Cabinet of Dr. Cali-
gari* (1919).

ed the heroes and ideal figures of the age and vicariously fulfilled
certain longings and aspirations of the filmgoing population. Some
roles—such as Rudolph Valentino's romantic lover, Douglas Fair-
banks's swashbuckling adventurer, Marilyn Monroe's naïve sexpot,
and Greta Garbo's sophisticated vamp—were so simplified and
streamlined that they weren't really to be confused with real people;
rather, they represented ideal or admirable types like the mythic
gods of Greece and Rome. Other roles represented more complex,
down-to-earth types who could be admired and also imitated.

The shift in roles of male stars has been an interesting progres-
sion. In the 1930s and 1940s, male stars were principally dominant
types, like Rock Hudson's strong, silent he-man; James Stewart's
folksy, morally upright character; Humphrey Bogart's hard-boiled
fellow who could also be gracious, fair, and tender, especially to
women. In the 1950s and 1960s, these types were replaced by young

Stylized acting in the sound film. Tim Curry and friends in Jim Sharman's *The Rocky Horror Picture Show* (1975).

rebels like James Dean and the young Marlon Brando, and then by the complicated, passive-aggressive, and insecure macho figures of Paul Newman, Dustin Hoffman, and the older Brando.

OLYMPIAN HOLLYWOOD. The film stars were heroes and heroines not only of the nation and the culture but also of Hollywood itself, and Hollywood itself was one of the grandest myths of all. In the press, in its own publicity, and in the films themselves, Hollywood was a paradisiacal never-never land where the stars reigned as gods and goddesses. The immense sums of money the stars were paid, their mansions, their limousines, and their yachts gave them a powerful worldly position, transporting them from the shadowy demimonde of the arts into the aristocracy of princes and millionaires.

One of the more striking inventions of the Hollywood mythmakers was that even a person of humble origins could be raised to the heights if fortune smiled. The discovery of Lana Turner at a drug-

store soda fountain was a Cinderella-like fairy tale—a scullery maid could become a queen at the touch of a magic wand!

STABLES AND VEHICLES. The early producers and film studios in New York foresaw the development of stardom, but feared the potential economic clout of a too-popular performer and therefore tried to keep their players nameless. In spite of their efforts, however, audiences flocked to see the anonymous "Biograph Girl," who was actually played by Mary Pickford. Eventually, the producers climbed on the bandwagon, and film stars became influential figures in the industry. In fact, Charlie Chaplin and Mary Pickford became powerful enough to join with D. W. Griffith to form their own film-production company—United Artists.

The major Hollywood studios valued their stars both as talents and as financial assets. They carefully developed an actor's "image," nurtured it with appropriate publicity, and found or created scripts that would display the star's personality and image to best effect. These tailored scripts were called *vehicles*, and were essentially devices to get the star on the screen. With each new star, the studios quickly established a contract that required the star to appear in a certain number of films. The star would thus join the studio's "stable," and the studio would be able to bank on the star's popularity and gain an assured financial return from its investment in publicity and huge salaries.

STARS AS FILMMAKERS. In the film industry today, stars are more powerful than ever. They have been able to escape from the long-term studio contracts and can now negotiate immense fees for appearing in single films. Many have even set up their own independent production companies. In the age of independent producers, stars remain an essential part of the filmmaking "deal," and it is quite difficult to finance a major film that does not feature at least one star.

Following in the footsteps of Charlie Chaplin and Buster Keaton, a number of contemporary film stars have managed to take over creative control of their films by becoming film directors. Some, like comedians Jerry Lewis and Woody Allen, both star in and direct their own films. Others, like Robert Redford and Paul Newman, have on occasion played the director's role, remaining behind the camera and directing other actors.

Actors Who Play Stars. In recent years, some filmmakers and

screenwriters have created roles based on the lives or personalities of former stars (usually retired or deceased) or on the ideal film star as such. These roles are played by current film stars or by lesser-known actors.

In the 1960s, the work of several more or less experimental filmmakers—including Andy Warhol, Jack Smith, and the Kuchar brothers—gave rise to the phenomenon of the underground star. Such "stars" were people who played the roles of film stars, sometimes in films but often in their own private lives as well. Some would model themselves on specific stars; others on idealized movie-star roles, such as the blond sex queen. Some were transvestities— men who impersonated female movie stars. These films were *about* Hollywood and about the mythical world of movie stars as much as they were about anything else. They also embodied an implicit criticism of Hollywood, since they were made on very low budgets and acted by nonconformists, eccentrics, and bohemian individuals who valued their own free life-styles more than commercially successful careers.

Several underground and Punk filmmakers of the 1960s, 1970s, and 1980s made Super-8 or 16mm feature films modeled on the style or even the scripts of the French New Wave films of the 1960s, which were themselves based on the American "B" movies of the 1940s and 1950s. The role of the film star is central to these contemporary homages, although it is played by relatively unknown actors. Even in the commercial cinema, filmmakers have based scripts and roles on the star concept. In Jean-Luc Godard's *Breathless,* for example, the French actor Jean-Paul Belmondo models himself on the tough-guy role of Humphrey Bogart. In film remakes, or recreations of older films, the characters are usually modeled on the roles as they were played by the stars of the original versions. For example, Jessica Lange's heroine of the 1976 remake of *King Kong* is clearly based on Fay Wray's role in the original 1933 version.

Performing Artists. Many films have featured professional performing artists whose principal expertise and experience lie in an area other than acting *per se*—perhaps in dance, or in musical performance. These films range in style from simple documentaries in which the artist performs, to documentaries that include both performance and scripted or improvised elements, to carefully scripted and designed films that showcase the performers.

Performing artists sometimes make cameo appearances within films featuring their acts, or simply act in a film without making use of their particular expertise. These performers are often people such as pop stars, whose profession requires an almost constant media awareness. They are familiar with the techniques of shaping and presenting a public image, and their experience in this area can transfer quite readily to film. One example of this kind of performance may be found in D. A. Pennebaker's *Don't Look Back*—a complex documentary in which musician Bob Dylan not only performs his songs for an audience but also enacts his own life as a pop star for Pennebaker's cinéma-vérité camera. The offstage life of a pop star sometimes resembles a continual performance, and Dylan seems subtly aware of this duality as he improvises and "plays himself" for the camera.

One of the more resilient of Andy Warhol's "superstars": Holly Woodlawn in Paul Morrissey's *Trash* (1970).

The performing artist in film: Chuck Berry in D. A. Pennebaker's concert film *Keep on Rockin'* (1970). The extreme close-up evokes an intimacy and intensity that we can't easily experience in the large concert hall.

Richard Lester's *Hard Day's Night* and *Help,* featuring the Beatles, represent a more designed and scripted kind of film. The Beatles both perform their own music and play themselves in fictional plots and situations. Lester's experience in TV-commercial productions led him to reinforce through quick cuts and surreal settings the absurdist humor of the script and the performers. Michael Schultz's *Sgt. Pepper's Lonely Hearts Club Band,* also based on the music of the Beatles, features another group, the Bee Gees, as performers. Here the script is completely fiction: The group plays a good-time band in a surreal world of heroes, heroines, and villains.

A performer's offscreen talents may be exploited to different degrees in film. Fred Astaire and Judy Garland were performers whose film careers were in many ways built around their special talents: Astaire's as dancer/choreographer and Garland's as singer. Other performers—including pop musicians Art Garfunkel and

Robbie Robinson—have acted in films without employing their musical talents.

The Filmmaker as Actor. Some filmmakers combine several creative roles by writing, directing, and acting in their own films. Many of these have been comic artists, including Chaplin and Keaton in the 1920s and, more recently, such multitalented personalities as Jerry Lewis and Woody Allen. Other filmmakers—such as John Cassavetes and François Truffaut—have acted in films by other directors. (Truffaut has also acted in one of his own films, *Day for Night,* in which he plays the role of a film director.)

Many experimental and avant-garde filmmakers act in their own films, sometimes playing themselves, sometimes playing a character in a fictional story. Performing artists and other modern artists occasionally use film footage of themselves in their work in other media. In several of her dance/theater works, composer/choreographer Meredith Monk has incorporated short film clips in which she appears alone or with other performers.

Nonprofessionals. Filmmakers often make use of nonprofessional actors—people who are usually not involved in acting at all, even on an amateur basis, but who can provide a special appearance or an air of authority to a film, either fictional or documentary. They are often inhabitants of the location or participants in the activity that the filmmakers wish to film, people such as workers in a factory or locals in a small town.

NONPROFESSIONALS IN FICTION FILM. Nonprofessionals are employed in fiction films for several reasons: (1) Their roles as walk-on players or extras do not require any training or experience in acting; (2) they can lend a feeling of realism or authenticity to the film; or (3) their special appearance or personal presence will contribute to the mood or atmosphere of the film. A nonprofessional playing a film role must either learn to act, play himself, or follow the instructions of the director without attempting to "act" at all.

During the neorealism movement in postwar Italy, filmmakers like Roberto Rossellini in *Open City* (1945) and Vittorio De Sica and Cesare Zavattini in *Bicycle Thief* (1948) successfully employed nonprofessionals as principal players. They sought out people whose lives were close enough to the subjects of their films that they could, in effect, play themselves, with some basic instruction and direction. Federico Fellini has screened thousands of nonprofessional "extras"

to find characters whose visual appearance would contribute to his semisurrealistic epics. Such parts do not usually require great subtlety of performance.

Robert Bresson, on the other hand, chooses to work with nonactors in order to avoid all taint of theatrical or "stagey" effect in his films. He directs his performers to deliver lines in an expressionless tone of voice, without any attempt to convey emotion or characterization. Oddly, some of the players in his films come across as quite subtle actors.

NONPROFESSIONALS IN DOCUMENTARY FILMS. In documentaries, the nonprofessional actor is often a principal subject of the film, either as a representative of a type or class or simply as an individual personality. For *Harlan Country, U.S.A.*, Barbara Kopple sought out coal miners and their families; for *Memories of Justice,* Marcel Ophuls looked for people who had been victims, prosecutors, or the accused of Nazi war crimes. Documentary filmmakers have also constructed film portraits of "ordinary" people, such as Nanook in Robert Flaherty's *Nanook of the North* or Paul the Bible salesman in Albert and David Maysles's *Salesman.*

The documentary-film maker has several techniques at his disposal to draw the desired performance from his nonprofessional subjects. He may ask them to reenact their normal activities or behavior for the camera, following directions of pacing and movement and breaking up actions for the camera. This approach is closest to the technique of working with professional actors in a fictional drama. The director may also suggest filming in special locations or may pick and choose which of the subject's normal activities he wishes to record on film. He may ask for a formal interview or an on-camera statement.

In another approach, sometimes called *direct cinema,* the filmmaker makes actors out of nonprofessionals by allowing them to go about their normal activities without prodding or direction. It is part of the theory of direct cinema that subjects can become accustomed to the presence of the filmmakers and can "forget about the camera." Filmmaker D. A. Pennebaker suggests, however, that the very process of filming creates a heightened awareness in the film's subject—an awareness, if only subliminal, of being filmed—and that in his desire to be true to himself, the subject will present what he believes to be his authentic self for the camera.

Finally, some filmmakers neither direct actively nor try to become inconspicuous, but choose to provoke the subjects of a film into an action or emotion in order to get an effect or heighten the drama. This practice has been used by cinéma-vérité and direct-cinema filmmakers, among others. For *Chronique d'un été* (*Chronicles of a Summer*), Jean Rouch set up situations that compelled a response from his subjects. He found his subjects for the film by darting into the street with camera rolling and demanding of passersby, "Are you happy?"

One of the more interesting experiments in the technique of documentary provocation was Alan Funt's television series "Candid Camera." For this program, Funt would set up bizarre situations and odd special effects in public environments, and the subjects would confront them without being aware that they were being filmed. The results were often hilarious. (The next stage after the filming was, of course, for Funt to obtain the necessary releases and permissions from his unsuspecting subjects.)

NONPROFESSIONALS IN EXPERIMENTAL FILMS. Experimentalists frequently make use of friends, family, or fellow artists as performers. For his experimental *Entr'acte* (1924), René Clair secured painter Marcel Duchamp, composer Erik Satie, and other celebrities of the Parisian art world as performers. Stan Brakhage has made numerous films featuring images of his wife and children, including a film of his wife, Jane, giving birth (*Window Water Baby Moving*).

THE TECHNIQUE OF ACTING

Some acting techniques and approaches apply to almost all dramatic media, whereas others are specifically adapted to film production. To understand and appreciate what goes into a film performance, we must know something about the general techniques of acting in addition to those used particularly in film.

Acting as a Discipline. All actors, of no matter what school of philosophy, work with the same basic instrument: the actor's body. In various methods and styles, they work toward the same purpose: to portray a believable and understandable character.

TRAINING THE INSTRUMENT. The actor can train or develop to varying degrees three physical aspects: the appearance, physical movement and sensitivity, and vocal expression. In all these areas,

the actor works through constant practice to achieve an ideal of exquisite control combined with a state of naturalness and relaxation that makes possible the most delicate and sensitive responses and reactions. This goal of freedom or naturalness combined with control is similar to the state achieved by master athletes, dancers, and virtuoso musicians.

1. *Physical appearance* is perhaps the most inflexible aspect of the actor's instrument, limited by such constraints as age, weight, and bone structure, but it can be extensively altered. Some actors develop and rely on a relatively consistent physical appearance. Greta Garbo was always beautiful and glamorous, Rock Hudson always clean-cut and handsome; Charlie Chaplin's tramp was instantly recognizable, as was Groucho Marx's own eccentric image. Other performers change their physical appearance and physical images from role to role.

Makeup and costume are the simplest ways to change (or maintain) appearance, but there are many others. An actor may practice and perfect certain physical mannerisms or stances, such as a limp, a stoop, or an erect posture. Certain groups, such as Jerzy Grotowski's Poor Theater and Peter Brook's International Center of Theater Research, have experimented with facial expressions and postures so extreme that they become masks or radical transformations of the physical character. The actor may also shave or grow a beard, grow hair long or dye it, or lose or gain weight for a role.

2. *Physical movement and sensitivity,* although limited to an extent, can be more easily developed by training. Many actors regularly study or practice dance, athletics, Yoga, or musical performance in order to develop their physical instruments. An actor may learn a skill such as singing, horseback riding, or boxing in order to play a certain role. Others limit themselves, or are limited, to roles that do not require much physical activity or agility.

Whether athletic or sedentary, however, every role demands from the actor a heightened *sensitivity* to the physical movements of the character. A way of raising the eyebrow or twisting the hands may be as powerful and effective a gesture as a leap across the room. The actor learns to train himself to this sensitivity by constant *observation,* both of his own physical behavior and of the behavior of the many individuals he encounters in life.

3. *Vocal expression and quality of voice* are perhaps the most

easily trained aspects of the actor's instrument. The actor may rely on his own natural quality of voice and style of vocal expression or may develop the voice toward a specific goal. Some actors have developed (or been born with) a distinctive and consistent vocal quality, style, or accent, which they bring to all their roles. Others undertake extensive vocal training and practice in order to control voice quality, achieve a resonant tone, and develop a facility with diction and speech patterns. The actor may also study an accent or manner of expression for a specific part.

STYLES OF ACTING. Traditionally, there have been two principal tendencies in acting technique and practice: (1) the external, representational, or technical style and (2) the internal, presentational, or "natural" style.

In the *external style,* refined in the traditional French and English theater, the actor strives to perform and execute all the external characteristics of his part, including physical mannerisms, tone of voice, rhythm and pacing of speech, and the like. He *imitates* the character he is playing, but with great skill and sensitivity, somewhat in the way that a dancer follows the movements of the choreography or a musician follows a score. John Gielgud, Laurence Olivier, Katharine Hepburn, and George C. Scott are masters of this style.

The *internal style* also has a long history, but in the twentieth century it was championed and brought to prominence by the great Russian actor, director, and teacher Konstantin Stanislavski. At the Moscow Art Theater, he evolved a system of instruction and practice in the art of acting that has since become known in the United States simply as the *Method.* Method acting is complex and subtle in practice and has been open to many interpretations but it is, in fact, based on a very simple principle.

In method acting, the actor does not strive directly for the external effect he wishes to achieve but instead works toward an inner concentration and emotional understanding of each small portion of the role, so that the external actions may be performed simply and naturally. The goal is to produce spontaneous actions and emotions that flow naturally during the performance. In a sense, the actor uses his physical actions to evoke real emotions in himself, rather than perfecting the physical expression of emotion.

Marlon Brando, Marilyn Monroe, and many other well-known

actors trained in this system. Study of the Method involves a great number of specific techniques and exercises, some of which were developed by Stanislavski, others by his various followers.

CREATING THE CHARACTER. No matter what technique is employed, the actor usually spends a good deal of time researching, analyzing, and thinking about the character he is to play. This process is called *building the character* or *creating the character*. The actor tries to imagine or deduce as many facts about the character as he can, even those that go beyond the scope of the script. For example, he may make up childhood experiences for a character who appears on stage or screen only as an adult and who never explicitly refers to his early life.

This kind of work on the character is quite similar to the work of the writer. The actor begins with the script as written, then tries to fill in many more details about the character and to understand him more deeply. In some film productions, the actor may have the freedom to change the written character, based on his own research and understanding.

IMPROVISATION. Improvisation has two basic uses: (1) as a means of exploring characters, the relationship between characters, or the relationship between characters and their circumstances; and (2) as a means of relaxation, of allowing natural and spontaneous behavior to occur free from the confines of the script or of the actor's own preconceptions.

Improvisation is almost always used strictly as a technique of rehearsal and preparation, although a few experimental theater groups have employed it during performance and some filmmakers have filmed improvised scenes as part of production. This is a rather risky process, somewhat akin to the cinéma-vérité approach of shooting a great deal of footage in order to capture a few precious moments.

There is no one technique of improvisation, and different directors and actors may discover various methods that suit them. However, there are three commonly employed approaches.

1. The actors may play a scene from a script, following the principal actions and confrontations but without using the actual written dialogue of the script.
2. The actors may follow the script but change certain elements.

They may imagine a different location than the one indicated, or different circumstances, or may shout their lines or exaggerate their expressions.

3. The actors may improvise scenes that have no actual counterparts in the script but are similar to a scripted scene or one that could occur between the film's characters. These might include arguments or exchanges about subjects that are not referred to in the script, or other imagined circumstances in which conflicts and tensions between characters might find expression.

Acting for Film. We can most easily understand the special requirements of film acting by comparing it to acting for the stage. Although certain elements, such as the actor's control over his physical instrument and his development of a character, are quite similar to stage work, the differences are just as important.

PERFORMANCE IN SMALL BITS. Although the actor rehearses a play in small bits for the stage, once the curtain rises, he is committed to a continuity of performance, which must be sustained even if lines are muffed or cues are missed. This need for continuous performance may actually assist the actor, since all his work will be concentrated in the relatively short duration of the play on stage.

In a film production, the actor performs in small bits, sometimes repeating the same action several times in a row for the camera, sometimes delivering a single line of dialogue, or simply a look of response, in a given shot. At the director's signal of "action," the actor must be instantly immersed in his role, and his concentration may be interrupted at any time by the signal to "cut." Between takes, there are often long waiting periods while lighting or camera position is changed, during which the actor's attention may be distracted from his role. There is little opportunity for the actor to warm up to his part through an extended performance, as can happen on the stage.

There are two ways of dealing with this problem: Either the actor is always in character, always playing his part even while the cameras are being set up or moved; or he becomes practiced in a quick preparation and release of the role and develops the ability to slip the role on and off like a costume. The latter approach usually results in a more relaxed working atmosphere.

LACK OF AN AUDIENCE. The actor on stage is always aware of

the audience and may develop a kind of rapport with it, adjusting his performance according to the audience's responses. For the film actor, the audience is a remote, abstract idea—there is no opportunity for the heightened awareness that comes from communicating with a live audience.

Sometimes the film crew can serve as a kind of audience, but the crew members are usually so wrapped up in their production activities that the actor may feel positively neglected. It thus falls upon the director to serve as audience, so that the film actor can feel there is someone there to act for, someone who will appreciate and respond to his performance. The film actor may thus become more dependent on the director than would be the case in the theater. The experience is subtly different, however, from that of acting for an audience since the director is a known quality and is also an active participant in the filming process, not a crowd waiting passively to be moved or entertained.

PERFORMANCE IN A BUSY SETTING. An actor performs in the theater before a hushed audience, in a darkened space, illuminated in a magic circle of light. The film actor performs in broad daylight or in a small area of a massive, well-lighted sound stage, surrounded by lights, cables, reflectors, crowds of technicians, cameras gliding about on dollies, and sound recordists walking about pointing microphones. The degree of concentration required of the film actor is thus far greater because so many distractions must be shut out.

The actor may learn to use some of these distractions to add realism to his performance. Marlon Brando said that on one occasion during the filming of Elia Kazan's On the Waterfront, his frustration with the cumbersome and lengthy process of setting up a scene in foul weather became the spark for his rage within the scene.

PERFORMANCE OUT OF SPACE-TIME SEQUENCE. The continuity of a film actor's performance is not only broken into small bits and separate shots but may also be fragmented in space and time as well. Scenes that use the same location or the same group of players are grouped together in production though they may not follow the sequence of the script. The end of the film may be performed before the beginning, and the middle after that. Sometimes a director may call for shots or actions that will be used at a yet undetermined point in the edited film, or he may even call for certain scenes to be played without explaining to the actor where they will fit in.

This again means that the actor has no opportunity to build and

sustain a continuous line of performance and character development. Instead, he must be able to immediately become immersed in the character at different points of time and plot development, sometimes even without knowing exactly what the plot line is.

THE DIRECTOR'S CONTROL. In the theater, once the curtain rises, the actors are in control—they run the show, and the performance succeeds or fails with them. The director does extensive work and is in charge during rehearsals; but after the curtain rises, the play is out of his hands.

In film production, the director is always in charge. Scenes are performed out of sequence; the director can start and stop the action at any time, can call for retakes, and can revise the action, the dialogue, or the blocking. He can also make decisions about camera placement and camera angle, choose long shots or close-ups, favor one actor over another—all circumstances that greatly influence the effect of an actor's performance but over which the actor has no control.

The director's control can be so extensive that the actor's appearance and tone of voice become more important than his technique and understanding of the role. Even tone of voice can be unimportant if the film is dubbed; another actor's voice may issue from his lips. The director can change physical appearance as well, through lighting, camera angle, and choice of lenses: For example, a wide-angle lens can make a face appear fleshy and bulbous, and a short actor can be made to appear taller through camera placement or by having him stand on a box.

THE EDITOR'S CONTROL. The director's control over the actor's performance either continues into the editing room or passes into the hands of the editor.

The editor can control the pacing and rhythms of performance, orchestrate the delivery of lines, and decide which actor will be emphasized visually in a scene and whether an actor will appear in close-up or as part of the crowd. The editor's manipulations can subtly change the subtext and the implications of an actor's performance, can give new meaning to a line of dialogue, and can even alter the characterization itself.

As is well known by all film actors, lines or whole performances can be reduced or cut to almost nothing, and an aspiring player's career can be made or lost by the editor's choices. Even an excellent,

moving performance may be left out of the final cut of a film if it seems to weight the dramatic development in the wrong direction. On the other hand, a mediocre performance can be vastly improved by editing. Pacing can be speeded up or relaxed and awkward moments removed. An actor can be given a strong personal presence in a scene through the choice of close-ups or reaction shots that may have been shot completely out of sequence.

ADJUSTMENTS FOR THE CAMERA. The film actor must continually adjust and adapt his performance to the needs and demands of the recording apparatus: the camera, lighting setup, and microphone.

This adaptation may be flexible or controlled. In many documentary films, it is the camera and sound recordist that adjust themselves to the subjects, and fiction films may be shot in a similar way. A director may choose loosely defined angles and allow the camera to follow the actors so that the actors really determine the shots. On the other hand, the action may be rigidly choreographed and composed for the camera, so that the actors have to attend as much to the precise pacing and direction of their movements as to the other aspects of their performance.

Different kinds of visual and editorial compositions may require different degrees of adjustment by the actor. For example, a scene composed in montage—in a series of separate, quick shots—may be relatively easy to perform, since each part of the action may be composed separately for the camera. A scene shot in mise-en-scène—in a long, continuous take—is more difficult to execute. Actors may have to move about in the scene, and the camera may move as well, so that a series of different visual compositions can be achieved in the single take. It then becomes important that the choreography of actors' movements and camera movements be precisely coordinated and that the focusing of the lens be precisely adjusted. During the take, this choreography can be further complicated by the need to move the microphone to a new position or by a shift in lighting.

In such situations, the actor may be directed to precise marks, indicated by tape or chalk marks on the studio floor. The pacing or timing of his movements becomes critical, since he many have to move from one mark to another in exactly the time that the camera is making its own move.

Some kinds of control may be required for both montage and mise-en-scène shooting. The actor may have to hit precise marks even if the camera doesn't move. For the taking of close-ups, the actor may be directed to look in a precise direction, right or left, so that the edited shot may preserve correct continuity.

One of the striking adjustments an actor makes for the camera is to restrain his gesture and expression compared to what is usual for the stage. The camera can magnify the slightest gestures (the raising of an eyebrow, the twitch of a muscle), especially in close-up, so that gestures that seem normal on the stage appear as wild overacting on the screen. Especially in close-ups, the audience seems to *read in* emotions and responses, and the film actor often finds that an expressionless face may be far more effective than any gesture he could make.

SOUND RECORDING AND THE ACTOR. The actor usually has little adjustment to make to sound recording except in the dubbing process, but the potential for technical manipulation of his recorded voice is considerable. Theatrical voice projection is usually not required for film, since microphones can be boomed in to pick up the quietest tones. The actor may also be fitted with a tiny *lavaliere microphone,* connected either to a wireless transmitter or to a miniature tape recorder that he can carry in his pocket.

If *cue cards* are used, the actor may even be able to get through a scene without memorizing a word of dialogue. A cuing system is any device that displays the actor's lines of dialogue outside of the frame so that he can read them while performing the scene. It may be a complicated automated device, like that used by television newscasters, or it may be a more primitive arrangement. Marlon Brando has reportedly cued himself by secreting small bits of paper around the set with lines of his dialogue written on them. Jean-Luc Godard made use of an unusual cuing system in *La Chinoise:* He fitted an actress with a concealed miniature earphone so that he could whisper directly to her the answers she was to give to an off-camera interviewer.

Dubbing, of course, offers the greatest potential for control over the actor's performance, even to the point of combining one actor's voice with another's image. For some productions, a *scratch track* is recorded on location, but the actors are called back after the shoot-

ing to dub in their own voices in the controlled environment of the dubbing studio. Lines can be altered slightly and voice quality can be modified through sophisticated studio recording equipment.

Unlike location recording, the dubbing process is technically demanding for the actor, who may have to do many takes of a single line to achieve accurate synchronization with the picture. It is also more difficult for an actor to capture the mood and flavor of a scene when facing the machinery of the recording studio than in a performance situation. This difficulty can only be increased when the voice is dubbed by an actor who has not actually played the role before the camera.

THE ACTOR-DIRECTOR RELATIONSHIP

An exciting screen performance is usually the result of an active collaboration between the actor and the director, both of whom contribute to what we perceive on the screen.

The actor prepares for his performance by studying the circumstances of the script. He explores and creates a character through research, observation, imagination, and improvisation; engages in appropriate physical exercises or training; and adapts his performance to the technical requirements of the production.

The director also studies the script and the circumstances of the action and tries to arrive at a clear understanding of the overall theme of the script. He considers each character in the script, each character's relationships with the other characters, and each one's connection with the overall theme.

The Director's Responsibilities. The director is responsible for the progression of the action and for the emotional and aesthetic unity of the production. He gives instructions or makes suggestions to the actor about his characterization, and, if need be, explains the actor's relationship to other players and to the main events of the script and to each scene as it is played. The director must also set the *blocking* for each scene—that is, determine the physical movements of each actor in relation to the other actors and to the camera and the set. Whenever an actor is confused or at a loss as to how to play a scene, it falls upon the director to make suggestions or give instructions, to explain the meaning of the scene, or in some other

way to elicit the response he is looking for. Sometimes he may evoke a response indirectly by referring to circumstances outside the script or to the actor's personal life.

Always, the director must be an attentive and critical audience, carefully evaluating every nuance of the actor's performance, indicating which elements of the performance should be retained or accented, which should be changed or dropped. He must see that a continuity of performance is maintained and that the actor's characterization remains consistent throughout the film. Particularly if the film is shot out of sequence, he must help prepare the actor for the subtle shifts in characterization that take place between different sections of the script.

The director must constantly balance the abilities and needs of the performers against the technical requirements of the production. He must decide when a good take has been achieved, when for technical or performance reasons a shot should be repeated, when the performers and crew have the resources of energy and attention to attempt a difficult scene, or when a simpler scene should be shot. He can decide to emphasize a certain moment of a scene or of an actor's performance by shooting a close-up; or he can compensate for an actor's difficulty with a line or a whole scene by remaining in long shot, by shooting so as to avoid the actor's face, or by shooting portions of a scene out of sequence.

Styles of Working with Actors. The director may exert varying degrees of control over the actors and the shooting process. He may demand absolute obedience from both actors and crew or may allow the actors a great deal of creative freedom and input into the decision-making process. He may collaborate extensively with one or several actors and simply give precise instructions to the others.

The decision to command or to collaborate affects both the technical side of things—the choice of shots and angles—and the nuances of the actors' performances. Some directors try to achieve a balance between the two poles; others lean toward one extreme or the other.

DIRECTORS WHO COMMAND. Control over actors can be maintained in two ways: (1) by building the drama and emotion of a scene through the juxtaposition of images rather than through continuity of performance, and (2) by providing precise and detailed instructions for the actor's behavior before the camera. Alfred

Hitchcock was notorious for his meticulous preparation of shooting scripts and storyboards, in which every shot was laid out on paper just as it would appear in the edited film. His actors were expected to simply execute the movements and the dialogue of the script precisely as indicated. They became pawns or puppets in Hitchcock's elaborate compositional and dramatic structures. Although Hitchcock claims to have been referring to an unprofessional minority in saying early in his career that "actors are cattle," the statement does reflect something of his view of the actors' function.

Other directors have held similar views, although with perhaps more of a tone of respect. Robert Bresson refers to players in his films not as actors but as "models"—the human elements of the audiovisual composition. The performance is made in the combination of shots, he maintains, and the first goal in working with the performers in a film is to get them *not* to act.

Some directors have learned to maintain a kind of absolute control over their actors without precise scripting. Michelangelo Antonioni has been known to work with actors without ever allowing them to read a full script, so that they never really know who their characters are or what they have to do with each other or with the theme of the film. They thus become totally dependent on the director and can only follow his instructions from scene to scene.

DIRECTORS WHO COLLABORATE. The director may expect a certain amount of creative decision-making from his actors. This creative contribution may be limited to the interpretation of roles and to the blocking of scenes, or may extend to the actual revision or creation of action and dialogue.

On a detailed level, the actor may suggest slight changes in dialogue—if, for example, the scripted lines seem awkward or unrealistic—and may contribute small bits of *business* (actions not called for in the script, but which fill out or add realism to a scene). On occasion, the director may consider major changes in plot or action or major revisions of a characterization based on the actor's suggestion.

The more powerful and successful the actor, the greater the influence he may have over the script. In fact, even before production begins, a known film star may call for major revisions in the script. A script may even be written from scratch for a specific actor or film star to exploit the qualities of his screen personality.

The director may also evoke creative contributions from the actors through the technique of improvisation. Results achieved in improvisations may be used as the basis for further writing of scenes and dialogue or may be filmed directly. Robert Altman is one director who has relied heavily on creative improvisational contributions from his actors, especially in *Nashville* (1975). John Cassavetes, a director who is also an actor, used improvisation in the filming of such works as *Shadows* (1959) and *Husbands* (1970).

The extent of the actor's contribution to a film affects not just the performances themselves but also the camera positions and choice of shots. If the actors improvise a scene or work out their own blocking and pacing, the camera must perforce adjust itself to their movements. Jean Renoir was working in this way with his carefully scripted films long before the more radical experiments of Cassavetes and Warhol with filmed improvisation. In the antithesis of Hitchcock's approach, Renoir's compositional eye and aesthetic vision were brought to the film after rather than before the actors created their performances. "I don't want the movements of the actors to be determined by the camera," Renoir stated, "but the movements of the camera to be determined by the actor."

Reading for Further Study

Andrew, J. Dudley. *The Major Film Theories*. New York: Oxford University Press, 1976.

With a simple and clear presentation, Andrews sums up and compares the work of the important theorists, from the early writers on the silent film to the structuralists and semiologists of the seventies.

Barnouw, Erik. *Documentary: A History of the Non-Fiction Film*. New York: Oxford University Press, 1976.

A thorough, thoughtful, and very readable account, with many illustrations.

Dwoskin, Stephen. *Film Is: The International Free Cinema*. Woodstock: Overlook Press, 1975.

Befitting its subject, this is an impassioned and highly personal account of the history and scope of experimental film. Part memoir, part criticism, and part appreciation, the book communicates excitement. Thirty-two pages of stills.

Field, Syd. *Screenplay: A Step-by-Step Guide from Concept to Finished Script*. New York: Dell, 1979.

Although written as a handbook for the would-be screenwriter, this little book provides a direct and succinct discussion of the mechanics of the classical narrative film.

Goldstein, Laurence, and Kaufman, Jay. *Into Film*. New York: Dutton, 1976.

A remarkable book that manages to combine a detailed study of film aesthetics with a clear, practical approach to the techniques of filmmaking. Illustrated by shot-by-shot sequences taken from over a hundred films.

Hagen, Uta. *Respect for Acting*. New York: Macmillan, 1973.

Acting is to be learned more from doing than from reading, but Hagen's fresh and personable approach is a useful introduction to some of the actor's basic techniques and vocabulary.

Knight, Arthur. *The Liveliest Art*. Rev. ed. New York: New American Library, 1979.
Although occasionally opinionated and uneven in emphasis, this is nonetheless a quite readable short introduction to the history of film.

Lipton, Lenny. *Independent Filmmaking*. New York: Simon & Schuster, 1972.
For the serious filmmaker interested in 16mm production, this is a basic reference text in film technology and practical technique. Oriented toward the individual filmmaker working on a limited budget.

Lipton, Lenny. *The Super 8 Book*. New York: Simon & Schuster, 1975.
Some very interesting new film work is being done in Super 8, and there are several international festivals devoted to the format. With his usual informal approach, Lipton describes and critiques various equipment and technique options.

Malkiewicz, J. Kris. *Cinematography*. New York: Van Nostrand, 1973.
A brief, practical introduction, with some treatment of sound recording and editing, accompanied by many diagrams and by photographs of the most commonly used equipment in professional 16mm production—cameras, lighting equipment, and the like.

Mascelli, Joseph. V. *The Five C's of Cinematography*. Hollywood: Cine/Grafic Publications, 1965.
Camera angles, continuity, cutting, close-ups, composition—this is the bible of classic filmmaking technique. The focus is not on equipment and technology but on the visual presentation of subjects, actions, and locations. Numerous photographs illustrate the basic principles followed by the cinematographer and the editor.

Monaco, James. *How to Read a Film*. New York: Oxford University Press, 1977.
Subtitled "The Art, Technology, Language, History and Theory of Film and Media," this is a thoughtful and comprehensive general reference text, with emphasis on the psychological and political aspects of film. Includes coverage of the history and technology of television. Profusely illustrated, with an extensive glossary and reference bibliography.

Nizhny, Vladimir. *Lessons with Eisenstein*. Translated and edited by Ivor Montagu and Jay Leyda. New York: Da Capo Press, 1979.
Based on notes and shorthand records of Eisenstein's classes at the State Institute of Cinematography in Moscow, this book is unique in its presentation of how a director sets up shots, blocks the action, and breaks down a scene for the camera, all with a view to visual and dramatic nuance.

Index